Author's Foreword

I started this book in 2021 and then stopped, concerned that I might be trivialising what has been the devastation of many hundreds of thousands of lives out of 3.8 million women affected, and so I stopped. Three years on I have concluded that the only way we can get the truth out there and into the public awareness is by being forced to fictionalise it. So please be aware that this is primarily a work of fiction. But...

I have used anecdotal evidence of true circumstances, with the occasional bout of fictitious humour for my book and I have modelled my characters and situations on a combination of several of the characters of the women that I have been privileged to have encountered along my campaigning for justice, and whom I have great admiration for.

I have not included real names as there are too many to acknowledge but you know who you are and may recognise elements of yourself... I would hate to miss anyone, as every contribution has been a personal and often painful fight for the truth and justice. The 1950's women demonstrate the grit that British women were renowned for in earlier times.

We fight against a hugely financed opponent in a misogynistic scandal that exceeds any other in the previous 100 years. An injustice that has been smothered down by a government that would not admit its complicity in our suffering. Their deliberate targeting of a ten-year age group of 1950s women knowing that, by keeping them un-informed and an isolated 'Timebound' target, they would get away with the biggest cash grab of our pensions in history.

What they overlooked was that they had chosen a generation with true fighting spirit. This is just a small part of the story of 3.8 million women who had up to 6 years of their pension taken, many with no notice. This is the story of their suffering, but mostly of their spirit, their strength and sisterhood. They fight for themselves, each other, their daughters and their life partners and families.

Make no mistake, this type of reckless playing with people's lives by a government, using our retirement funds like a Monopoly money, affects us all.

Please note: Those who know me are aware I do not buy into 'groups' I use the term WASPI as a generic term for all 1950s women, whilst acknowledging the wonderful work done by all the separate groups that have formed from grass roots campaigning, Including 100s of small support groups under

different names and on up to the mainstream larger groups. My local support group just happened to be WASPI Campaign 2018 and I make no apologies for that.

This is not a story about groups, it is about individual women coming together in opposition to injustice.

Special admiration, however, for Julie Delve and Karen Glynn who turned their lives upside down in having the courage to stand as the two complainants in the Back To 60 court case, and for all they have endured with great dignity.

For the 330.000 {and counting} women who have died fighting, without justice to date. You will have my everlasting admiration and respect. Special remembrance to Cath Ritchie, who I did not know personally, but who campaigned for justice almost until her death, and who's personal fight was one of the stories that inspired me to write this book.

Finally for my husband, Duncan, who with great patience, has supported me, even when my obsession with getting justice, has taken our precious remaining time together, and to my family who have also lost the special moments they should have had with their mother and grandmother, because of this.

A small part of every woman I have stood up with against this scandal is in this book and will be forever in my heart. I wish I could list you all, but I would forget someone and therefore I will name none, but you know who you are.

If you wish to read some of the true accounts of these women's loss. There is currently an extensive book of them compiled by Trudy Baddams of We Paid In You Pay Out. She can be reached through Facebook.

NON ABIENS

NOT
GOING
AWAY

BY

DEE WILD KEARNEY

Cover Design by Charlotte Aspinall

Artwork by Patsy Allen
© Elsworth Creative

Chapter One

A Gathering of Strength and Numbers 2018

Rain lashed against the bay windows, mirroring the storm brewing inside Beatrice. At 60, she should be sipping a great wine in an Italian vineyard, not staring down the barrel of yet another final demand with a bank account as flat as a discarded pancake. Life, it seemed, had a cruel penchant for rewriting retirement brochures.

Her once trusty Volvo recently renamed 'Boris' after a rising 'star' in the conservative party, and equally unreliable. With a penchant for wheezing and leaking oil, sat outside, lifeless as her sex life and currently her career. The mechanic had quoted a sum that would make even an MP creaming off his expenses wince, leaving Beatrice with the automotive equivalent of a paper cut on the aorta.

On the kitchen table, the overdue final demand notice glared like a cyclops with a mortgage broker for an eye. "Immediate action required" it declared in bold, underlining "immediate" with a flourish that would shame a Renaissance calligrapher. Beatrice snorted; a laugh tinged with something bitter. Action, she could do. It was the 'immediate' bit that was proving tricky.

She slammed the meagre provisions she had bought at the overpriced village shop in the absence of a moving vehicle, into the cupboard, hoping the aggression might disperse the explosion of frustration that was bubbling to the surface, and she clicked on the kettle emphatically, bugger the cost of electric!

Her retirement dreams of pottering around a sunlit studio in the garden of a thatched cottage had long since gone the way of the dodo, the pension she'd diligently paid her NI contributions to, snatched away by a government with the ethical compass of a toddler playing pirates. At the age of 59 she had been informed by a colleague that they had taken six years of her pension, raising the qualifying age from 60 to 66. Done in a series of hikes, brought in, as all governments did when they expected opposition, under the radar and without bothering to inform her. To bring it into line with men they had said. Well, that would be the first time anyone

of her generation would have had equality with men!

Now, she was a WASPI Campaigner – cast adrift in a sea of broken promises and rising living costs, without even the courtesy of a brief memo to let her know that devastation was on its way. Retirement savings she'd made from downsizing were trickling away like sand through a sieve, and she was staring at the last grains, mesmerised by how quickly they had drained away.

Desperate, Beatrice had scoured the job market. Despite in her earlier career, being tied to the northwest with two growing kids that prevented her working farther afield on the bigger productions, her CV was still extensive. Once resplendent with credits for many theatre productions and her one and only award-winning costume design featured of all things on 'Songs of Praise,' now felt like a faded passport to a vanished kingdom.

"Experience" they craved, not the seasoned kind that came with wrinkles and varicose veins. "Tech-savvy" and "dynamic" were the buzzwords, leaving Beatrice feeling like a dial-up modem in a world of broadband babies. At college, many years previously, as she walked away with the student prize, someone had said that in this business you can be passé within a week. Well, she had managed many years, and as she had once quoted to a

newspaper article, "she had "never been to work, just to the theatre."

What she'd give to be back in 1991, a newly qualified 'late starter' after motherhood and divorce, launching into her creative career once more, knowing what she knew now. She would have beaten someone with a blunt stick until they'd given her a work pension, bought property with every spare penny and not placed her trust in a government system, but in those days few women were given that option.

As a freelancer, she had been paid well for the run of the show, then unemployed for a couple of weeks until the next project and so on. That's just the way it was. She loved it, but as a single mum, she never had the chance to accrue savings or contribute to a private pension. Keeping afloat was as much as she could do and if the kids were fed and clothed and the mortgage paid, she had been on a good month.

Now after downsizing to pay off the remainder of her mortgage, she had left her comfortable home in Manchester, for a small terraced in Margate thinking there would be more work nearer to London. She hadn't reckoned with ageism. So here she was scrabbling for work and still couldn't afford to live, how the mighty were fallen.

Today, on the way back from the shop, some small salvation had arrived in the form of a flyer she found clinging to a lamppost. A local WASPI group, promising "Laughter, solidarity, and the occasional cake." It was a lifeline, a raft in the torrent of her misfortune.

That same evening, she found herself in a community hall smelling of stale biscuits and cautious optimism. A gaggle of women, mostly her age, sat around a table laden with fairy cakes and mugs of builder's tea. Introductions were punctuated by sighs about rogue knees, dodgy hips, and grandchildren who laughed at them because they thought Tinder was a type of wood.

She was introduced firstly to Christina, a retired nurse with a laugh that could silence a foghorn despite the affliction of a very bad back brought on by years of nursing. She obviously had managed to retain a sense of humour. Sylvia, a florist whose floral hat defied horticultural logic and who seemed frightened of her own shadow, and then there was Maureen, the group administrator, an ex-teacher with eyes that sparkled like mischief and a tongue sharper than a stiletto heel. Manda, an ex-paramedic with a taste for tie die and straight talking, and Sheila, a cleaner, with language colourful enough to shame a Liverpool docker. Another woman Deidre arrived late and apologised for her tardiness due to work commitments and as

she was introduced Beatrice noticed the specs of paint on her hands.

"Fellow Artist?" she asked, nodding to said hands. Deidre looked down and smiled.

"No, reluctant painter and decorator" she replied.

"Welcome Beatrice," Maureen declared, raising her teacup in a toast. "To surviving on Werther's Originals and the sheer bloody audacity of being over 60 in this ageist wasteland."

The room erupted in cheers, some loud, some half-hearted, a small chorus of defiance against a world that deemed them past their prime. Beatrice smiled as she waved her hand in greeting, a genuine one that crinkled the corners of her eyes. Maybe, just maybe, this wasn't the end. Maybe, in this motley crew of misfit queens, she could find not just a lifeline, but a revolution. A revolution of sequins, bingo wings, and the unshakeable belief that being over sixty was just the beginning, not the finale.

As the rain continued to lash outside, a different kind of storm gathered in that hall. A storm brewed of resilience, laughter, and the unyielding spirit of women who refused to be written off, even if their pensions and knees had other ideas.

Beatrice's kids had long since grown, with their own children now, and too busy fighting their own personal battles, to even contemplate the dire straits their mother was facing. Her parents were gone some years ago, leaving her as an only child, feeling oddly orphaned. Maybe here she had found a new family. Sisters driven by outrage and the strength born of all the sexist shit her generation had endured, and then the final insult, the up-ending of their life for nothing more than a government cold blooded and misogynistic cash grab.

For Beatrice, it was the start of a new chapter, a black-comedy odyssey where the odds were stacked against her, but the heroine had a wicked sense of humour and a shed full of paints and canvas. The curtain was up, and Beatrice, ever the designer, was ready to paint her own damn masterpiece or at least graffiti her feelings on the walls of parliament.

Chapter Two

Sylvia stared at the plump velvety crimson petals of the Christmas cactus as if it were a crystal ball revealing her impending doom. Mrs Bannister, the shop's manager, hovered with the grim air of a tax inspector examining a dodgy receipt. This, Sylvia sensed, was her last 'Tiptoe through the Tulips.'

Her fingers twitched near the scissors, longing to liberate a bloom, an act usually as natural as blinking in the sun-dappled greenhouse. Today however, the urge wasn't just about getting her quota done; it was about rebellion. Stealing, after all, was the only way she could have the tiny luxuries that kept her sanity clinging on by its badly manicured fingernails.

Usually, she would creep around the shops lifting small items, A tube of lipstick the shade of a defiant poppy, a tin of sardines bathed in lemon oil, a paperback with a heroine who didn't have to ask permission to breathe, which she would hide under the sofa cushions ready to read when 'he' had gone to bed, safe in the knowledge that her husband never plumped cushions. That was women's work.

"Sylvia dear," Mrs Bannister droned, her voice as dry as a deflated soufflé, "sales are down. We've had to…rethink staffing."

Rethink meant boot out, and Sylvia knew it. Her arthritic knees, her penchant for wearing strange floral hats, her inability to 'hang' with the younger members of the flower wholesalers' team and her occasional tendency to power nap amongst the hydrangeas – all charming eccentricities in boom times – were fast becoming inconvenient liabilities in the face of the recent economic blight.

The thought of returning to Alan, her husband of forty years, with no escape through a job she loved, sent a shiver down her spine. Alan, a man whose idea of foreplay was asking if she'd remembered to defrost the sprouts, saw her not as a wife, she mused, but as a particularly troublesome houseplant – one that needed constant pruning and watering, but never sunlight or fertilizer.

"But Mrs. B!" Sylvia exclaimed, her voice cracking like a gerbera stem in a gale. "I know orchids! I can coax wilting lilies back from the brink! I once crossbred a begonia with a marigold and almost won Village Gardener of the Year!" It was a desperate cry for recognition of her talent.

Mrs Bannister, bless her tightly coiffed and botox'd forty something soul, cracked, almost literally, a smile. "You're a marvel Sylvia, no doubt. But the numbers just aren't there, and you've reached an age where you deserve a rest." Ageism at its inconsiderate best, thought Sylvia resentfully.

"Yes. I do deserve a rest Mrs B, preferably with the pension I worked hard for all my life, and not breaking my back here every day with no thanks just to survive!" The words were spat out and she paused in shock at her own voice. Well, she'd said them, and she meant them. Mrs B's overly botox'd face, if it could have shown any kind of expression, would have been astonished, but as she was incapable of raising one eyebrow, let alone two, it was hard to tell.

Desperation, sharp as a thorn, pricked Sylvia's finger. She glanced at the crimson Christmas cactus again, its velvety petals like an open invitation. One bloom, just one, wouldn't hurt. It would be her own private Christmas miracle, a tiny act of defiance against a world that seemed determined to snuff out her spark.

Before she could overthink it, Sylvia's fingers danced across the stem, snipping a perfect bloom. She tucked it into her apron pocket, the feel of its soft velvet a secret rebellion against the impending frost of unemployment, turned and walked to fetch her coat, expecting she had just served herself an immediate notice.

As she walked home, the cactus bloom nestled against her heart like a stolen ember, warming the dread that gnawed at her. Alan might own the house, the bank accounts, and the remote control,

but Sylvia she realized, possessed something far more precious: the audacity of hope, the resilience of a weed pushing through concrete, and the secret language of flowers that whispered of beauty and defiance even in the harshest winter.

If only she'd received her pension at sixty as expected she wouldn't have been beholden to a man who questioned her every expense, until it was easier to succumb to his control and bear the indignity of threadbare underwear and out of style clothes, than endure the inevitable two hour 'discussion' on her extravagances. Occasionally when it had been all too much, she fought against the adrenalin and terror of thumbing her nose to everything. when she slipped a new pair of gloves or tights into her pocket at the supermarket. So far, she had been lucky.

Sylvia entered the house, the stolen bloom hidden like a contraband love letter. Alan grunted from his armchair, a newspaper masking his face like a disapproving shroud. The smell of overcooked cabbage from this morning's bubble and squeak hung heavy in the air and settled like the culinary equivalent of his personality.

As she hung up her coat, Sylvia held the crimson bloom to her nose, inhaling its sweet defiance. Tonight, maybe, she wouldn't make mashed potatoes. Maybe she'd make Alan watch a

documentary about carnivorous plants. Possibly tomorrow, she'd find a new bloom, a new job, a new way to keep her spark alive, one stolen petal at a time.

After all, a woman without flowers was like a garden without sunshine – drab, dusty, and utterly forgettable. And Sylvia, by golly, refused to be forgotten. Not while she still had scissors and a rebellious streak the colour of a stolen Christmas cactus.

Chapter Three

The sun, weak and watery, cast long shadows across the frost-rimmed gardens of Ash. Inside, 60-year-old Deirdre stirred a pot of builder's tea, the steam swirling like a phantom above her. Her gaze fell on the calendar, a stark reminder of the six years stolen from her state pension. Six years of security of dreams gone, leaving only the gnawing worry of their dwindling savings and Roger's arthritic hands.

Roger her husband of 15 years, shuffled in, his paint-splattered overalls hanging loose on his once-broad frame. At 62, he should be pottering in the garden, not battling ladders and scaffolding. But the arthritis, a cruel souvenir of years spent wrestling dust sheets and paint cans, perching for hours on ladders, and crawling around skirting boards on all fours, had him hostage, along with a two year raise on his own pension.

He had supported her all the way, bless him, and his favourite response to her political outbursts were that he'd "...like to see one of those white-collar twats who brought this policy in, perched on a ladder eight hours a day at the same age as him. When they could work a month alongside him without crying like a baby, he'd accept the rise in the pension ages and all they'd done to us."

Deidre set down the mugs, bracing herself for the daily drudge. "Alright love, let me see those hands."

Roger winced as she gently pried open his fingers, each joint swollen and knotted like gnarled tree roots. The familiar ache in her heart mirrored his. She remembered the days when she first knew him, that he'd scaled houses like a nimble spider, his laugh echoing across the rooftops. Now, his movements were slow and deliberate, each brushstroke a battle against the creeping stiffness. Each day another nail in his coffin of working beyond his physical capability.

"We need to find someone to help Rodg," Deidre said, her voice tight. "You can't keep doing this."

Roger shook his head, his eyes stubborn. "We can't afford to take anyone on love, the work is scarce enough these days. Besides, I built this business, bit by bit. I won't let it crumble now."

Deirdre knew the pride masked a deeper fear. Losing the business meant losing their lifeline, their independence. The thought of them, two pensions theft casualties, relying on handouts, was a bitter pill to swallow. Though their retirement savings were almost gone, they were still too much to allow them any kinds of benefit support. They couldn't spend them as planned because they now feared the future. So, they worked hard, but lived without

any expectation of holidays or the retirement future they had saved so hard for. No help with the rent, pension credits changed to exclude them. The one thing they retained after a public outcry, was the right to free prescriptions from 60, and boy were they needing them more and more. Between doing overnight care for her granddaughter and labouring for Roger, she was feeling broken.

Deidre had lost 6 years of state pension, finding out through a random Facebook post only one year before she expected to retire. With no time to prepare, it had devastated both their lives. This government had no shame, and the callous career driven tory that had boasted how much he had saved at all these poor women and their families expense, could go straight to hell, and if there was a hell, she hoped he would be condemned to spending eight hours a day atop a rickety ladder for all eternity, with arthritis. He hadn't saved money; he'd stolen it from vulnerable people without thought for the tsunami of suffering he was about to unleash.

She sighed; her own hands clenched into fists. "Alright then. But I'm helping you. No more ladders, no more heavy lifting. You're the boss, I get it, but I'm the foreman now."

A flicker of protest died in Rogers eyes, replaced by a tired resignation. He knew she was right. He

squeezed her hand, the warmth a balm against the winter chill. "You're always one step ahead Dee, my little paint-stained angel."

The days stretched before them, a canvas of peeling walls and chipped window frames. Deidre would mix paint, her movements slow, but efficient. Roger, perched on a stepladder (with Deidre's stern gaze fixed on him), used his brush with the practised ease of a seasoned artist.

As the afternoon sun dipped lower, casting long shadows across the room, Deidre paused. Looking at Roger, his face dusted with paint, a smile crinkling the corners of his eyes, a lump rose in her throat. He might be a warrior with aching joints, but he was her warrior and the kindest man she had ever met, who came to her late in life.

They weren't just fighting arthritis and the effect of her lost pension. They were fighting for their pride, their independence, their future. In that shared struggle, in the rhythmic scrape of paintbrush against wood, they found a different kind of peace, a sunset painted in the colours of quiet defiance.

The journey ahead would be tough, but Deidre knew they'd face it together, brushstroke by brushstroke, hand in hand, a paint-stained tapestry woven against the harsh winter of their stolen years.

That evening, she turned on the news as they sat down to an evening meal, to catch up with the budget statement points. They were showing parliament but not what she expected,

"Roger come here quick!" A huge smile came over her face as Roger came in with a tray of food. He looked to the TV where the Waspi women were stood in the public gallery, holding up signs with the amount of their pension that they had lost on them and shouting, "Shame on you!" They were receiving a standing ovation from the opposition, In the middle of the Budget!

"Roger…I've got to find me these women! …They are out there fighting for our rights!" Her face was a picture of amazement.

"Good for them!" said Roger,

That night Deidre went online and ordered a big yellow roll up banner with what she thought was her stolen pension amount.

Scanning the internet that evening, she found there was going to be a rally soon, and booked a train ticket, determined to stand outside parliament and make her point, even if she did it alone.

Imagine her surprise when she recognised a pretty lady at the station that she had seen locally a couple of times, but never spoken to, with suffragette colours of green, purple, and white and a sign that said, "We've Been Robbed!" Deirdre hadn't even known what suffragette colours were, and she felt ashamed that she had been so ignorant of women's history till now, she made a vow that she would learn and never be ignorant of politics again. Apparently, there were dozens of support groups all over the country and Margate had one. East Kent WASPI

"What's WASPI?" she'd asked.

"Women Against State Pension Injustice, or inequality, there's two groups now, but there's also lots of other groups all fighting. All with different names, but WASPI are one of the main ones."

"I had no idea! "She breathed.

"Most of us didn't have an idea about anything, especially that they were about to steal up to six years of our pensions!" came the reply.

That was the day that Deidre became a determined Waspi, and poor Roger didn't know what was about to hit him.

Chapter Four

Amanda 'Manda' Paris, 64 years old and sporting a mane of fire-engine red hair that would put Ariel to shame, ambled through the park, her trusty Collie companion with equally flaming hair, trailing along like a sentient cloud.

The crisp air nipped at her cheeks, but it couldn't dampen the jubilant swagger in her step. Two years. Two bloody years until she could finally kiss the siren song of the ambulance goodbye and tell the ageist 'tossers' at the station, who had no empathy for her plight, where they could stick their lanyards. She spat out a stream of smoke from her vape, with a silent wish that one days she would have the chance to splint one of those conniving politicians' legs, boy would she make them pay.

For decades, Manda had been a whirlwind in a fluorescent tabard, a one-woman mosh pit against misfortune. Broken bones, bad trips, babies popping out in taxis – she'd seen it all, her weathered hands delivering comfort and fighting chaos in equal measure. But the years, coupled with a dodgy ticker that made a grandfather clock sound like a rave beat, had finally forced her hand. Enough was enough. She was desperate to down tools and head off into the sunset in her battered camper.

The WASPI injustice, the six stolen years of her state pension, had been the final straw. It was like the government had nicked her retirement dreams of travelling and replaced them with discount bus passes and bingo nights. Not on Manda's watch. So, she'd donned her tie-dye dungarees, the uniform of her long-suppressed inner hippie, and declared war.

Her weapon? An arsenal of placards crafted from cardboard liberated from the local Co-op, some emblazoned with slogans that would make a sailor blush. "Same Shit – Different Century!" or "Granny on the Rampage: Give Us Back Our Stolen Pensions!" She'd become a one-woman picket line, her protests a technicolour splash against the grey monotony of bureaucratic indifference.

Today's target: the swanky MP's office nestled in a quiet corner of the park. As Manda and Bindi approached, a gaggle of immaculately dressed aides emerged, their noses wrinkled in distaste at the sight of the tie-dye rebellion. But Manda, unfazed, planted her backside on the pristine steps and unfurled her latest masterpiece: "Tories are Toast: We Want Butter, Not Bullshit!"

The ensuing melee was pure British comedy. The aides, sputtering and clutching pearls and adjusting collars in the embarrassment of having to deal with a woman who was clearly not going away, tried to reason with Mandy, their pleas dissolving into

bewildered sighs as she launched into a passionate tirade about betrayal, stolen dreams, and the audacity of MP swigging champers subsidised by taxpayers, while WASPI women were left scraping by on apples and peas from their gardens. Bindi, sensing the chaos, added his own commentary with a series of well-timed barks and enthusiastic tail wags.

In the end, it was a passing pensioner, bless his grumpy old heart, who finally got through to them. "Just give the woman a cuppa love," he grunted, shoving a biscuit from his pocket into Bindi's eager maw. "She's harmless, just a bit loud and its cold!"

Manda wanted to tell him to "fuck off" for patronising her, but he meant well, and she could use a brew. They'd better bring out the good biscuits that the taxpayers were paying for though...

And so, amidst the scattered placards and bewildered stares, Manda found herself ensconced in the MP's office, a steaming mug warming her hands as she regaled him with tales of WASPI suffering. He listened, actually listened, a flicker of understanding finally sparking in his usually glazed eyes. But then they always appeared to listen, it was the integrity and follow up they often lacked.

Manda knew she wouldn't win the war single-handedly. But as she left the office, Bindi trotting

happily at her heels, a defiant glint in her eye, she knew she'd planted a seed. A seed of awareness, of righteous anger, of tie-dye rebellion. And who knows, maybe it would blossom into something beautiful, something loud, something that would finally give the WASPI women their due.

Because Manda Paris, the hippy come hard woman, wasn't done yet, not by a long shot. The revolution had just begun, and it was going to be a technicolour riot, one placard, one biscuit, one bark at a time.

Chapter Five

Grace squinted at the sun glinting off the frost-rimmed parsnips, their emerald spears poking out from the mulch like defiant little soldiers. They were her battalion, her silent army in the war against the gnawing emptiness in her belly. Her garden, a riot of kale and leeks, was her fortress, a verdant barricade against the encroaching shadows of poverty and fear.

At 65, Grace was a widow sculpted from the granite of self-reliance. Her husband, Harold, had been a man of grand pronouncements and hollow promises. He'd handled everything, she'd believed, like a seasoned captain navigating the treacherous shoals of life. Except, Harold had forgotten to pack her a life jacket for the inevitable storm of his own mortality. "She should have kept more independence" she would berate herself in quiet moments since the funeral, but she was a generation that just preceded women's lib, and she had remained in the comfortable chains of reliance on another, just because it was the norm.

Their life had been uneventful, childless, and inevitably closed off from everything but each other. If she had had her pension at sixty as expected she would have managed. Instead, she was now surviving on foraging, and the contents of her garden. The bills were stacking up where she

had put them to one side, intending to address the issue, but had forgotten.

Now, adrift in a sea of bills and dwindling savings, Grace clung to the one thing she knew – the earth. Her days were a ritual of weeding, watering, and whispering endearments to her precious crops. The soil, currently cold and damp beneath her calloused fingers, was a solace, a confidante. It didn't judge her trembling hands, her thinning hair, or the memory lapses that left her staring at a half-peeled potato, the next step a mystery. The neighbours, bless their nosy souls, had noticed.

Mrs. Strewd, three doors up, with her eyes like disapproving currants, had cornered Maureen, who by chance was the local Waspi group administrator, at the village panto. "Grace, poor dear," she'd clucked, "living off nettles and rainwater, I wouldn't be surprised." Maureen, a woman with a smile as wide as the Thames, had taken it upon herself to stage an intervention.

The knock, loud on Grace's door, was as a startled robin in the quiet of her afternoon. She peered through the lace curtains, suspicion hardening her features. It was Maureen, her face a beacon of well-meaning cheer. Grace, with the aura of a startled deer, jumped back from the nets when spotted by her determined visitor, and she was forced, out of courtesy to answer. Maureen, armed with a

casserole and a relentless optimism, wedged her foot in the narrow gap and would not be deterred, and so Grace relented, and reluctantly swung the door wide enough for her to enter.

Inside, the silence was thick with the musty scent of forgotten books and dust motes dancing in the pale winter sun. Maureen's eyes, sharp as a magpie's, took in the bare cupboards as she was led into the kitchen, the solitary wilting parsnip on the windowsill, and a pang of alarm shot through her.

Grace, perched on the edge of a chintz-covered armchair, was a study in quiet desperation. Her skin, once rosy, was now pale as a winter moon, her eyes shadowed with a weariness that belied her years. Maureen, a woman who'd seen the world through the lens of Waspi, knew the signs of silent suffering all too well. Maureen only had to notice the way her eyes kept going to the casserole she had placed on the worktop to realise this woman was desperately hungry.

"Come with me Grace," she said, her voice firm but gentle. "The Waspi group meets today. We'll have tea, laughter, and a right good chinwag and you can warm us this casserole up when you get back."

Grace, her pride a fragile shield, mumbled a protest. But Maureen, with a steely glint in her eye countered, "Think of it as a reconnaissance mission.

You can gather intelligence on the enemy – loneliness, you see, and who knows, you might even find a few allies."

Defeated, Grace donned her warmest coat, the threadbare fabric barely a whisper against the January chill. As they walked, the crisp air nipped at her cheeks, bringing a flush to her pale face. Maureen, a whirlwind of anecdotes, filled the silence with warmth but nevertheless noticed her lack of appropriate clothing for the weather. There was more going on here than just hunger.

At the community hall, a cacophony of chatter welcomed them. Women, their faces etched with the wisdom of years, sipped tea, and swapped stories. Grace, overwhelmed by the sudden surge of humanity, retreated to a corner chair, her gaze fixed on the swirling steam in her mug whilst she tried not to fall on the cakes someone had brought like a ravenous hyena. It took all her willpower to eat slowly. Within ten minutes the sugar icing had gone to her head like a double vodka, and she found herself smiling for the first time in quite a while.

Maureen, a seasoned social activist, nudged her gently into the conversation. Soon, Grace was sharing tales of her garden triumphs, her voice gaining strength with each word. The women, their laughter echoing like wind chimes, listened with rapt attention. Grace listened also. She hadn't even

realised she had been the victim of an injustice, she didn't understand, but from what she was hearing from these feisty women, she had missed something catastrophic occurring, and possibly the reason her cupboards were bare.

As the afternoon wore on, a sense of belonging, of shared vulnerability, began to weave its magic. Grace, for the first time in months, felt a flicker of hope. Maybe, just maybe, she wasn't alone in her quiet war against the encroaching shadows. Maybe, in the warmth of this makeshift battalion, she could also find the courage to face the enemy within.

Chapter Six

Christina hobbled down the cobbled lane, her laughter echoing off the brick walls like a belligerent Jackdaw. At sixty-five, with knees as creaky as a haunted Victorian dolls' house, she should have been a woman eased into the armchair of comfortable retirement, sipping tea and reminiscing about the days of full wards and overflowing bedpans. Instead, she was a rogue wave of defiance, a two-crutched tornado wielding her pension invitation letter like a pirate's cutlass.

The government, bless their nylon-socked souls, had finally coughed up her due. "Five years late," she bellowed to the wind, her voice gravelled with righteous fury, "and enough dust on it to fill a politician's promise drawer!" Her cackle, a rusty merry-go-round whistle, pierced the sleepy air of the seaside town.

Christina, a retired nurse with a spine as twisted as the NHS itself, had known this day would come. Years of hoisting patients twice her size, of wrestling gurneys and battling bedpans, had left her a walking medical textbook. But what the years hadn't stolen was her fire. Oh, the fire! It crackled in her eyes, the colour of a stormy North Sea, and burned bright in her tongue, sharper than a surgeon's scalpel.

"They thought they'd break us, Maurice!" she declared, turning to her husband, a man as weathered and loyal as the pier's wooden planks. Maurice, a retired shipbuilder with hands that could mend a storm and a heart softer than a marshmallow in a bonfire, simply smiled. He knew the drill. He was the anchor to her tempest, the calm to her storm.

Their retirement hopes, once a sun-kissed beach in Greece, had been ravaged by the government's fiscal tsunami. Five years of scrimping had sucked the marrow out of their savings. They were WASPI

women… and men, for their men suffered alongside them, and in some ways because of them, and Christina was determined to be their Joan of Arc, a warrior queen in Primani slippers.

"But look at us love," she crowed, brandishing her pension letter like a trophy, "still standing, still shouting! We'll spend this on a feast fit for a king… or at least a Morrisons' manager's special offer."

Maurice chuckled, his eyes twinkling like the harbour lights. "Just don't cause a riot in the biscuit aisle," he teased.

Christina winked. "No promises dear. This pension's enough to buy the entire bakery stock, and I have a serious case of biscuit-rage to settle." No more scanning the cupboards for what needed to be eaten first, so it wouldn't waste, rather than a meal of choice, no more value beans, well this week at least, no more adding up as she shopped in fear of not having enough. Today she would splurge!

And with that, the letter clutched tight in her fist, Christina hobbled on, her laughter a battle cry against injustice, her spirit is indomitable as the weathered cliffs overlooking the sea. They could have her pension, they could steal her savings, but they couldn't steal her fire. No sir! not this WASPI warrior. This was just the beginning. Let the government beware. The teacups were about to

rattle. She laughed as she realised her internal voice sounded like a scene from Braveheart.

Chapter Seven

Annette, an elegant and willowy woman, quietly spoken and seasoned with a lifetime of dry wit as biting as the sea winds when the occasion required it, stormed into the kitchen, her signature floral tea towel billowing behind her like a cape. Her husband, Arthur, a retired doctor with a twinkle in his eye and a perpetual air of amusement, looked up from his newspaper, his brow furrowed in mock concern.

"Another injustice unveiled Mrs. Peverly?" he inquired; his voice laced with feigned innocence.

Annette slammed a sheaf of papers onto the table, the headlines screaming in bold: "Women Robbed of Pensions! The Scandal of the Waspi Injustice!" Her normally rosy cheeks were flushed a fiery red, her usually bright eyes narrowed with indignation.

"Finally, something in the newspapers! Robbed, Arthur! Robbed, I tell you! Six years of my life, all those years of contributions, vanished into thin air! And for what? To line the pockets of those fat cats in Westminster?"

Arthur sighed, a theatrical sigh that Annette knew all too well. "Now, now, Annette. Don't get yourself

worked up. It's not good for your blood pressure, you know."

"Blood pressure be damned! This is about principle Arthur! They can't just steal from us like this, especially not from women our age! It's discriminatory, misogynistic, the whole rotten lot of it! You show me a man that's had six years pension taken!

Arthurs winced and decided to leave her to vent, which she continued to do, His lovely, quietly spoken wife that one carried a mischievous twinkle in her eye was no more.

"…Not to mention my private pension start date runs to my state pension age. They've had six years of that as well. No wonder the pensions companies kept it quiet too. Somebody's making the big bucks from our misfortune!"

Arthur knew when Annette got on a roll, there was no stopping her. He adored her passion, but recently it singed the edges of their previously quiet life. He loved her dearly, but a retirement life, filled with protests and petitions wasn't exactly his cup of tea. He preferred a good book, a glass of port, and the gentle melody of their record player from the study.

"Look, I understand you're upset love," he soothed, "but what can you do? You've written your letters; you've signed the petitions. It's out of our hands now."

Annette scoffed. "Out of our hands? Don't be ridiculous Arthur! This isn't some game of bridge where we simply accept the cards we're dealt. This is about our rights, our futures! They think they can silence us because we're old, because they think we'll just fade away. Well, they've got another thing coming!"

She brandished a flyer with the words "1950s Women: Fighting for Our Rights!" emblazoned across it. "I'm joining the protest Arthur, and I'm not coming back until they hear us loud and clear!"

Arthur's heart sank. He knew this was no idle threat. Annette, once a mild-mannered civil servant, had morphed into a formidable force since the pension scandal broke. She spent her days researching, networking, and rallying the troops on Facebook – a one-woman army fuelled by righteous anger and a thirst for justice.

He admired her spirit, truly he did. But the thought of her out there, marching in the streets, her voice hoarse from chanting and getting herself hauled off to the cop shop, filled him with a dread that rivalled his fear of public speaking.

"Annette," he began, his voice laced with concern, "you know I support you. But wouldn't it be better to…"

"No, Arthur!" she interrupted, her voice firm. "This isn't about me. This is about all of us, the millions of women who were cheated out of what they rightfully earned. We won't be silenced!"

Arthur knew the battle was lost. He could argue, plead, but it wouldn't change her mind. So, with a resigned sigh, he poured himself another glass of port, raised a silent toast to his wife, the new generation of suffragette, and the quiet life they were about to lose.

As Annette marched out the door, her tea towel flapping like a battle flag, Arthur knew this was just the beginning. The pension posse had a recruit, and the fight for justice was far from over. The quiet streets of Kent were about to be filled with the roar of a very angry, very determined 64-year-old woman, and Arthur, for better or worse, was along for the ride.

Chapter Eight

Agendas, Action, and a Sprinkling of Scones 2019

The aroma of freshly brewed tea and indignation hung heavy in Maureen's living room, a floral and fiery blend that could knock a Tory off its high horse. Several formidable WASPI women dressed in sedate workwear, to funky grandmas belying a steely resolve, were gathered for their second planning meeting. Not one woman followed the expected format of the twin set and pearls Grandma, did they even exist anymore? But Grandmothers, mothers, aunts, and partners to someone they certainly were, and deserving of respect regardless of their personal circumstances.

"Right ladies," Christina spoke, her voice a like foghorn navigating the treacherous waters of bureaucracy, "last week we discussed the injustice. This week, we plot our revenge...er, I mean, our peaceful protest."

Annette, the resident historian, adjusted her spectacles. "Remember, we're not harpies screeching outside the Commons. We're wronged women, demanding what's rightfully ours. Dignity and decorum, that's the WASPI way.".

"Hear hear!" chirped Deidre, ever the optimist, her smile as bright as her t shirt newly acquired with

the slogan 'Your first mistake was thinking I was just an old lady' replied. "Though a well-placed custard cream lob wouldn't go amiss."

She grinned, and Christina chuckled, a sound like gravel in a wind tunnel. "Now, now, Deidre. We'll stick to placards and pithy slogans for now. Beatrice you're the artist, can you be on banners?"

"Six years stolen, futures scorned, WASPI women rise in one accord!' How's that?" Someone volunteered.

Murmurs of polite approval rippled through the room. Manda grimaced and chimed in, "Perhaps a touch more...punchy?"

Beatrice winked. "Leave that to me, Manda. I've got a few humdingers. 'Lost pensions, stolen dreams, grannies on the warpath, Big Ben's screams!"

The room erupted in laughter, the tension dissipating like a deflating balloon. Even Manda the ever cynical one, cracked a smile. Biscuits were dunked, tea slurped, and strategies formulated, Annette, the tech whizz, volunteered to create a Facebook group page "WASPI Warriors Unite!" – while Christina, the ex-union rep, planned logistics, chants, and a strategic deployment of mobility scooters, if they could find any women brave

enough to make the train journey to London on one, was perhaps a little ambitious.

"All we've got to do is turn up at 11.30am in time to drown out Prime Minister's question time. Women are coming from all over the country from different groups," said Maureen.

"How many groups?" asked Sylvia, getting brave.

"God knows, no-one's counted them all but over a hundred at least."

"Wow..." mouthed Sylvia.

As the meeting drew near to a close, Maureen surveyed the troops, a glint of mischief in her eyes. "Remember ladies, this isn't just about our pensions. It's about sending a message. We are 50's women, and we will not be silenced! Now, who fancies a slice of Victoria sponge?".

Grace nervously raised her hand trying not to appear greedy, this would be her third slice. Maureen cut her an extra-large slice and handed it over without drawing attention from the rest. Every little helps she thought. She had been popping round every couple of days on the premise of helping Grace in the garden as a new hobby. Grace had gradually let her guard down and allowed

Maureen access, tempted by the goodies she always brought as much as by the companionship.

This week, she had confided that she was struggling sorting her bills and Maureen had offered to make a few phone calls on her behalf. Far more emotionally equipped to negotiate the nightmare of computerised voices and waiting times, she had spent several hours on her mobile on the woman's behalf.

The true horror of the difficulties Grace was in were beginning to emerge and Maureen sent up a prayer of thanks that she had a small work pension that was bridging the gap. It didn't make it feel any better though. £57000 of her hard-earned pension gone was still an earth-shattering amount. The audacity and immorality of it was astounding. She thanked God that she wasn't in the position of some of these poor women. She worried Grace would waste away or be so desperate enough to take her own life, as some already had. There was no way this was going to happen to Grace, not on her watch!

Chapter Nine

Sylvia, some days earlier after receiving her marching orders from the florist wholesalers, and not given to full on confrontation, had been quaking in her floral wellington boots as she entered the house like a rogue hurricane of emotions. She retrieved the bloom from the apron she had failed to take off on leaving the market garden and looked at it for a moment as she took a savage breath and opened the living room door.

Alan, sprawled on the sofa in his beige cardigan, the racing blaring out on the telly, barely flickered an eyelid on her entry, but as she announced, "I've lost my job Alan." It came out so loud it got his immediate attention.

Alan slowly raised his eyes from the afternoon tv, "Lost it, have you? Typical. Always daydreaming instead of grafting, not surprising you were fired."

Sylvia, used to his barbs, steeled herself. "No, Alan. Not fired so much as made redundant. The wholesalers are closing down." It was a white lie, but the signs were there, so it wasn't really lying.

Alan snorted. "Redundant? You push flowers around Sylvia. Hardly brain surgery, it's casual work."

It occurred to her that since he had got his pension, any kind of graft was alien to him, especially around their home, and she swallowed hard as the words fought to break the surface.

"It's more than that Alan," Sylvia's voice, usually a gentle murmur, rose an octave. "It's about everything...independence, feeling valued, respect." She realised as she spoke that she could have been talking about his attitude to her.

Alan scoffed. "Independence? You can barely boil an egg without setting off the smoke alarm." He swung his legs off the sofa, threw the racing pages down and glared at her as if she had done him a personal affront. "How will we manage without your wage; you'll have to get another job, and quick!" The thought that she'd always 'had to,' rather than, 'wanted to' do something in her life, stuck in her craw, and she found herself staring right back. She was stood, he was sat, that gave her the psychological advantage, didn't it?

Tears stung Sylvia's eyes. But this time, they wouldn't fall for him. She took off her floral apron taking a breath, and folded it, its vibrant pattern a stark contrast to the beige blandness of the room and the words escaped before she had time to think. "I'm going to London Alan."

Alan choked on the cup of tea he had managed to make in her absence and had raised to his lips with a scornful sneer. "London? What the hell for? Don't be so bloody daft."

"The WASPI protest," Sylvia declared, her voice surprisingly firm. "We're fighting for our stolen pensions, Alan. Six years stolen; our futures scorned!"

Alan's laughter boomed, harsh and humourless. "WASPI? A bunch of whinging old hens. You'll be back before the day is done, tail between your legs." He slowly got to his feet and towered over her smaller stature.

Sylvia squared her shoulders. "Maybe Alan. But at least I'll have tried, and I certainly won't be here, waiting for you to tell me what to do. I'm going to do something for me!"

His hand swung out with a heavy slap across her cheek that reeled her backwards against the sideboard and knocked over several of the Coalport floral china collection handed down from her grandma. She steadied herself quickly to avoid breakages. And as she turned away from him to stand a couple of them back up, something snapped.

She took a long breath and turned around. "That's the last time you will ever hit me, if you ever do that again, I will have you arrested!" She faced him down with a steely gaze. The bloom in both cheeks not entirely down to the slap and forty years of domination to make up for.

The silence that followed was thick enough to cut with a butter knife. Alan, for the first time, seemed to truly see her, the defiance in her eyes, the set of her jaw. He sputtered, opened his mouth to argue, but the words wouldn't come.

Sylvia, made brave by his lack of ready response, sensed victory and heart pounding like a hummingbird's wings, she grabbed her purse.

"I'm taking the train in the morning, Alan. You'll have to make your own dinner as I need a bath and time to prepare. I'm not sure when I'll be home".

She closed the living room door on him and found herself looking at a slightly wild-eyed woman in the hall mirror. Touching a tentative finger to her cheek that was red and looking likely to mark, she thought of all the times over the years that he had lashed out, and she had let him get away with it, well no more. She went to the cupboard under the stairs, got out the emergency savings tin she had hidden, filled by nicking the odd pound from his change left carelessly about, and rushed upstairs.

She glanced once more in the mirror to assess how much of a mark she would have to hide. "Dear God" she whispered, and made her escape up the stairs, grabbing all she needed and darting into the spare room.

The next morning, the timid florist donned the most dramatic purple floral hat she owned and crept out before Alan had woken. Leaving behind a beige world and her controlling husband. Stepping into the unknown, armed with nothing but a battered shopping bag filled with sandwiches, and her newly acquired sash, which she had paid for on this occasion. The refreshing taste of a heart full of newly unrepressed anger, a flicker of hope and not a little pride in her bravery, combined with a lot of fear of the reception on her return, was beating loudly against her ribcage like a prisoner rattling a cup along the prison bars.

As the train set off towards London, Sylvia looked out the window. The world seemed brighter, the colours sharper. She wasn't sure what awaited her in the city, but for the first time in years, she wasn't afraid. The WASPI women that would join her at various stations on route, united in their fight, were her unlikely allies. Together, they would make their voices heard. Even if it meant facing down Big Ben.

Chapter Ten

Two's Company Several Hundred's a Crowd!

The train thrummed, a metal caterpillar inching
toward the big smoke. Inside, a riot of purple
bloomed with defiance against the commuter
monochrome. Sylvia, ever the cautious one, peeked
around a hand-painted banner emblazoned with
"WASPI! Robbed of our Pensions, Not Robbed of
our Spirit!" Her floral hat contained not only the
vibrant colours of the suffragettes, but also
concealed the telltale fading purple bloom on her
cheek, a souvenir from last nights 'disagreement'
with her husband. Today though, fear was
overshadowed by a newfound resolve.

Christina, her back groaning under the weight of
years of lifting patients and righteous anger,
cackled like a startled magpie as she perused their
uncomfortable travelling companions. "Look at
them Maureen! Bet they never saw such a sight –
Geriatric glitter bombs on the move!"

Maureen, the ex-teacher, adjusted her reading
glasses and snorted. "Grammar may be failing them,
but their spirit certainly isn't!"

She smiled as she surveyed the affect these women
were having on the commuters, there would be a

few people taking their story home tonight, and with old lady charm and passion, they engaged with whoever would listen, willingly or otherwise.

Amanda, resplendent in her purple tie-dye dunga's, pumped her banner in the air causing the suit at the side of her to duck. "Sisterhood, united and unafraid!" she shouted..." Time to shake these parliamentary cobwebs loose!" Behind her, Beatrice, on a table seat had spread out the placards and surveyed their handiwork with a theatrical flourish. "Behold darlings! Banners fit for the West End, made from curtains destined for the charity shop. Upcycling for justice, wouldn't you know it?"

She passed out the black markers from her demo kit to write slogans on the lilac umbrellas, which attracted interest from travellers intrigued by what was coming next.

Grace, eyes downcast but hands clutching a homemade sign demanding "Justice for Widowed WASPI!", blended into the background. Sheila, however, did not. "Don't you dare go all Victorian fainting flower on us Grace! We need you girl! Remember, stick with me, I can outswear a docker on a bad day and still get him smiling. Shame on the government for shafting us!" Grace grimaced in embarrassment but then relaxed into a smile.

Annette, the ever-organised ex-civil servant, brandished her lilac Waspi sash. "Remember ladies, stay focused! We have facts, figures, and righteous fury on our side. No emotional outbursts, just clear, concise demands for compensation! Loud and proud. Dignity always".

"Bugger dignity" said Sheila "I'm sitting my backside down in parliament square and stopping the traffic, there's only one way to get noticed here and that's by action."

"Well, we'll just have to disagree on that one Sheila" retorted Annette, not a little peeved.

Deidre, her usual business acumen honed to a sharp edge, chimed in. "We need to show everyone we're not just a bunch of greedy grannies like they are trying to paint us. We're savvy, capable women and I for one refuse to be silenced!"

The train lurched, and a young man in a sharp suit tripped over a stray purple umbrella. He glared, muttering about "bloody pensioners." Three women at least answered, "I wish!" simultaneously, and they all burst out laughing. Manda grinned and nudged Deidre. "See, Deidre? First casualty...At least he'll remember us when they come for his pension!"

As the train pulled into King's Cross, a wave of purple, green and white, spilled onto the platform. Heads turned, tourist cameras flashed, and a smattering of cheers went up as women recognised friends from other parts of the country. The confused frowns of commuters who were wondering if they were witnessing a suffragette re-enactment brought a smile to the faces of the women in procession.

Jo Public didn't know about the WASPI women, the Government didn't want them to know... and neither did some of the Waspi Women approaching sixty years, who were still unlucky enough to not know that six years of their pension had been stolen. Those poor souls were still oblivious to the devastation they were about to face in their retirement dreams and lives.

Banners held high, women streamed from different platforms, umbrellas unfurled like defiant blooms as they marched towards the city, their laughter and demands echoing through the air. This was no ordinary protest; it was a vibrant tapestry woven from anger, humour, and unwavering determination. And London, they were about to learn, had never seen anything quite like it.

"Fucking Hell" breathed Manda as they turned the corner into Parliament Square and saw the sea of purple, green, black, and white. Group logos for We

Paid in You Pay Out. Back to 60, Waspi and Waspi Campaign. Women of Wales, Waspi Pembrokeshire, Norfolk Pain, Waspi Scotland, Wirral Warriors, Modern Day Suffragettes, to name a few. So many women from many different groups were there, and there must have been over a thousand strong. It was a sight to behold and something unheard of since Victorian times.

"I wasn't expecting this! Wow!" declared Maureen as they walked onto the green. Keep close ladies, we don't want to lose you. Grace grabbed Sheila's arm in a moment of panic and Sheila turned to her and grinned. "You'll be alright with me, I used to be a football hooligan in my younger years, this is nothing!" Grace's mouth dropped open as she was propelled forwards on the tail of Sheila's laughter. Christina's voice, louder than most, was directing the path through the crowd. People were singing, drums were drumming, and the excitement was palpable.

Women had pictures of Ian Duncan Smith MP with NOT GOING AWAY emblazoned across them due to his unfortunate statement telling a previous pensions minister to not engage with the WASPI Women. 'IGNORE THEM, they will go away.'

The pensions minister at the time, with a conscience, and a woman, had been disgusted, and had reported his words in an interview. Ian Duncan

Smith in his callous dismissal, had created the biggest hashtag of the campaign.

NOT GOING AWAY

Sheila, the WASPI warrior with a laugh that could curdle milk and a throwing arm that could launch a pension book into the stratosphere, was on a mission. Armed with a tube of industrial-strength superglue and a fistful of protest banners, she surveyed the railings of Parliament Square like a seasoned battlefield commander. Grace, her fellow WASPI Woman with the temperament of a startled sparrow, fluttered nervously beside her, clutching a banner that read "Don't Steal Our Biscuits You Jammy Dodger!"

"Right Grace," Sheila boomed, her voice a foghorn in a teacup, "we need to stick these banners up good and proper. No namby-pamby sticky tape for us, we're using the real deal!"

Grace gulped; her eyes wide as saucers. "Sheila, are you sure that's wise? What if we get stuck and arrested?"

Sheila snorted. "Get stuck? Don't be daft love. I'm a dab hand with this stuff. Now, pass me that 'Stop the Pension Rip-Off' banner."

Grace, a newly converted dutiful soldier, did as she was told. As Sheila squeezed the glue, a mischievous glint sparked in her eyes. "Hold still Grace and watch this!"

Sheila lunged towards the railings, tube of glue squeezed and ready to spread poised like a paintbrush in the hands of a particularly clumsy artist. Unfortunately, Grace, ever the worrier and slightly distracted by all the noise, decided to take a precautionary step back at the exact same moment. The result was a slapstick ballet gone horribly wrong. Sheila's hand clenched and the glue came out indiscriminately, going goodness knows where.

The glue, with the adhesive properties of a lovesick barnacle, made contact not with the railings, but with Grace's outstretched hand. Panic seized her like a chihuahua on a sugar rush. She flailed, shrieking like a banshee, tried to wipe it off on the banner and got stuck. Sheila tried to pull the banner off her friend, but in that glorious moment of chaos, managed to connect her thumb, now filled with newly squeezed glue to the other half of the banner connected to Grace's equally glued hand.

For a beat, the world held its breath. Then, a sound erupted from Sheila's throat, a sound that could only be described as a hyena gargling with glee. "Oh, bugger!" she roared, tears of laughter streaming down her face from the sheer absurdity of it all.

Grace, her face the colour of a particularly ripe tomato, could only stare in mute horror. Stuck to Sheila, banner in hand, they resembled a bizarre, two-headed pensioner hydra.

The crowd, around them, initially stunned into silence, erupted into laughter. Pensioners chortled, tourists gasped, and even the stoic-faced policeman guarding the gates cracked a smile.

The passing MP, a man renowned for his charisma-free personality, seeing the women's struggle, choked on his cough drop, his face turning the colour of a particularly fetching beetroot as he laughed unsympathetically at the two women's predicament, unaware in his amusement that he had brushed his beautifully tailored suit against an unfortunately superglued Waspi sash, unravelling it unnoticed from the hapless owner's neck as he walks away still smirking. Pushing his way through the crowd with a dismissive hand, he scowled disdainfully at the women blocking his route to a liquid lunch before PMQ's, unaware he was sporting a Waspi tail billowing gracefully from his backside.

A roar went up from the crowd, eyes following his unfortunate choice of route as he walked on oblivious. Sheila caught a glance and threw her superglue over the fence and stood innocently with an "It weren't me guvnor" expression and ever the pragmatist, surveyed the situation.

"Well Grace," she chortled, "looks like we're stuck in this together. Might as well make the most of it!"

And so, they did. They marched, hand-in-glued-hand, through the heart of Parliament Square, their banner held high. The crowd cheered, cameras flashed, and even the flustered MP's trying to get past, couldn't help but chuckle. They became an accidental symbol of solidarity, their plight overshadowed by the sheer comedic genius of their predicament.

By the time help arrived, Sheila and Grace had become folk heroes to the rest of the crowd, who would later regale their families with the story, wheezy tears of laughter running down their faces. The glue, thankfully, yielded to their combined efforts and a pot of nail polish remover pads (courtesy of a kindly protester with a penchant for sparkly talons and a large handbag containing everything for any eventuality which was most likely the cause of her frozen shoulder). They emerged, slightly sticky but triumphant, their message

amplified by the laughter that had echoed through the square.

As they walked away, arms linked but thankfully unglued, Sheila winked at Grace. "See love? Sometimes, a little chaos can be just the thing to get noticed."

Grace, still slightly traumatised but undeniably exhilarated, could only nod in agreement. After all, who needs a perfectly executed protest when you have industrial-strength superglue, a dash of panic, and a whole lot of laughter? In the grand scheme of things, sometimes the most effective way to fight the system is to accidentally glue yourself to it. And if you can make people laugh while you're doing it, well, that's just the icing on the pension-stealing cake.

Chapter Eleven

News at Nan

Meanwhile, Beatrice had got over excited and followed a strong voice shouting" Come on girl's, News at one awaits," and got herself separated from the group whilst following the voice of a larger-than-life woman, dressed as Rosie the Riveter and with biceps to match, brandishing a loud hailer.

The news tents were on the green outside Parliament. Knowing they had had a glut of news photobombers recently, and now the added threat of a load of volatile grannies, they had fenced off the green with barriers. The women gathered all around the outsides watching the news crews setting up. It was five minutes to one.

"What are we going to do, they've stopped us getting close and I can't get over that barrier with my back!?" one woman wailed, clutching her broken umbrella that had blown inside out with the biting wind. Standing next to Beatrice was a tall woman with short reddy brown hair. Fumbling in her bag, she withdrew a small pair of nail scissors and grinning at Beatrice, she signalled to her hand and whispered. "We're not going over, we're going through."

"How?" whispered Beatrice fearing she would have a repeat of the time when she had caught her knicker gusset on a similar barrier at a U2 concert, trying to get into the VIP area and nearly did herself a mischief.

"These numpties are not the best at security, I rekk'd this earlier and they've tied this broken one with a cable tie!" With that she snipped through the plastic, yanked open the barrier and before the fuzz could even blink, forty women, armed with banners, purple brollies and righteous fury, surged through like a tide of purple, onto the green and made for the spot below the mobile studios, whilst the rest of the women closed the gap and cheered loudly from outside the barriers. A mob of 'pissed off' women with a voice ready to be heard. The scouse woman with the scissors ran to the front. "Come on girls, they're going live any second! Get ready!"

Someone grabbed the loud haler and marched up and down calling the chants, Beatrice unrolled her large banner and stood at her straightest to one side. The other women who hadn't time to get through, had closed the barrier off, as though the gap had never been there, and now the police had nowhere to push them out through.

The crowd along the edges applauded the women inside, and photographers ran out to capture the moment, just in case something big kicked off and

they could sell the shots. Big Ben chimed one and despite the police's best efforts initially, they deemed it easier to let them have their moment rather than be seen live on tv, dragging old ladies from the ground where they had staged a sit down, come stand in, in glorious purple.

Suddenly a hand came on Beatrice's shoulder, and she jumped thinking she was about to be arrested. She swung round in horror to find Maureen standing at her back.

"You don't waste time, do you?" she laughed. "How did you manage to get here?"

Beatrice waved to the women sat on the floor at the front of the rabble." I followed her." she pointed.

"That's Anne, one of the founders of the campaign."

"Wow! Beatrice whispered as she looked at these fearless women, who were thumbing their noses to government, right under government noses and live on TV. She was star struck, and those images of those amazing women would stay in her memory forever. It was the moment in her life where she had realised you had to take a stand.

The news crew, initially aghast, scrambled to adjust. The presenter, a man with an overcoat that could house a small family, tried to maintain his composure as the women chanted and waved their banners as his backdrop. Cameras zoomed into mid shot, conveniently hiding the source of the ruckus behind his large frame.

But for Beatrice, new to campaigning, it was a victory. A glorious, purple-clad, middle-finger-to-the-man victory. They may not have made the telly, but the memory of that shared defiance, that moment of stolen glory, would forever be etched in their hearts.

Later, when someone posted a video online, they discovered the BBC's clever trick. But for those who were there, who felt the adrenaline in their veins, and the fire in their bellies, it didn't matter. They had been heard, even if not seen. And that, in the grand scheme of things, was all that mattered.

So, the next time you see a news report with suspiciously quiet crowds, or wonder why the Brexit protesters, shot from behind seemed to have a liking for lilac brollies, remember the women behind the scenes. The ones who may not have made the headlines, but whose voices, like whispers in the wind, still carry the power to challenge. Just don't tell the BBC, they might need bigger overcoats...

Most of the women were heartened by the number of MPs that came out to support their cause that day, The trick was divining who was genuine, and who was out for publicity photos or a sound bite for their webpage, a valuable addition to their Facebook presence, demonstrating their social concerns for the masses in the impending elections run up.

For Maureen, a couple of years campaigning had left her a hardened cynic, but she understood the value of visibility. There were those MP's that were genuine and that she had great respect for. These were the ones who stood week after week hammering home the questions to draw attention to the Waspi plight. Expectedly they were met every time with the same stonewalling answers. "They could not comment whilst there was a legal action underway," or "they could not comment as the case was currently in the hands of the Ombudsman" and more recently "their case before the Ombudsman couldn't continue whilst there was also a legal case in process."

'What a load of baloney' she thought, A way to set one campaigning group against another. Divide and conquer. Half-truths and the dirty tricks brigade in play. This was big money, and no political party

really wanted to be the one to address it. It was a political hot potato.

There was always a get out clause, but none of them acknowledged that they could pass a law at any time, without needing a court order or Ombudsman's report that could give the 1950's women justice and proper compensation immediately.

She had heard Cameron bat it off with half-truths that never allowed the public the true knowledge of what had really gone on, and her faith in the integrity of government had started to falter as her knowledge of the workings of Parliament grew.

Teresa May was now in the hot seat, doing the same. Ignoring and stonewalling, with carefully tailored statements that she, and the women all knew, were far from the reality. A 50's woman herself, she was loaded, and had no reason to protest the loss of her pension. The paltry amount that was the British State Pension so vital to many, was merely 'Tip money' for tonight's highly priced restaurant of choice for the elite.

Teresa was not an island of indifference. Many, but not all the other 50's Women, privileged by circumstance, wore an impenetrable cloak of self-preservation, choosing comfort over conflict. Their final years were precious, their lives comfortable

enough to remain unblemished by the struggle, they chose to do nothing. It was a case for some of 'I'm all right Jack' and Maureen understood this retreat. What she couldn't forgive was the absence of solidarity with the hundreds of thousands of their poorer peers, suffering the brunt of this disastrous policy's effect, and it gnawed at her.

Some women, following the conditioning of a lifetime of sexism, felt there "…was nothing they could do to change it" and so did nothing. How different things might have been at this moment, if they had stood up to be counted at the onset, and not left it to the women who were prepared to put their health, their sanity, and their precious time on the line to fight for justice.

Others simply did not know what had happened to them, or didn't understand and in some cases, had yet to find out, twenty years on after the legislation had started to be brought in. Now what does that tell the average person blessed with moderate intelligence? It screamed STEALTH!

Meanwhile, the storm raged for the "have-nots." Homes were lost, retirement dreams shattered, lives decimated. Some died from illness, betrayed and in despair, others succumbed to the weight of injustice and poverty, taking their own lives. This tragedy unfolded silently, away from the media's glare. Yet, every Facebook share, every local newspaper article, was a Waspi warrior's rallying

cry, a snowball of truth gathering momentum in the absence of mainstream coverage.

Maureen's heart overflowed with pride for those who fought back. Her eyes welled up as she saw the woman with the walking frame, surrounded by her Coventry comrades – warriors she'd met at protests across the land.

Some 'of the have's,' burdened with empathy, joined the fight, recognizing this injustice transcended their own comfort. It was a matter of principle, a fight for the forgotten. Widows, divorced women, the sick, the working class, unable to save for just such a hit as this, The exhausted... Annette was one of these, and Maureen could see how genuine she was and the toll it was taking from her in ways some couldn't understand when they were likely complaining, "It's all right for her, she has money".

The strong fought, the financially fortunate, often just 'let it go,' preferring to not waste their lives fighting. The fragile surrendered, fulfilling the policymakers' callous expectations. Some, driven to despair, took their own lives. The human cost, the collateral damage, was chilling. Maureen's friend Susan, most recently wheelchair-bound and in what was to be her final weeks, protested for recognition of her plight outside the Tory conference, whilst crates of champagne were unloaded in front of her.

There were no words...

A wave of defiance swelled around Maureen, the chant "Hey, Hey! Teresa May. How many women have you robbed today?" echoing with righteous anger. Yet, her heart faltered, her usual optimism dimmed by a chilling calculation. It was 2018. How many women would be missing from this crowd if they were still fighting this in 2019.

This, it seemed, had been the plan: a targeted assault on a decade of women, their time deemed expendable. Over £50,000 ripped from the hands of over half the 3.8 million 1950's women affected, lesser sums stolen, equally devastating, from the earlier born women, all with callous disregard for the human cost.

Maureen had long since concluded that their age was no coincidence. Unlike the Suffragettes, whose footsteps they boldly followed, these women lacked the historical lens, the ready understanding of their struggle. The WASPI Women, therefore, bore a double burden: fighting for their rights and fighting to be heard. Yet, chosen for their expected compliance. Instead, they defied expectations, banding together in a fight for justice.

In the quiet heroism of their generation, they challenged the narrative, refused to be erased, and commenced a new chapter in the fight for women's equality.

No younger generation of women was going to pick up their banner and continue to rally the cause. They were already being conditioned into not expecting a pension in time to enjoy retirement with some hope of health. Neither were they asking why they were paying the pensions element of their NI Contributions if no pension was likely to await their final years.

Well! She for one would die fighting! Maureen drew in a long breath. Christina was calling that it was time to be heard.

"Right girls!" she shouted. "Let them hear that we're not going away! and heard they were. Traffic came to a standstill; Parliament Square was completely blocked, and yet Jo Public saw nothing on the mainstream news. It was as though they were invisible.

Invisible women subjected to a cleverly concealed cash grab in the name of equality, against women who had never experienced it in their lifetime. The government was doing its best job to keep a lid on the real scandal.

They returned on the train that evening, jubilant and excited, only to have hope dashed as they turned on the 6 o'clock news and then the News at Ten…Nothing.

Chapter Twelve

Behind the Mask

The salty spray of the sea whipped around the faces of the Waspi women in the early morning breeze, as they pulled their white masks out of Beatrice's bag of tricks. The eerie featureless masks now having become a Waspi accessory and a symbol of their invisibility in the eyes of the government, and truth be known a pretty good disguise for acts of genteel mischief, were donned with grim determination.

Not your average Margate Monday, these formidable figures were here to make a splash, and not the kind that involved paddling in the rock pools. Their target: the Shell Lady, a Margate icon usually resplendent in her seaside attire at the end of the Harbour Arm. Today, however, she was due for a makeover – WASPI style.

They were a small group today, Deidre was working overtime on a large decorating job with her husband, poor love, not good with bad knees and hip to contend with. Sylvia had been coming but had failed to show and Maureen made a mental note to check on her later. Something wasn't right there; her instincts were screaming it. Grace was also absent, but she was forgetful so that was

understandable. All in all, it was a good turnout from a small area.

Beatrice, the project designer, and costume maker on this occasion brandished her dressmaking scissors and a handful of cable ties. "Alright ladies," she croaked, nerves creeping in, and her voice muffled by the mask, "Let's give this old girl a taste of what it's like to be truly shell-shocked!"

Manda, missing Bindi on this occasion, had brought her camera and was already clicking manically. Whilst Annette fumbled with her phone for back up shots, trying to activate the hidden camera app whilst squinting through the eye slits of her mask. "Beatrice, are you sure this is legal?" Annette asked worriedly.

Maureen, overhearing and ever optimistic scoffed. "Don't be daft Annette. We've more chance of falling off the dock than getting arrested. Besides, we're adorning her, not damaging her." Her eyes veered to where a recent recruit was leaning precariously over the dock edge. "Polly! ...come back from the edge, it's a long drop and you're hampered by that mask darling."

Polly edged backwards and peaked out of her mask to get her bearings, realised how closed to death she had been and swiftly returned to the group. "It's like the edge calls you..." she murmured.

"Well, it can't call you today dear, we need all hands-on deck, or dock, so to speak" replied Maureen with a patient smile, handing her the bag with the costume in.

Christina, ever the joker of the pack chimed in, "Relax Annette! We're just giving the Shell Lady a new look. Think of it as a seaside fashion intervention!"

Sheila, the muscle, climbed the statue and hoisted the WASPI-emblazoned crinoline skirt over the shell lady's head. "Let's get this petticoat party started!" she crowed.

The women wrestled the skirt onto the Shell Lady's metal hips. Beatrice, huffing and puffing, as she secured the lilac crinoline around the Shell Lady's waist and made a few last-minute adjustments with more ties purloined from Manda's duffle bag.

Atop the startled statue's head went a wide-brimmed hat adorned with a WASPI badge. Added then, a lilac Waspi sash and in her hand, a purple umbrella emblazoned with the slogan "SHELL OUT OUR STOLEN PENSIONS!"

Finally, the pièce de résistance: a placard reading "WE'RE NOT SHELLFISH PENSIONERS, WE'RE SHELL-SHOCKED!" held aloft by Christina. The

WASPI Women stood back, arms crossed, surveying their handiwork.

"Well, I think the old broad looks rather fetching," laughed Christina.

The effect was, well, let's just say it wouldn't win any fashion awards. The Shell Lady looked like a deranged Bo Peep sporting several white masked Gremlins as her entourage. But hey, it was attention-grabbing, and that was the point.

As if on cue, a gaggle of tourists materialised, their cameras flashing like paparazzi at a pie-throwing contest. "Blimey, what's that?!" exclaimed one whilst the women posed for the camera's, huge grins beneath the white masks. The onlookers were delighted at having stumbled on the impromptu protest.

"Looks like a right old knees-up for the Shell Lady!" guffawed another, slapping his mate on the back. "Twat!" muttered Manda under her mask.

Annette, ever the worrier, hissed, "They're laughing at us Beatrice!"

But Beatrice, having worked in theatre and TV, was unfazed. "Let them laugh," she whispered. "Laughter is the best medicine, and right now, we

need a whole pharmacy's worth! They will remember us, that's what it's about really. Facebook here we come!"

The women launched into their prepared speeches, a chorus of righteous anger and witty retorts (courtesy of Christina, of course). They spoke of broken promises, stolen pensions, and the indignity of being treated like yesterday's chip paper. Anyone inclined to heckle soon faded away under Christina's intelligent and cutting replies. The woman took no prisoners. If you were rude then you were fair game for a hilarious tongue lashing.

The tourists, initially amused, grew quiet and began to listen. Afterwards a young woman, her eyes welling up, approached the group. "My nan was a WASPI too," she whispered. "She says they treated her like dirt... she died a month ago. Well done you!" She stuffed a tenner in Sheila's hand and left them with a wave of solidarity, a blown kiss, and instructions to buy everyone coffees.

Another tourist, a burly man with a gruff exterior, nodded in agreement. "My mums on a state pension, barely scraping by. It's a disgrace."

"Imagine then how she would be with no pension at all for up to six years, that's what's happened to most of us, and not just us, it affects our husbands and partners too" replied Christina.

"Doesn't bear thinking about love, good luck to you, I hope you sock it to them …thieving bastards!" he snarled and left.

The initial laughter had morphed into murmurs of support. The WASPI Women, emboldened, pressed on once more, their voices ringing out across the harbour, a chorus of defiance and frenzied leafleting against injustice.

The sun reached its zenith, casting a winter warmth across the harbour arm as they passed the steps of the Turner Contemporary. Walking towards them, a smartly dressed woman, down from London for the day, held out a hand to attract their attention.

"Excuse me ladies, I'm sixty-one," she said. "They told me when I applied for my State Pension a year ago that I had to wait another six years. I thought it was supposed to be sixty. Am I one of you?" she asked.

Sheila stepped forward. "That you are my love, come and have a coffee with us, there are things you should know."

2018 and women were still only just finding out…

Chapter Thirteen

Roger hobbled in, his ankle having given way yet again today, it was getting to the point where he was afraid of falling off his ladders and it was frustrating him immensely.

Deidre put the kettle on and pulled a cheap frozen meal from the freezer and banged it into the microwave. She had heard a discussion on the radio today about living standards and what was considered moderate and what basic. She'd quickly realised if they hadn't been drawing on their retirement savings, they would have fallen somewhere in between the abject poverty and starvation level!

What happened to the woman that had travelled the world? A career phoenix fuelled by fire. It seemed all her fire had dimmed, and with it her self-esteem. Replaced by the dull thrum of daily drudgery when her body was exhausted and pained.

She saw it also in Roger's slumped shoulders, the way his smile never quite reached his eyes. "Cuppa love?" she offered, knowing the answer before it left her lips.

"Please" he answered, easing himself onto the kitchen chair. He wasn't himself and it troubled her.

"What's the matter? you look like you lost a fiver and found a shilling" she asked.

"I went into the office today; I think they're giving some of my work to someone else. We can't keep drawing out savings. There won't be anything left when we need it." He stared down into his mug despondently. There would be no answer in the tea leaves.

Deidre had noticed the decline as she did the accounts and had rung the manager of the agency they worked for. They had always had a good relationship and they had always been reliable and loyal, but what did that count for in today's cutthroat world? Younger men were coming in and it was always a worry. She had been given reassurance that the property maintenance end was badly down due to the economic climate, and they were still the number one go to. Deidre had cynically thought. 'Yeah right, not due to them fazing them out in any way in favour of some young gun with a sprayer instead of a roller,' the signs were there. Deidre's own experience of ageism recently had given her a knew clarity on her lack of value as a woman over 60 years, and now it seemed Roger was about to fall victim.

She had taken redundancy at fifty-four from the business consultancy she worked for, to move to Kent to help support their daughter with a disabled

child. Anticipating her pension at 60, they had downsized and had a small inheritance. It was only that currently keeping the wolf from the door.

Deidre's efforts to get work of any quality once she realised she had lost six years of her pension, were met with no response at all, or at best a 'no thank you.' All her experience, her qualifications counted for nothing. They couldn't see the dynamic mature woman, they just saw a number, one that would be getting ill or wanting to retire soon. It was clear that they also hadn't heard the news that now she had almost a decade to go…

Her own best friend, a pensions adviser for a major company, had said to her at the point she was making the decision to move, was that all she had to do was get through the six years to her pension at sixty. Roger would move his business down south, and the monies accrued from downsizing would easily support them through.

The majority of pension advisors, paid and trained to be in the know, with a duty of care, knew nothing. How could she blame them, she hadn't known either! That the professionals, paid to know, didn't, screamed STEALTH once more.

She glanced across at her husband who looked tired and drawn. He was a worrier, and she was the

strong one. She rarely cried, but right now she could have sobbed her heart out.

They had worked together on a big job because money was so tight, just to get it invoiced sooner. Everything hurt, that just bending to the cupboard was an effort, but she'd work through the pain if it meant the money was coming in as it had used to. Instead, the diary once so full that they couldn't keep up, was frighteningly empty.

She gave herself an inner telling off. Worrying about things out of your control brought you down. She would tackle the things she had control over. Roger might fret, but she was the oak she told herself, weathered but unyielding. With a determined glint in her eye, she pulled herself together and set about brewing a different kind of tea - one steeped in resilience, flavoured with the memory of their shared love, and sweetened with the hope that, even in the harsh light of government betrayal, they could still weather the storm, together.

Chapter Fourteen

Sylvia clutched her basket to her as she entered the Co-op like a shield against the fluorescent onslaught of the supermarket aisles. She could hear Alan's words "and use a basket not a trolley, you'll spend less," as he handed her the list of things 'she' needed. Her usual brisk march had devolved into a shuffle, the weight of redundancy and Alan's latest control tactic since she defied him to go to the protest in London (a suspiciously empty purse), pressing down on her shoulders.

Suddenly, a voice, crisp as a newly ironed tea towel, cut through the hum. "Sylvia? Heavens above, you look like you've swallowed a particularly grumpy cloud."

It was Maureen, the WASPI group leader, her comfortable trainers, as opposed to Sylvia's cheap pumps. Her confident clothes and hair cut fashionably, a stark contrast to Sylvia's garden-stained dungarees and escaping frizzy curls. Maureen's eyes, usually twinkling, narrowed with concern. "We missed you Saturday, it was fun, I must have conjured you up, I was going to ring you later to see what had happened to you."

Sylvia mumbled something about a bad back and the price of everything. Maureen, bless her cotton socks, was not fooled. She steered Sylvia towards the cafe, ignoring her feeble protests with a "Well you better put that basket back and get a trolley,

you can't be carrying all your shopping in that with a bad back."

"Coffee," Maureen declared, brandishing a ten-pound note. "And don't you dare argue. looks like we need a good catch up."

Over lukewarm latté's, Sylvia's carefully constructed dam of "everything's fine" crumbled. The words tumbled out: the redundancy, the tightening purse strings, the fear that simmered beneath the surface. Under Maureen's perceptive questioning she confessed the incident - Alan's temper, her brief rebellion, the suspicious lack of funds that followed. He was making sure she hadn't the means to do anything without his say so. Sylvia's face crumpled and Maureen's hand instinctively covered hers as the tears spilled.

Maureen listened, her face a mask of calm empathy. Finally, she spoke, her voice low but firm. "Sylvia, listen to me. You are not trapped. You are stronger than you think, and we have a small amount of funds to help members with travel, so don't ever think you are alone."

Sylvia scoffed, a shaky, humourless sound. "Stronger than Alan? He controls everything. My money, my time, even the things I buy. He wouldn't even let me buy a tray of geraniums last week for the garden, he said they were too loud! "

Maureen's eyes twinkled again, a mischievous glint replacing the concern. "Geraniums, eh? Sounds like

a plan. Give me a minute". With that she popped out of the café and came back a few minutes later, placing a packet of sunflower seeds on the table in front of her.

Sylvia blinked, confused. "A plan? For what?"

Maureen leaned closer; her voice conspiratorial. "Operation Sunflower. We're planting a revolution, one colourful petal at a time. He doesn't like flamboyant plants; he doesn't know the meaning of flamboyant. There's only one way to beat bullies and that's to outsmart them". She grinned broadly and Sylvia's heart, long dormant under layers of fear, fluttered. "Revolution? But how?"

Maureen smiled, a sly, subversive grin. "Let's just say Alan might find his precious control... slipping through his fingers."

The details were whispered over the rim of Sylvia's coffee cup. A seed of defiance, nurtured by Maureen's quiet strength, began to sprout in her chest. Just as it had when she'd snipped the cactus bloom that fateful day. As they left the cafe, Sylvia straightened her shoulders, her bad back forgotten. Her gaze fell upon the display of vibrant sunflower seeds, their faces turned towards the sun. In their golden promise, she saw a reflection of herself - ready to bloom, even in the shade of Alan's control.

Operation Sunflower had begun. And this WASPI, once resigned to her fate, was about to paint the town (or at least her garden) a defiant shade of

yellow. That way every time she saw their golden faces, bold and full of colour she would gather the strength to do something about her life.

Chapter Fifteen

The winter wind clawed at Maureen's face as she hurried down the cobbled street to her quaint little cottage, just off the village main street, her worn briefcase clutched tightly in her hand. The biting January air echoed the chill in her heart, a hollowness that had become a constant companion since Ruth's passing four years ago. At 63, retirement should have been a golden time, filled with well-earned adventures and quiet evenings by the fire. Instead, it was a stark landscape of loss and uncertainty.

Maureen, a woman whose sharp intellect had once guided young minds in the classroom, now poured her energy into a different kind of education. As the leader of the local WASPI support group, she became a beacon of hope for a community robbed of their rightful pensions. The stolen years of contributions, the government's broken promises, fuelled a fire within her, a righteous anger that transcended her personal grief.

Compared to some of the women she supported, burdened by the fiscal landslide of no expected state pension, with no private pensions to fall back on, and added to that, the ever-widening gap between income and expenses, Maureen was fortunate. They had downsized in readiness for retirement, their cozy cottage bought outright, eliminating the gnawing worry of a mortgage. They

had some savings and each a private pension which they had had to draw early when Ruth had become ill. From then on, frugality had become a necessity, each pound stretched thin to bridge the gap until their state pension kicked in. Ruth hadn't made it over the finish line, so a lifetime of her contributions went back into the government's coffers whilst she was left to make sense of it all, a huge weight of grief bearing down on her.

Luckily, they had made the house home before the storm hit. Ruth was insured, but only enough for the funeral. The savings they had thought would buy magnificent memories, instead bought necessities.

The sting of financial hardship, of getting by on a small teacher's pension, paled in comparison to the emptiness left by Ruth's absence. Their dreams of travel, of shared laughter echoing through their home, of volunteering together, now lay shattered, replaced by a constant ache. Memories, bittersweet and poignant, were her only companions in the quiet evenings.

Yet, amidst the struggle and loss, Maureen found solace in her fight for justice. The WASPI meetings, once a platform for shared grievances, became a tapestry of resilience and camaraderie. She saw the spark of defiance in the eyes of her fellow members, their stories of hardship fuelling a collective fire. They were not just fighting for their pensions; they were fighting for dignity, for a

recognition of the decades they had poured into society, often at the expense of their own financial security. Daughters, Mothers, grandmothers, wives, carers, rarely time to be just women.

As Maureen led the group in discussions and strategized their next steps, a familiar warmth bloomed in her chest. It wasn't the warmth of shared laughter with Ruth, but a different kind of warmth, born of purpose and solidarity. She was no longer just a woman grieving a lost love; she was a leader, a voice for the voiceless, a beacon of hope in the storm.

The fight for justice was far from over, and Maureen knew there would be challenges ahead. But as she walked home that evening, the wind no longer felt so cold. The anger, the grief, and an unwavering sense of right burned brighter than ever. It was a fire that would not be extinguished, a fire that would illuminate the path to justice, not just for herself, but for all the WASPI women who stood beside her.

As she hung her coat up in the hallway, she thought of Sylvia, poor Sylvia, she could have been so vivacious with all those curls and yet she had faded like a picture in too much sunshine. Maureen wished she could help. Perhaps she could take her for some advice, some way of toughening her up. What would she like to do with that controlling bastard that had her cowering like a timid little mouse. She wished she could give Sylvia an

overhaul both physically and mentally. The sunflower ploy had been just that and nothing more, just a seed to plant to cheer her up in a moment of despair. Something to make her smile and remind her of her worth and hopefully instigate a quiet insurrection in the confinement of her marriage.

She pulled a cup from the cupboard, tipped out her shopping and turned on her laptop determined to find something that would bring them all some hope.

Chapter Sixteen

Sheila "Iron Fist" Grimshaw stared at the phone, the receiver pressed to her ear with the air of a seasoned soldier taking orders. The voice on the other end, a trembling soprano belonging to Grace who was in full-blown meltdown. Grace, a fellow WASPI and unfortunate victim of the pension injustice, was a walking hurricane of misfortune, prone to misplacing keys and mistaking strangers for long-lost cousins.

"Sheila," Grace wailed, "they've got me! stuck in this charity shop like a naughty schoolgirl, accused of... of..." her voice trailed off, replaced by a sniffle.

Sheila, whose vocabulary could peel paint at fifty paces, opted for a more delicate approach. "Grace love, calm down. Explain what's happened, and I'll sort it."

It turned out Grace, in a state of near-malnutrition-induced delirium, had "borrowed" a selection of mismatched teacups, a deflated inflatable banana, and a rather fetching porcelain budgie from the local charity shop. The shop's manager, a man with the temperament of a startled badger, was threatening to call the constabulary.

Sheila, channelling her inner Houdini, whipped into action, and got herself down there pronto to find a red eyed Grace kettled into the knitting wool section, surrounded by a nervous posse of volunteers.

A well-placed quip about the manager's resemblance to a particularly grumpy bulldog, coupled with a strategic donation to the shop (courtesy of her "rainy day" stash), managed to diffuse the situation. She retrieved a tearful Grace, whose confusion was endearingly paired with a complete lack of memory about the pilfered goods and got her out of there before anyone changed their mind.

Back in Grace's draughty home, the reality of the situation hit Sheila like a rogue wave. The bare cupboards echoed, the only sustenance a wilted cabbage and a packet of instant noodles past their prime. The woodstove looked like it hadn't seen action in weeks, and they were in the middle of a cold snap. Grace, frail and bewildered, looked like a lost kitten in a hurricane.

Sheila, whose maternal instincts were normally buried beneath a thick layer of cynicism, knew this was no ordinary case of absent-mindedness and she had a soft spot for Grace. The recent loss of a husband couldn't have been easy under the current circumstances. Hunger, she thought, coupled with what was looking like early-onset dementia, had driven Grace to desperation. And Sheila, the champion of the underdog and sworn enemy of injustice, wasn't about to stand by and watch.

She sat Grace down and made her a strong black tea in the absence of any other contents of the kitchen cupboards. She then raked the old ashes

out of the fireplace into a bucket. Opening the back door, she deposited the ashes in the hedge, quickly found the log store well stocked in the large garden, and grabbing an armful brought them back in. At least the poor sod would have a fire tonight. Why wasn't she keeping warm at least, there was no reason for it with all the wood outside. They must do something to help her. She got chips and couple of muffins and shared an impromptu meal with her till she calmed down and then left, vowing something must be done.

Thus began Sheila's unorthodox crusade. Armed with a list longer than a pensioner's shopping spree and a vocabulary that would make a sailor blush, she stormed into the office of "No-Can-Do" Norton, the local MP. Nigel, a man whose political savvy was matched only by his disdain for WASPIs, found himself under a one-woman siege.

Sheila, with the theatrics of a Shakespearean actress and the ferocity of a bulldog with a bone, laid out Grace's plight. Nigel, used to dealing with polite letters and well-heeled party donors, was bewildered by the whirlwind of accusations, threats (veiled and not-so-veiled), and a colourful description of his political career.

By the time Sheila finished, Nigel was a pale shade of puce, his neatly barbered hair slightly askew. He stammered promises of investigating, of social worker visits, of "looking into the matter." Whether he meant any of it, Sheila couldn't care less. She

wouldn't rest until he followed it with action, or, failing that, a full-blown scandal that would make the local rag's headlines about his ineffectiveness in supporting a starving 'would be, should be' pensioner may well be on the menu.

As Sheila marched out of Nigel's office, a triumphant grin split her face. Grace's battle was far from over, but she was no longer alone. Sheila, the WASPI with a heart of gold (and a vocabulary rather bluer), had just declared war on this particular injustice.

Chapter Seventeen

Ah, 3am. The witching hour for insomniacs, singletons with questionable online dating searches, and Annette, waging war on the very fabric of sleep. Her fingers, once adept at crafting corporate memos, now hammered away at the keyboard, birthing letter templates for her fellow pension campaigners. The rhythmic clatter was the soundtrack to her anxiety, a symphony of injustice keeping the sandman at bay.

Arthur, her long-suffering husband, resembling a beached walrus in the other room, snored serenely, oblivious to the nocturnal crusade brewing in the room next door. Separate bedrooms, they'd decided recently, were the only answer to her shuffling and his honking. Not the most romantic arrangement, but let's face it, romance had taken a backseat to the WASPI campaign months ago.

The only thing was that with Arthur no longer having to be considered, Annette gave full rein to her anxiety, and would sit up surfing for hours on end, searching, hoping for anything that would push the campaign further into the public eye. Arthur would catch her wandering about in the dark of the early hours on his way to the loo like an occupant of the Marie Celeste. He would shake his head despondently as he spotted the blue light of her laptop lighting the room beyond, and she would return to bed, determined to finish off and

try to sleep, but one thing finished was followed by the start of another, and sleep seemed as far off as her State Pension.

Annette had tried everything to silence the internal discourse. Self-hypnosis, allegedly to calm her just made her shuffle more, meditation tapes that' sounded like whale mating calls irritated the life out of her, and eventually a mild natural sleeping pill nightly that left her feeling like a drugged sloth in the mornings gave her some down time.

The only thing that truly motivated her was the campaign. It was her fuel, her purpose, her reason for existing. Everything else, her once vibrant hobbies, her love of Bake Off, even the allure of a decent gossip mag, paled by comparison. She cultivated anger, obsession, and depression in equal measures.

Arthur, bless him, just couldn't understand. How could he? Not one man had ever had over £50,000 filched from their state pension pot and then been treated with the lack of respect normally reserved for single mothers and PIP applicants. The man simply didn't get it. He saw anger, not injustice, wrinkles, not battle scars. He was, in her increasingly frustrated eyes, as clueless as a pigeon at a chess tournament.

"Why won't you just let me look after you?" he would ask in desperation.

"Because you shouldn't have to! It's my right to have independence and they have taken it from me. So much for doing this in the name of equality!"

"But Annette, listen to me, I'm a doctor. I can see this is making you ill, even if you can't!"

"Arthur, you don't get it. There are women dying out there because of this, and if they're not dying directly because of it, they are dying in poverty without comfort or basic dignity. I must fight because I can!"

She would then set her lips tightly and Arthur knew nothing would dissuade her. The decline in her temperament, her energy, their relationship, even her previously optimistic view on life going forward, was clearly visible to him, but she would not see it. She was consumed.

So, Annette soldiered on, fuelled by righteous fury and a questionable caffeine intake. The campaign was her lifeblood, her insomnia a mere inconvenience. Sleep was for the weak, and she, was anything but. She was a WASPI warrior, and the fight, as they say, must go on. Even if it meant sacrificing her sanity. For now, sleep, that fickle friend, had abandoned her, replaced by an obsessive mission to shove their plight into the spotlight

Chapter Eighteen

Sheila, self-appointed protector of Grace. and a woman clad in the rough armour of experience, held within a heart as soft as the apple pie she baked. This crust, formed over years of relentless toil, began with the promise of a dental nurse's career, a future cruelly shattered by divorce and the weight of single motherhood.

The gleaming prospects of her career dimmed as the need to collect children and prepare evening meals clashed with the rigid demands of the dentist's surgery. The dentist didn't want someone who needed to leave at 3pm to pick the kids up and give them tea, and so she lost that career prospect, exchanged instead for bar work, waitressing, cleaning, wherever she could work around the upbringing of her kids became the reality.

The impact of several part time jobs meant the dream of owning a home, once a tantalising whisper in the wind, became a distant echo as she juggled work with the demands of raising her children. No work pensions, they didn't offer them to women like her, running from one job to another just to survive.

Nor were they telling her that she'd need a private pension as they were about to rob her of her hard-earned retirement as they had now done, conditioning the following generations to expect

the theft of their NI contributions and the pension they were supposed to fund.

In the nineties, her friends, oblivious to the silent struggles, would offer well-meaning advice about Thatcher's right-to-buy scheme, a cruel joke in the face of barely affording rent. Yet, Sheila persevered, each hardship hardening her resolve, transforming her into a formidable woman who spoke her truth, unafraid and unflinching.

The finish line of her pension loomed, but even that wouldn't mark the end of her fight. The anger at the years of deprivation, the bitter taste of an unfair system, still lingered. Yet, amidst the shadows, bloomed a beacon of hope – her son, Sam. His practical gifts, his quiet support, a testament to the caring children she had raised.

On her 65th birthday, a year shy of retirement, a bittersweet truth dawned. Her children were thriving, their lives buoyed by an inheritance from their father, his life a stark contrast to her own reality since the divorce many years ago.

As her family were due to gather, the radio's cheerful melody resonated, a spark of joy igniting within her. But the joy was tinged with the knowledge of the despair of countless women like her, trapped in a cycle of drudgery, wishing their precious lives away and counting the days to their long-delayed pension. "Stop it," her inner voice

chastised, urging her to savour the moment. "Not today." One year to go…

The apple pie, a symbol of her love, and the half-cooked chicken awaited the kids, a promise of warmth and togetherness. The intercom buzzed, her son's voice a familiar melody. "Hiya mam."

"Hello darlin' come up" she replied,

"Can you come down mum, the front doors stuck."

"Ok, give me a second."

Sheila slowly progressed down the stairs thanking her lucky stars that she lived in a maisonette rather than a high-rise. She could see the shadows of her kids and grandkids through the frosted glass of the front foyer. That buzzer always stuck and trying to get the council out took forever.

Then, the surprise – a chorus of happy birthday erupting from a shower of party poppers, followed by a gift that brought tears to her eyes: a dinky bright red Fiat.

"For you mum, for all you've done for us, insured, taxed, service plan and £1000 for petrol for you, so you can afford days out. No more buses when you are tired after work. You can jump in this baby and be home in minutes. No more dragging the shopping home on the bus."

Sam was emotional. He had seen how hard his mum had it these last few years and he knew she was slowing down and struggling. It was despicable what the government had done to her. At least now the family had the means to make life easier for her, even if it had taken his dads passing and his inheritance to achieve it. She would be more comfortable now."

Sheila cried; his big tough mum cried for ten minutes until they could calm her down into loud hiccupped sobs. It had affected her more than they could know. Her old banger had given up a couple of years ago and she hadn't been able to replace it. It had been a terrible symbol of all that she endured and had lost. and its loss hit her hard.

Sheila, the woman who had weathered life's storms, finally found solace in the love of her family and the promise of a brighter future. Her tears, a testament to the resilience of the human spirit, were not just of joy, but of the unexpected beauty that can blossom even in the harshest of winters.

Chapter Nineteen

Up North

Right then, Beatrice was driving back to Manchester for the Media City Protest like a one-woman convoy, representing the Margate ladies. Travelling wasn't easy for most of them, and she had willingly drawn this straw as an opportunity to catch up with her long-standing friends up north. As for the rest of the Margate crew, health, train fares, work, caring duties, the lot conspired to keep them grounded in Kent. In a way though, being unemployed had its perks. Job searching? remotely done. Friends in Manchester? plenty of couches to crash on. In this instance Linnie's.

The prep for this protest had been weeks of Zoom calls and virtual coffees, and 'Facebooking,' where she encountered women from other regions. Some names stuck out, some less so, and let's not forget the trolls. It never failed to amaze her how even in a fight for justice, where everyone should be singing from the same hymn sheet, egos and bad apples just had to make an appearance. Still, theatre folks like her were used to seeing prima donnas pout - water off a duck's back darling. Just hoped nobody mistook her years of creative industry sass for arrogance. Confidence was key in these situations.

On her Facebook campaigning journeys where she had now started using her media experience to do little protest videos, she had started to discover that there was a nucleus of amazing women who believed in real sisterhood and the concept thrilled her. They were as she, ready to support whichever group was organising the latest protest with no regard for boundaries or the self-inflicted allegiances some tied themselves to. The trolls delighted in causing trouble, but she would not be one of those buying into factions. She was a 1950s woman subject to a great injustice and that was the only group she had loyalty to.

The real problem here was many of the 1950s ladies themselves. Oh, the government picked them well all right. Born right on the cusp of the women's liberation movement, somehow their feet had missed that cultural pirouette in their youth, and they faced old age going placidly amongst the haste and grandchildren, accepting their pension pilfering with all the enthusiasm for the fight of a slug facing a saltshaker. Equality? Wasn't even a word in their vocabulary. For the majority, their world had always been part-time jobs, child-rearing, divorce drama, and a healthy dose of casual sexism. Low opportunities, unequal pay, glass ceilings galore. And don't get her started on lack of work pension opportunities.

Their doe-like acceptance of this discriminatory system drove Beatrice batty. Not her, no siree! She'd escaped that world by the skin of her teeth.

Divorced at 27, she'd retrained in design and launched herself into the technicolour chaos of theatre, where everything was questioned, dissected, then thrown onto the stage. Feelings were aired, women were expected to be loud, proud, and creatively volcanic. Beatrice embodied all three and wouldn't apologize for a second of it.

Luckily in this she was not alone, and gradually as the news of their pension dreams in tatters filtered down, the firebrands of their generation started to surface. Whilst the weaker mouthed the words "There's nothing we can do...." It was left to the ones who had taken the step to independence and fought the system all their lives to take up the banner for justice and hold it aloft with pride, and thousands of them were doing just that, in every town and city.

To be free to do that, they fought the very things that had held them back in life. Family commitments, caring roles, the need to work, especially now to survive. Ill health, disability, and in some cases, they were opposing their own men to rise up and deliver the message. 'Oh No...Not to this woman you're not!'

She pulled up at Linnie's and her friend came running out, and they hugged each other warmly. How she missed her friends up north, many close to her since her twenties. She and Linnie had met at

salsa twenty years previously, as Beatrice had arrived for her first class in army pants and boots, covered in paint spatters from the set she was painting that day.

She made an incongruous sight, on her own, slipping off her Doc Martins in exchange for heeled dance shoes. She hadn't had time even to wash off the paint and was due back at the theatre in two hours for a tech rehearsal.

Lin, equally alone with vivacious bubbles of curls and a smile that was bright as her personality, had approached her and struck up a conversation. From that day on they were as close as sisters. Lin being older had only had a couple of years of her pension taken but she was still ready to stand alongside her friend.

Linnie pulled a large banner out of the boot of the car.

"What's this then? she asked.

Beatrice handed her one end and unfurled it saying, "That's your end, this is mine."

Lin looked at the words and burst out laughing. "Right choice of words for us" she chuckled.

"All true," Beatrice replied. "Well behaved women seldom make history!"

"Not a truer word said!" came the response "... kettles on, let's get you in." Lin hauled her case out of the boot and headed for the house.

Chapter Twenty

'NO PENSION NO LIFE'

Beatrice had been a guest at the Media City first light up and it had been impressive, but she had left Manchester soon after and had never been back. She had hoped to be here one day as a high point in her career, it never happened. Her mother's dementia had caused a hiatus and career break just as she was getting known. By the time she had nursed her and eventually had to sort care for her, when she became a danger to herself, the opportunity was gone, and Beatrice was on the wrong side of fifty. In all her career and never in a million years did she ever think that instead, she would be planted outside these tinted glass centres of creative power to protest.

The changes were dramatic and here was a thriving area now for creatives and it gave her a buzz just to be there. She and Lin arrived early to get the lay of the land and her heart fell as there was just a couple of people milling about amongst the creative's toing and froing. Had she got the dates wrong? They walked over to one of the organisers to say hello and a sweet-faced woman smiled as she was dishing out boxes to volunteers.

"Hi, are we in the right place?" Beatrice asked.

"Yes you are, welcome. I'm just setting out the stage area here on these steps, if you want to help, it won't take long, where have you come from?" came the reply.

"Well, me, near Dover, and Linnie from Bolton"

"That's a hell of a way to come!"

"Couldn't not, and my friend here is kindly putting me up" Beatrice replied.

"But your accent's northern?"

"Yep, born and bred."

"Well, I'm Glenda, I'm so pleased you came, it's so hard for everyone to make the journey."

Beatrice brandished her trusty phone. "I've been doing some interviews on my phone and sharing them on Facebook, do you mind if I grab a few people today…and can I start with you?

…and so, she did. This wonderful lady, despite great tragedy in her life, had fought against the system for some years. Her husband, an ex-shop steward with a very dry wit had been quite a bit older than her and she was very much aware how precious time with a loved one could be. She was not going to lay down and let the government steal her final years with him, as they had done her expectations as a mum and a grandma.

She had lost her only son far too soon through medical mistakes in a system stretched ever thinner with cuts. Though she had got her admission and apology, money was not her motivation, Justice was, and in Manchester, the home of the suffragette she hoped to bring that same fighting spirit to the eyes of the media. Right to their doorstep in the form of the 1950s women.

Currently, she was "heartily sick of the media not taking up the story of the loss of their pensions" she explained, and she had decided to set up a group in Manchester, which was fast becoming one of the most active in the country.

Today she had decided, "if the media wouldn't come to the 50's women, then the women would come to them. Right on the steps of the square in front of the large BBC and ITV buildings. Let them say on the news tonight the injustice didn't exist!" she said with a glint of challenge in her eyes.

Within this small, gently spoken woman, beat the heart of a lioness. As she stood facing Beatrice's camera phone telling her story with no ego, just a bright green and purple suffragette print dress. Speaking with pride about her beloved son, her precious years now being taken from spending time with her husband as she was forced to work on to 66 years, Beatrice knew that here was a woman she would one day, be proud to call friend.

Just as they had finished. Beatrice looked up to see that as she had been engrossed talking to Glenda, the square had suddenly become fuller, women were streaming in a beautiful burst of purple, white and green. Some, their men with them, and some had brought their daughters. Beatrice's heart soared.

Beatrice left Glenda with a hug as she and Lin took up their banner and held it aloft to greet the new arrivals. A shout went up as a roar of voices came from an alley between the BBC and ITV buildings. Someone shouted "It's the Women from Wales! We're definitely on a go now!"

Go it was. As this large group of women, a proud Welsh dragon flying high above them marched chanting past the large windows of the Beeb. It was a moment of theatre that Beatrice could appreciate.

At the front, a tall woman with blond hair with pink streets directed operations. "They won't be ignoring this lot so easily" said Bea and smiling, she and Lin walked over to greet them. It's funny how there are just people that walk into your life and you know you'll never forget them. This woman was one. The funkiest Welsh 'dragon' she had ever met!

"Allo there, I saw you on the green at London" The funky woman said to Beatrice,

"Did you?" Beatrice was amazed. She didn't think anyone had noticed her, but this woman apparently missed nothing.

"You'll have to give me your number girl, we could use someone like you" she said with a grin.

"But I'm not Welsh" Beatrice responded a bit bemused,

"Well, you are now, give me your number, and we'll get our heads together!" and with that small moment a friendship was created and a partner in crime.

The crowd grew and they even managed to get a local news crew in there, which was not an easy feat. The flags and banners billowed in the wind, but they were lucky, the weather was being kind.

Beatrice scanned the slogans and one in particular, held by a woman who looked like she carried the weight of the world on her shoulders, but was still standing regardless. Stated the simple phrase, NO PENSION NO LIFE and Beatrice's eyes filled as it hit home. This is how it was for so many of them. Life that they had expected in retirement, taken from them in one fell swoop of a bureaucrat's pen. Bless these women for fighting back in a society that was breeding apathy. They were warning everyone, but it went unheeded. Support us or become us were words no one was hearing.

One seasoned campaigner, sporting a yellow and black beret that could rival Cruella de Vil's, rallied the troops with a great speech and a promise to live to 114 until she'd squeezed every stolen penny back from the government and had her monies worth.

Andy Burnham, Mayor of Manchester and a strong supporter of the campaign, and a heartthrob for some of the women, gave a great speech. Beatrice could certainly see why he was popular and made sure she got a photo with him to make the girls jealous back home. A local poet, a beautiful and clearly sensitive young man recited his poem, and the audience listened. immensely moved. It was about the value of women.

Time then to rev the crowd back up with a rousing karaoke of 'Sisters are doing it for themselves' which in truth made Beatrice cringe slightly, but hey they were having fun in an otherwise miserable life! They were celebrating sisterhood and women standing for women.

Then it was time to march. Everyone had brought letters of complaint about the lack of coverage on the BBC which they posted in Glenda's specially made post box.

They marched up to the plate glass front of the building and lined up in their hundreds to chant as the letters were delivered to reception. Obviously,

some bright spark at the BBC had decided they didn't want to look at a load of would-be pensioners spoiling their view, and being the background to any interviews and so they did the unthinkable insult. They started to bring the blinds down across the whole of the building. Maybe it was a stunt to incite violence, but really? It was so symbolic of the treatment these women had experienced so far at the hands of the government that it was even more of an affront.

They were not that daft. Women of a certain age know just how far they can go and with a great roar of laughter and challenge, they stepped forward, pressed their faces to the glass and sung all the louder. It was like a scene at Belle Vue when the Osmond's had come to Manchester in the 70's! "We want our pensions" came the cry and a few rousing choruses of 50's women stand united and we're not going away!" was the result.

Their voices resounded around the large square and up into the offices and studios above them. They were heard but would they be noted. That was the question.

The whispers were filtering through the crowd that women were now dying directly and indirectly because of the callous seizing of their pensions, and the numbers were growing. Beatrice made a mental note to find out the numbers.

It was important, but she didn't know just at that time how much.

Chapter Twenty-One

The Seed is Sprouting

Maureen was the only one daring enough to knock on Sylvia's door and face Alan's cold expression. She countered it eloquently with a packet of biscuits and a statement that she was "Here to get some gardening tips from Sylvia" who was sculking timidly in the kitchen doorway with a look of thinly veiled horror. Nevertheless, Maureen's determination twinned with a heavy coat of charm won the day and she gained entry.

Sylvia had been in the doghouse again, still unforgiven for not having yet gained a job. She was getting desperate, if only in her desire to be somewhere else other than under Alan's watchful eye. But caring roles were all that were on offer locally, and at her age she'd be physically broken within a month and so she waited, scouring the jobs vacant website every day but getting no response. Who wants a woman her age anyway?

Alan retreated to the tv, and the women sat in the kitchen hugging a coffee and making headway into the choccy biscuits.

"I thought I'd help you plant your seeds now that the weather is getting warmer. No time like the present." Maureen said.

Half an hour later they were chatting happily away in the greenhouse and Maureen realised that she enjoyed her new friends' company more than she'd known possible. Sylvia hid her sparkle beneath a veil of 'Eau de Timide,' but for the moments when Alan was forgotten, she came to life and shone with easy humour and something eccentric that would shoot her off at a tangent and leave Maureen laughing heartily. Maureen recognised that in Sylvia's gentle and funny company, she forgot her own inner grief and even found herself opening up about Ruth, how they had met, their hopes for retirement and the devastation of losing her great love.

Sylvia listened and then gave her the sweetest of hugs and for a moment Maureen felt genuinely cared for by another human being once more. Her lack of family had left her to pull herself together or to fall apart after Ruth's untimely passing, and Maureen was never going to be one to fall apart. This was nice, an easy friend, someone just to be with, without having to be strong.

"Right, now we're planting these little fuckers everywhere. You will see them from the windows

and every time you look out and see them grow in strength, you imagine you're growing with them... and who knows before you know it, you will be."

Sylvia dusted the warm compost from her hands and gave a genuine smile that lit her sweet face up. "Do you know I think I already am" she said.

Chapter Twenty-Two

Honking Mad

Westwood Cross, the Bermuda Triangle of boredom, was usually only exciting if you mistook a rogue shopping trolley for a runaway horse. But this Saturday, the air crackled with a different kind of electrifying energy – the kind that made polyester itch and hair frizz in unison. The Waspi women, Manda, Deidre and Annette with wrinkles and wit, were on a mission.

But for this merry band of Margate warriors, it was their stage, their soapbox, their chance to grab attention and shake the cobwebs off the government's collective memory. The roadside at Westwood Cross was a great place to get attention and most Saturdays they took turns to put a small group there between the hours of noon and 1pm to attract the attention of drivers and passers-by to the campaign. "Honk if you support us," their roadside banner said. The current record was one hundred and ninety-two peeps per hour. "Not bad for a few old broads" Manda had said.

Recently, the air was thick with righteous fury, thanks to a certain Mr. Osborne. His recent New York Business Club address, where he practically did a tap dance over "saving the nation" by raising the Waspi women's pension age, had gone down

like a lead balloon. The "equality with men" facade had crumbled faster than a soggy bourbon in Nana's handbag. This was about saving money, in this case 181 billion, not some noble quest for fairness, and the Waspi's wouldn't stand for the glorifying of what had become essentially a cull of older women.

The recent video of George, the financial Houdini who'd vanished their pensions with a flick of his golden cufflinks, had them spitting tacks. His smug pronouncements about the "biggest financial coup" were like nails on a national chalkboard. Gone was the flimsy excuse of "equality," replaced by the unvarnished truth: they'd been shafted, pure and simple.

News of a Waspi woman in Margate sleeping in her car, life ravaged by the missing pension, only stoked the flames. Another, battling chronic illness and mounting bills, pushed to the brink of suicide by a government that seemed to care about fish quota's more than its own citizens. The anger simmered, seasoned with worry and a healthy dose of determination.

Donations poured in, not just for basic needs of women in a desperate plight, but also for the "Back to 60" court case, a recent beacon of hope in a sea of bureaucratic indifference. In four days over £80,000 court costs were raised, every pound donated from many a hopeful dipping into an otherwise empty purse. That a famous American

suffragette had once quoted that 'Every woman should have a purse of her own' was never truer than at this moment.

Armed with a banner that screamed "NO NOTICE, NO JUSTICE, NO PENSION" and a couple of Waspi dogs looking dapper in their purple coats, the women stood their ground.

The honking of support from drivers spotting them, was their victory song, a cacophony of solidarity against the Margate Siberian winds. Manda, their resident ambulance warrior with a wit as sharp as a tack, expertly deflected unwanted attention from the occasional 'Saturday night special' straggler, her vape pen puffing defiance into the air.

It wasn't glamorous. It wasn't easy. But as they stood there, united in their fight, a flicker of hope ignited. The Waspi's were no damsels in distress. They were real women, raising their voices, demanding justice, and proving that even in the face of a bumbling, self-congratulatory government, they wouldn't be silenced. The revolution, it seemed, would be honked, not televised. And Manda, with a mischievous glint in her eye and a vape cloud trailing behind her, wouldn't have it any other way. People made change and Governments only complied when it was in their self-serving interest, and they couldn't talk their way out of it.

1pm arrived and Manda looked at the dogs and the women with her whose noses had turned pink with

cold, puffed on her vape one last time and turned to the other two.

"Bugger this, I'm frozen, we've suffered enough for one day! Come on Bindi. Home boy," and with a companionable wave she departed.

Deidre looked at her little Westie who had been so patient and was starting to shiver, poor love. "Me too I think, do you need a lift, Annette?

"I think I need a thermal blanket actually!" she grimaced, blowing into her chapped hands.

Chapter Twenty-Three

Arthur, armed with a washing-up brush and Radio 4's dulcet tones, found solace in the mundane after a lifetime navigating the NHS's turbulent seas. Retirement, once a distant dream, was now a comfortable armchair, allowing him to pursue wildlife and history, passions long neglected. Yet, a shadow loomed over their idyllic life – the injustice inflicted upon his beloved Annette.

Occasionally he would take a couple of locum shifts to allow something extra coming in for those holidays, though in truth they didn't really need it. Nevertheless, it allowed them to splurge for the more unconventional adventures.

He had taken the decision to walk away from the NHS when the government had started messing with the taxation of his private pension. Having accrued enough for a comfortable lifestyle, he chose retirement. As they were doing nothing to encourage older doctors to stay on in the profession, it was an easy decision. Now because of the government's own fiscal policy, they had a shortage of doctors and especially in rural areas. He particularly knew his old surgery was desperate to fill the gaps and failing to operate efficiently, but he had done his time.

Corporate greed was fuelling the rape of the land around them, where the so called 'affordable

housing' magnates were snapping like a rabid dog at the old village boundaries, and highly priced, ticky tacky boxes were starting to cover every spare acre of Kent that they could get away with. A money tree for the few, without regard for the wildlife, lack of drains, eco system or infrastructure. The money men were taking British life apart piece by highly profitable piece and the government was complicit.

His musing had naturally brought him around to his wife's own plight and he felt for her. She had worked in the civil service for many years, often in job centres. In all that time she had not once had sight of the leaflet that the government had allegedly sent out to inform her generation of the rise in their state pension age.

Having said that, around fifty thousand leaflets for 3.8 million women would have not even scratched the surface, and as Annette had said, only a tiny proportion of 1950s women frequented the job centres where they had allegedly been placed. The majority being housewives or working several part time jobs because of childcare. They would never have had cause to walk through the doors let alone see a small leaflet, more than likely stashed in a cupboard, never to be given out. The back pages of the financial times and the odd tiny article were hardly the appropriate place to reach that demographic.

The lack of any believable evidence was there. These ill targeted and obscure methods of disseminating important information, were all that the government could cite as their comprehensive informative campaign. The fact that they could have simply put a large header on the top of a P60 or tax return calling the 1950's women to take heed, left them no valid excuses. Surely it was at worst a deliberate ploy or bureaucratic incompetence at best.

Annette had done a good job in her research, and her constant tirades had taken seed and she had him convinced that she was right in her belief that this had been planned and executed to keep the women in the dark until they were just starting to seriously think about their retirement claim. A stealth tactic by which time the majority would be too old and worn down by life to fight. Clever, but a total disgrace to treat the women of this country with such flagrant disrespect.

Yes, Arthur was intelligent enough and had a keen interest in politics, long enough to not to believe the propaganda and he understood the injustice 100%. What worried him most though, was the effect it was having on his previously calm and confident wife. and he feared for her mental health.

Arthur, despite his own political acumen and simmering indignation, worried for his wife as he watched her hanging out the washing.

Her crusade, noble as it was, chipped away at her spirit. Sleepless nights, lost weight, and a gnawing bitterness eroded the woman he loved. He longed to shield her, to whisper, "Let it go my love, enjoy the time we have left." But the fire in her eyes, the righteous anger that fuelled her fight, held him silent.

There was just too much money involved and under her tutelage he now knew the figures required to compensate them were staggering. No government, however socially inclined, would be keen to pick up this ticket. It was a massive hot potato that would require sound costing and he doubted any of the parties trying to oust the conservatives would be willing to pick up this batten.

However much social justice required they righted this wrong, he feared that these poor women would be left to die, without resolution, quietly swept under the carpet as though their lives and contributions held no value, and it would take a miracle for any party to commit to tackling this well buried scandal. No wonder they were trying so hard to keep it out of the news.

Annette exploded through the back door, phone in hand. She carried it everywhere now like a junkie hanging onto their stash,

"Maureen's just rung me; they've got a court date!"

"When?"

"June"

"Good then, not too long to wait." He smiled and secretly sent up a prayer that they would see true justice finally, four years into the fight. Annette believed justice would be served in the courts. He thought otherwise. They'd bring in Sir James Eadie, the Treasury Devil. For this kind of money there was no way they could allow them to win. He envied Annette's unwavering faith in the courts, a naive hope that tugged at his heartstrings. The law, he knew, could be a fickle mistress, more likely to be wielded as a weapon than a shield. Seeing her face lit up with excitement he didn't want to pop her balloon, let her have this moment of glory, they had all worked so hard to get it to court and by God they deserved a win for their determination alone.

Chapter Twenty-Four

Queen of the Purple Army

Beatrice's recent interview with Christina on the green outside parliament went viral, catapulting her to Facebook fame (amongst the fifties cohort, mind you, the youngsters wouldn't be caught dead clicking "like" on anything not featuring avocado toast). Finally, their story was out there, even if it was mostly reaching women who still thought dial-up internet was cutting edge.

Christina, bless her fiery soul, shone brighter than Big Ben on camera. Her wit matched her intelligence, and while Maurice couldn't help but rib her about her newfound "stardom," he swelled with pride at his wife, the articulate plain-spoken dynamo who could also be a right pain in the backside.

"Bugger off, you silly old fool," she'd laugh in her familiar throaty cackle, sending Maurice into a mischievous grin. Domestic bliss, punctuated by well-aimed insults – the British way.

Today however, their playful banter was replaced by a determined glint in Christina's eyes. They were off to London, joining the "Back to 60" brigade in a show of solidarity. Some women grumbled about the government using the court case as a stalling tactic, a dirty trick to side-step the WASPI

Ombudsman route. Maurice, bless his ever-so-slightly-confused mind, couldn't quite grasp the legal nuances, but he knew one thing: his wife wouldn't stand for nonsense.

"Whatever route gets us there, that's the one we march on," she declared, her voice echoing the steely resolve of a Viking queen leading her purple-clad army. Unity, not squabbles, was the motto. Time for action, not egos.

Maurice, ever the supportive husband (though occasionally bewildered by his wife's crusades), grabbed her rucksack overflowing with purple paraphernalia – rosettes, whistles, the works and stashed it in the car boot as Christina, sporting her latest creation – a purple and white high-visibility waistcoat adorned with a giant rosette – marched out the door, leaving Maurice grinning in her wake.

A neighbour passed by and raised his hand. "Maurice, Christina," he nodded as he took in the battle dress and Maurice hovering behind. They were used to her now. Some laughed behind their nets, some admired, some avoided her in case she dragged them into the latest episode of her fight for justice. There was always a mix to be had. Christina on encountering apathy would always drop into the conversation a pertinent "Feel free not to support us, but I guarantee you're next…"

"What a cracker I married," Maurice chuckled, watching her disappear into the station as he sent

her off with a hug. No matter the odds, Christina wouldn't be kept down. Not by the government, not by anything. And Maurice, bless his bewildered heart, wouldn't have it any other way.

Chapter Twenty-Five

Roger couldn't believe how his wife had put one over on him, suggesting that they have a couple of days in London for their wedding anniversary and hang the expense. They'd had so little down time that he got a little buzz of excitement at the treat, and they set about finding a hotel.

It took three weeks for her to fess up that the outing had a dual purpose. A night in London would be lovely, but the daytime would be given over to supporting the court case. A demo outside parliament the first day, and outside the courts on the second. He had been duped big style, little minx!

He couldn't stay mad for long and had to laugh when she brought out the next part of his anniversary present. A purple t-shirt with the words 'I'M WITH HER' emblazoned across the front.

Together they made a matching set and as they walked onto the green on that auspicious day in June to meet with Deidre's campaign friends, she couldn't help but think how handsome her husband looked in support of all these women. and how proud of him she was that he was one of the few husbands physically stepping up to support their cause with patience and humour.

Roger wasn't stupid, he knew the government hadn't just stuck it to her, but him as well. The whole debacle had ruined both their old ages, which were fast approaching. When he met her, she had been a vivacious and career driven business advisor, long blonde hair, and legs to match. At a time when he was sadly coming out of a long relationship, she was the last thing he had expected to come into his life. He just wanted to find a small flat, a quiet life, and Sunday mornings tinkering with his scooter.

He answered an advert for her flat and as she opened the door and her friendly smile greeted him, he had a worrying niggle that he might be done for. She started as his landlady, and three years later in a sun-soaked garden in Italy, she became his wife.

She had convinced him to set up his own business and with her expertise, she just took the worry away from him, handling everything administratively. He was so proud the day his first van had been wrapped and he had posed for the website pictures.

They had downsized to have enough money for her to take redundancy and hopefully move to a small cottage in France, where he could continue his business on a smaller scale until their pensions

came in. It was their dream, and they worked towards it steadily.

They were just searching in Brittany and had found a beautiful little place, when their first grandchild was born severely disabled, and life changed beyond recognition. They moved to Kent, couldn't afford to buy because of the north south divide, and instead rented a small cottage in Ash, where they had lived ever since. It meant they couldn't retire till Dee was sixty, but they would be ok, they had a substantial amount from downsizing which would see them through. Or at least they thought so...

Then came the death blow. At fifty-nine, just on the home stretch for her, it was all gone. The finish line to respite had been moved when the government had swooped on their retirement like a magpie after a shiny bauble, and with as little remorse. He was now forced to work flat out and bless her, no one would hire a woman her age for the type of job she had always done, so she became the unpaid part of his business, supplementing it with a stand in overnight carers role for her granddaughter, until her spine gave up, forcing her to step back.

She had supported him into his own business years before, and now he would support her. She was his best friend, and he couldn't see anyone else that he would want to grow old with, and right now he was

feeling damn old. Her misfortune had become their misfortune. Savings were dwindling fast as was their health and every day was a toil.

His bright, once vivacious wife was weary and in pain, and yet she still insisted on helping him. He would not tell her just how much everyday hurt, but she knew. He had expected to work till 65, but now they were coming for the men, and it was 67. he couldn't understand why more men were not here standing with him on this green. He'd expected retirement at 65, but the goalposts had shifted like a deckchair in a gale. Now, they were raising the retirement age for blokes too! And let's face it, not many men considered the impact of being married to a WASPI warrior. No wonder he was one of the few males around on this green, apart from a pigeon eyeing a discarded chip.

The women loved him, and he kept getting waylaid by women who wanted him to stand alongside them for a picture. His t shirt was a big hit, and so now Roger ended up being with her, and her... and her. Roger, now their unofficial mascot, was posing for pictures like a bemused celebrity. 'who'd have thought it!' He, a social butterfly at heart, lapped up the attention like a cat with cream.

Meanwhile, Deirdre, God love her, had been swept away by a formidable-looking woman named Manda. Roger was to stay out of trouble - the police loved hauling off hefty blokes and accusing

them of 'mob-handedness'. With a wink and a shove, Deirdre handed him her camera. "If I get nicked, or do anything remotely photogenic, get snapping," she said, and off she went, swept away by a tide of chanting women.

Traffic ground to a halt as the ladies took over the zebra crossing. Roger, ever the dutiful (and slightly terrified) husband, took up his new role as campaign photographer. Click, click, went the camera, capturing the absurdity and passion of the moment. Someone from the crowd shouted, "Right girls, let's do it!" and with that the women that could, plonked themselves down on their backsides, the more infirm stood behind them. As the police closed in, Roger thought, 'Oh my God, this could get messy...

The women were now creating traffic chaos in Parliament Square and loving it. Finally, someone would have to listen to them. The taxi drivers, a happy accident that they were there also, and sympathetic to the plight of the women currently sticking it to the man under the shadow of Big Ben, had lined up ready to start their regular weekly protest. They had been a great help in blocking any likely escape routes, and traffic had come to a standstill.

Police were initially amused and then realised they had more on their hands than they'd originally thought and were moving along the women, requesting that they move or there would be

consequences. They were normally pretty good, having been shafted by the government on their own pensions, they were hardly about to start a wholesale manhandling of a load of grannies. What would they tell their mum if it came out!

Sheila, fearless as always in the face of the plod, as she called them, had rebuffed the first threat of arrest if she didn't move, by reminding them that she was a pension-less pensioner and better off in jail, where she would at least be fed, warm and where they hadn't closed the local libraries, and frankly, that was all she was asking for. He had moved on with a smothered smile to try his next tack. Unfortunately, it was Grace he encountered, who was already bemused by it all, and not at all aware of her impending arrest, had complimented him on his lovely uniform and "Did he get a chance to do any gardening?" The poor lad retreated, convinced he'd stumbled into a Monty Python sketch.

The protest was in full swing. A cacophony of WASPI anthems echoed through the streets, drowning out the coppers' pleas. The ladies, cunning as foxes, had suddenly developed selective hearing, their deafness conveniently flaring up at the mention of moving.

The lead officer was playing a waiting game, he knew these ladies from previous skirmishes, they wanted their moment and would move on

eventually. The ladies knew he knew that and were determined to stretch it out as long as possible.

A double decker and beautifully iconic red London bus had become blocked in, just in front of the women, and Manda grabbed Deidre's hand and yanked her over there to sit in front of it. "What a picture this would be" she shouted to Deidre above the noise. Both in their faceless masks and umbrellas. If this didn't make the news, she would eat her hat.

Deidre looked round for Roger, who instead of following them, had become embroiled in a 'I'M WITH HER' photo fest at the side of the road, and despite her desperate attempts to signal him, he was happily oblivious to the iconic shot he was missing.

"I'll bloody kill him!" she shouted to Manda who lifted her mask, looked over to where Roger was holding court and grinned,

"Leave him be, he's enjoying himself" and with that she replaced her mask, sat back cross legged and hoped someone was getting this.

The police now had reached the limit of time they had allocated for tolerant supervision and were starting to issue serious threats of arrest. Not so easy though to threaten an old lady with a walking frame, and so it wasn't quite moving as quickly as they hoped. Women were complying and then going round the back and sneaking back in.

Suddenly Manda and Deidre, being sat at the front were mistaken for organisers and a friendly young sergeant squatted down between them and the bus.

"Roger!" Deidre flailed her arms desperately trying to get his attention but no, still enclosed by his newfound harem who were getting their money's worth. This could be their last anniversary she thought annoyed at his distraction. The policeman must have thought she had some kind of Tourette's as he tried to open a conversation with the waving woman.

"Right ladies, do we know how long you are intending to hold this sit in? I will have to arrest you if this continues longer." His polite question had an edge of grit. And Dee and Manda looked at each other having no idea, but equally not looking forward to the consequences of non-compliance. Deidre remembered Roger's words as they had boarded the train this morning..." Please don't get arrested...we can't afford the fine!"

Sliding her mask back over her head whilst Manda sat straight, silent, and defiant, Deidre answered with her best attempt at charm, praying Roger was somewhere here getting all this. "I don't think it will be long officer, I think they're intending to march soon." The young copper stood back up and went to talk to someone and then the police all walked into a line at the front of the crowd.

"Times up!" growled Manda sideways through her mask. "Brace yourself and don't let them forget you're a little old lady!"

Her officer was giving it one last try. "Up we get ladies, this is your last chance."

Manda and Deidre glanced around and saw that some of the women were getting up very slowly indeed and making a meal of it, much to the police's annoyance, so it was pointless getting banged up for another couple of minutes.

"Don't you just love these women, look at them giving it their all" she whispered to Manda.

With exaggerated groans and wobbly legs, the ladies began to rise, each movement a slow-motion ballet of elderly defiance. The coppers watched; exasperation etched on their faces.

Deidre, turning to her officer with a twinkle in her eye, declared, "Oh dear, my back seems to have gone! Could you lend an old lady a hand luv?" in her best old lady voice.

Manda's faceless mask gave nothing away, but her shoulders shook with silent laughter...

Chapter Twenty-Six

A Gathering of the Clans

The next day, the crowd gathered outside the Royal Courts of Justice, a place Sylvia had seen many times on the tv when one big trial or another had concluded. The façade was very recognisable.

Today it was adorned with women, sporting the black and white colours of Back to 60. The Waspi purple, green, white, and purple of We Paid in You Pay Out and a myriad of other regional groups' battle colours were flying out front. Women were excited, there was real hope in the air.

Sylvia and Maureen had taken residence at one side of the entrance, and the main players were due to arrive soon. Maureen couldn't help but contemplate the stress on the shoulders of the two brave souls who had taken the long journey as the complainants with such dignity. They and their families must have gone through hell to reach this stage, honouring confidentiality. That took real guts and she prayed that their pain would be rewarded with justice.

A few familiar faces of seasoned campaigners had started to appear, and a couple of reporters were snuffling amongst the women like a pig searching

out truffles, asking for stories. Finally, they might be getting some media interest and there was no shortage of women ready to speak their own heartfelt truth to camera.

Deidre, Roger, and Manda arrived and unfurled the banner that they had created when the news had come through that so far, they had lost over 82.500 women without justice, through a combination of bureaucratic bungling and deliberate policy. The reporter saw it and asked them to hold it aloft. A Dutch sounding woman, sporting a Back to 60 plaque and a large smile offered a spare arm. Before the morning was over, she and Beatrice, who had just wandered up, were swapping life stories like seasoned knitters sharing gossip, already firm friends.

Another outspoken voice. who put so much energy into the campaign, and who was named affectionately by the women for her vintage Panda car as Mandy Panda, was going live through to local radio from the steps of the courts, her voice crackling with righteous fury, belying her diminutive stature, There were so many good women there that day, and Maureen, watching them shout to the passers-by and press, had renewed admiration for the spirit that kept them coming back year after year. Protest after protest.

The morning buzzed with solidarity, with leaders of different groups all standing together outside in support whilst the main protagonists stood against each other inside. Anne, one of the founders of the campaign had made the journey with a broken arm no less – true grit.

There was a momentary crumbling of sisterhood when the public gallery queue saw a scramble worthy of a Black Friday sale as the afternoon session commenced. Manda emerged, face as stormy as a November sky, muttering something about "bloody women" that could have been aimed at anyone or everyone. She was so thunderstruck that no-one dared ask. So few places, and too many women. Everybody wanted to witness true British Justice.

As Deidre stood looking around her at the women here from all kinds of backgrounds, an afro Caribbean woman clearly with a bad hip crossed the road and touched her on the arm.

"Excuse me" she said "Could I just ask you if I'm affected by this? I'm a nurse and I enquired about my pension last year and they said I had to wait another six years. I can't work through the pain in my job for another six years. I don't understand how I couldn't know."

"When were you born?" Deidre asked.

"1958"

"I'm afraid you are the same as me. You need to find a local support group, just search London Waspi or 1950s pensions injustice on Facebook. Something will come up in your area. I'll tell you why you didn't know, because they didn't want you to find out in time to challenge it!"

Deidre gave the woman a potted history and she went on her way limping back to a job she was too weak and old to do without further damage to herself. It was 2019 and they were still just finding out. Deidre had taken a picture with the lady; she wanted proof of how women were still unable to comprehend what had happened to them, even now. They didn't know then there would be worse to come for nurses of a vulnerable age.

The break for lunch had brought the news that six pieces of evidence had been introduced that demonstrated successive government ministers and Whitehall officials had failed over two decades to do anything to avert the impending catastrophe. Those in charge at the time, not only were fully aware there was over 50% ignorance by the women that they were about to lose their pensions so late in the day, and with only three years to go before the first changes came into effect. Knowing that, they chose to do absolutely nothing to warn the affected women, who remained blissfully unaware.

It was a bombshell, but a good one for them and the women came away from the courts that day,

with pockets full of new hope and a handful of new friends. The journey home on the train was one of quiet camaraderie and fatigue. Surely now they would have justice. It had been a long time coming.

Chapter Twenty-Seven

Nurture and Nature

Grace's well-being cast a long shadow, and Maureen and Sheila were determined to illuminate a path out of the financial labyrinth she had unwittingly wandered into. Bless her heart, Grace seemed blissfully unaware of the precarious state of her finances and Maureen and Sheila, with their combined experience of managing on virtually nothing, tackled the most pressing bills, negotiating extensions while simultaneously navigating the bureaucratic maze of financial support options. They also enlisted the help of a social worker, hoping to stem the tide of what appeared to be the early stages of dementia. They were currently trying to get her universal credit, but it felt like wading through mud and without a diagnosis of anything more than slight memory loss, there was nothing else on offer.

The system was being designed to block the elderly and vulnerable from any respite. How anyone on their own managed to negotiate this complicated mire if they were starting to lose their faculties, was a mystery.

The house, thankfully, was paid for. However, the ominous red bills, a constant source of worry for many fifties women, loomed large, their shadows stretching across an empty bank account.

Fortunately, Grace, ever trusting, had granted them access to her financial affairs, allowing them to grasp the full scope of the situation and it wasn't good.

A beacon of hope emerged in the form of a fundraiser launched on the local Facebook group. Donations poured in, a testament to the power of community. Some women, with generous hearts and open wallets, contributed over a hundred pounds of their savings, while others, with less to spare but no less compassion, offered a pound or two, a sacrifice that spoke volumes of their character. They raised £1300 which made a large dent in her outstanding bills and drove the slavering wolf of corporate greed back a few steps from her paint peeled front door. The local group rallied as well, filling Grace's freezer with nourishing meals, ensuring that even in the face of financial hardship, her basic nutritional needs would be met. At least now they were in the height of summer, and she wouldn't be cold.

Grace would potter in her garden whilst her benefactors came and went and was looking less thin. The lack of reasoning power, a fortuitous barrier to her understanding of her situation, was a blessing, but not for Sheila and Maureen who were bearing the brunt of the stress from constant service queues and council departments, combined with Grace's erratic financial record keeping.

"What are we going to do with her Maureen?" Sheila asked, watching Grace digging over a

vegetable bed through the window, whilst putting her cleaning skills to good use in Grace's chaotically arranged kitchen.

"Maureen's head popped back out from the understairs cupboard where she had been searching for a mop and bucket.

"She's no family to tell of, least none that will be bothered by the looks of it, but I bet they're on the doorstep when she pops her clogs."

"Poor bugger, what's awaiting her, she's going to end up sat in some nursing home lounge, ignored, and neglected, whilst the government sells her house off and leaves her with nothing! I hate this country sometimes."

"I know, but we need to do what we can for her, until we can't."

Maureen banged about under the stairs until there came a shout of triumph. "Yes! got one…Oh God it stinks."

She dragged an old plastic mop bucket out and a mop that had seen much better days and held it aloft.

"Phew, that crawling about under there has knocked me out. I've gone dizzy. Put the kettle on Sheila. I don't know about you, but I need a cuppa" and with that she plonked herself down at the table wearily and checked her phone.

"Oh bugger, Manda's been given a warning by the police for harassing her MP."

"What a twat!" responded Sheila.

"What…Manda?"

"No! that waste of space MP…I hope she got her monies worth!" Sheila grinned. "Is she upset?"

"Manda? No… water off a duck's back." She smiled at the thought of Manda giving the MP a few choice words. He wouldn't be forgetting Manda quickly.

The door swung open, and Grace appeared sweaty and happy. Her fine hair sticking out from under the brim of a baseball hat and wearing one welly and a slipper.

"Anyone for tomatoes? I've got loads."

Chapter Twenty-Eight

The Battle Lines are Drawn

Alan, perpetually perched at the dining room window, felt his soul deflate like a rogue balloon at a vicar's picnic. The garden, once his dominion, was now a full-blown sunflower coup. Those damn yellow orbs, like rows of grinning jesters, watched him with their silent judgement. It was all Sylvia's fault, of course. That woman, since January, had blossomed more than the entire greenhouse at Kew Gardens.

Everywhere he looked, the smirking ever cheerful faces of the sunflowers, were mocking him. They were everywhere, like a battalion waiting for the call to arms. Their cheerful stance a symbol of the change in his once compliant wife.

Since that last time in January, he had been very wary of any move he made towards her in an argument. Not that there were many arguments. She had assumed a cheerful disposition most of the time, but somehow it irked him. It was as though nothing he said went in. Beatrice, sporting a smile brighter than a rogue satsuma at Christmas, simply absorbed his barbs. It was maddening. Like trying to stab a cloud with a butter knife. Arguments, usually ending in her defeat, once his preferred marital sport, had become as rare as hen's teeth.

Then came the job at the flower shop, three days a week in a shop front role, suspiciously close to a particularly handsome young florist with a fondness for whistling show tunes, who he had caught her singing with one day when passing to go to the bookies. A role that had forced her to interact with people more, her confidence had grown.

An announcement, delivered with the nonchalance of someone discussing a cat's recent hairball incident, that she'd opened her own bank account. "Just for happy money" she chirped.

Her follow up remark "Your pensions are more than enough to pay the bills." left him speechless, his mouth open and closing like a codfish.

His large private pension, apparently, wasn't enough for their "golden years" he fumed. They needed "fun money." Fun, a word not uttered in their household since the cornflake incident of 77 (long story, involving 3 bowls of cornflakes, a large armchair, and a hungry dog).

She had finished by declaring that her hard-earned money at a time when they should be enjoying their retirement, would go towards making their lives happier, and that was the last she would hear about it from him. Her hard-earned money? She practically skipped out of the door to work, and he was left at home, a cash cow, to feed and clothe her, whilst she did exactly what she wanted.

The only problem was that his life wasn't any happier. She would ask him if he wanted to go to the theatre and when he would scoff. "The theatre, me? Ha!" she would quietly say, "Well that's a shame, but it's your choice" and go anyway, leaving him sat at home with reality tv, guaranteed to dumb down the most intelligent, and four beige walls to stare at.

She even looked different, her hair was styled and dyed! and a couple of new outfits had crept in. Who was she dressing herself up for, not him, that's for sure. That bloody Waspi woman Maureen, was behind this. This was her doing but he couldn't prove it.

Alan sighed, the sunflowers seeming to nod in smug agreement. This wouldn't do. He, Alan Bullerton, wasn't going down without a fight. and would reclaim his wife from the clutches of a sunshine disposition, and suspiciously perky florists. She would have to come to heel.

Chapter Twenty-Nine

Maureen, the retired teacher, and the spirited leader of the local WASPI group, settled into her familiar chair at the kitchen table, her gaze scanning the day's mail and the usual bills The spectre of her state pension shunted back for more than half a decade, half a decade!

Did anyone actually get the devastation caused by trying to survive for that length of time with none of their expected income? Her state pension, once a distant promise, now loomed closer, but with still a way to go, held little comfort. While her teacher's pension, meagre compared to many men's, had just about kept her afloat, the dream of a carefree future had evaporated when tragedy struck.

Ruth, her life partner, and confidante, was no more, succumbing to the cruel grip of cervical cancer. Their shared vision of leisurely Italian adventures – Puglia, Venice, Rome, followed by the sun-kissed shores of Sardinia and Amalfi – had tragically dissolved.

Their retirement funds, drained to fill the gap where their state pension should have provided, and by her inability to work whilst in the fight to save Ruth's life and care for her. Luckily, Ruth had her teachers' pension also, which though it was meagre compared to the pension pots of many men's, had allowed them to scrape through. The added income was certainly needed.

The insurance and death benefits from Ruth's work pension had paid for the funeral and put something back into the near empty pot, but she'd had to live so frugally, and the anger burned deep within her. They'd both worked so hard all their lives, to be left with this. Ruth dying with none of the comforts or

little treats or travels she had so deserved was a bitter pill.

The anger, a dull ember at first, now burned fiercely within Maureen. They had toiled their entire lives, only to be left with an empty nest of dreams and a future painted in shades of "just getting by."

Her thoughts drifted to the countless women she had come to know through WASPI, each with their own tale of hardship and injustice. These were remarkable women, resilient in the face of adversity, yet forced to fight tooth and nail for what was rightfully theirs. The frustration gnawed at Maureen – why did so few stand up for them?

The answer, she realised, was a labyrinth of policy changes and political manoeuvring. Successive governments, it seemed, had mastered the art of screwing over the very people who had built the nation. Stonewalling tactics, fearmongering, and a calculated media blackout and more recently the threats to take away people's rights to protest – these were the tools of the trade, effectively silencing the voices of those who dared to speak out.

The public, too busy struggling to stay afloat, lacked the energy or awareness to rally behind them. Big money compensation claims, Maureen knew, often came with even bigger efforts to smother public awareness and theirs would be one of the biggest.

The "fairness" of the ombudsman system was a bitter joke. This government, she fumed, sold it as an unbiased solution, yet she felt its true purpose was as clear as day: to derail investigations and silence complainants.

The ongoing court case, they argued, currently rendered the ombudsman route null and void during its legal process, effectively gagging thousands of women with legitimate grievances. This, she realised, was a blatant attempt to impede their right to seek justice.

The ones that had managed to get through to the Ombudsman, and the pathetic number of 6 sample cases from 3.8 million women who had been gagged with a threat of the consequences of non-confidentiality, had effectively silenced them from telling the millions of others what was going on, or in their case, not going on, and demonstrated how low government could stoop. Millions of women all with a justifiable complaint, actively prevented from accessing the very information they so badly needed.

She herself had been in the process of going through the complaints procedure and was at stage three when they slapped a moratorium on further cases coming through the DWP to ICE and then onto the Ombudsman, citing the court case. What dirty dealings was that? She was starting to

question if what they had done was legal? How could a government department legally prevent an individual having the right to complain and progress to the Ombudsman?

Maureen, once naive to the government's devious tactics, had become a hardened cynic. The woman staring back from the mirror was no longer the same – she was steeled by indignation, her resolve burning brighter than ever. The fight for justice, for herself and countless others, had just begun. This was not just about a stolen pension; it was about dignity, fairness, and the very fabric of a society that had failed its most deserving citizens.

"Bastards!" she spat out throwing the letter to the table, standing to go over to the mantle where the most treasured pictures of her and Ruth resided. Ruth, her witty, sparkling, take no crap Ruth. Laughing out from the pictures with her love of life.

"What can I do Ruth? Send me something I can do to help these women." Ruth smiled lovingly back at her as if she understood her pain and Maureen picked up the silver frame and brushed her fingertips across the smiling faces from a time that now seemed decades ago.

Placing the picture gently back, she turned to gather up the rest of the mail to take to her desk and file. Her laptop stood open where she had been checking her NI contributions were enough to get her full pension. She now did this regularly as they

kept 'upping' the number of years required with no visible warning, and glancing down at it, she paused.

Somewhere in her a lightbulb had switched on and, turning on the computer, she sat down and began to type. Ruth had sent her a double whammy of an idea. One to help the few she was close to and one to help bring this shameful debacle to the public awareness.

Chapter Thirty

The late summer sun, a fading warmth on her neck, couldn't mask the gathering storm in Maureen's heart. The cosy community café, usually abuzz with chatter, felt heavy with anticipation. Boris, perched on his gilded political throne, had dangled hope with his "fresh eyes" on the 1950s case, a memory conveniently hazy since his ascension. The court judgement loomed, mere weeks away, its outcome a life raft in a sea of uncertainty.

Maureen scanned the familiar faces, noticing the empty chairs where working members waged their own battles. Seeing a hesitant newcomer hesitantly by the door, she raised a hand in welcome. "Are one of us Waspi women, come in, welcome". Maureen's voice held warmth, beckoning her forward. Christina, their ex-nurse, offered a reassuring pat on the vacant chair next to her.

The newcomer, face etched with exhaustion, sank down. It was lucky a few were working today. Perhaps for the best as she was quaking in her boots and looked likely to retreat.

"Well then ladies, shall we start by introducing ourselves to our new member. Christina, you go first," said Maureen.

"Christina, ex nurse and buggered spine, forced to work on till I couldn't any longer. Lucky enough to have a husband with a pension and my nurse's

pension, but we are barely scraping through. I find it very anger provoking that my contribution to society has been both ignored and disrespected. It was a contract that we were sold as young women and I intend to hold this government to account, Its theft, pure and simple." She looked to Maureen to continue.

"I'm Maureen, administrator of this group. Widowed, forced to see my partner die without the comfort of our pensions to make her end of life more comfortable. Damned if I'm letting them get away with it."

Annette was next to speak, and she paused to think first. "I'm Annette, I'm lucky enough to have had a comfortable life but why the hell should I be reliant on my husband for the clothes I stand up in. I have a right to dignity in old age as do all of you. To take our due pensions away from us with no notice in the name of equality and in doing so make us dependent on a man, is at best, indirect discrimination. I also had my private pension delayed because it commences on my SPA date, so a double whammy. I will fight as long as there is breath in my body". She looked to Deidre, who picked up the baton.

"Deidre, I'm the other face of the coin. The loss of my pension has taken away all our retirement expectations. My husband has had to carry on with

a manual job even though he is riddled with arthritis. I help him, but there's only so much I can do as I'm the same, so I do mostly admin. We have a little savings left but so far, we have used three quarters of our retirement savings just plugging the gap. So, it's not just women affected, it's our partners as well. They've shafted us all in some way or another." Maureen raised an eyebrow; Annette wasn't normally given to profanities.

The table had come full circle and now they looked to the woman who was sat clutching the cup of tea with a shaking hand.

"I'm Adele." Everyone responded with smiles to encourage her, and then waited for her to carry on. "I got divorced about fifteen years ago and we sold the house, and I bought a smaller house, but I still needed a mortgage, I was struggling at work as I was being bullied and when they offered me redundancy, I took it, thinking that I could make it through to retirement and just get a part time job to pay the mortgage. Then I found out from Facebook that there would be no pension till I was sixty-six. I couldn't keep up the payments and about a year ago, I lost my house. Then I had nowhere to go, so I put all my clothes and furniture in storage whilst I tried to find somewhere. The storage place had a fire and I lost everything I owned, everything…" her voice faltered, and she looked down at her shaking hands whilst she tried to stem

the tears. The silence around the table was deafening.

Christina, whose big heart empathised, filled up, and she covered the woman's spare hand with her own.

"Oh love, you've been through the wars" she said.

"Where are you living now? We haven't seen you before" questioned Maureen.

Adele blotted her tears away with a tissue Annette handed her.

I lived in Dartford, and I was staying with a friend at first, but she was getting married, and it wasn't fair to them, it was time to go. I've got a cousin in Margate, and she's been letting me sleep on her sofa, but she can only help me short term as it's a small flat."

"Can't the council help you?" asked Maureen.

"I hope so, but nothing's happening so far." She crumbled and it was clear to say that the poor woman was broken. The group were lost for words whilst silent tears poured down her cheeks, despite her best attempts to stem the flow.

"I can help," said Annette, and everyone turned towards her. Adele looked to Annette.

"I didn't come to ask for help, I just hoped there might be some news on compensation, and I saw the leaflet in the window."

"No-ones saying you did my love," said Maureen. "We're in a bit of a hiatus at the moment news wise, hopefully if there is any justice…soon.

Annette sat forward. "Listen Adele, I'll have to check it out, but can I take your number, do you have a phone?"

"Yes, yes I do," and with that she fumbled in her pocket.

"You see, we have an apartment over our garage, it's a mess as we've used it for a dumping ground since the kids were grown, but it's not bad, we could do it up for now, just till you get somewhere."

"We could all help," said Beatrice.

"Great, I'll ring you as soon as I can, my name is Annette in case you've forgotten."

"I don't know what to say, I really don't." Her tears spilled over again.

"I think another brew is in order ladies" said Christina giving Adele time to recover her composure.

Annette thought to herself "What have I done; Arthur will go berserk! But too late now, and here

was her chance to do some real good and by God this woman needed some help, poor thing."

Every woman around that table went home that evening with a heavy heart, but equally thankful they were not in Adele's situation. This damned injustice was doing massive harm. A normally cheerful and feisty Christina went through her front door silent and stormy, and on finding her husband chipping potatoes, promptly burst into angry sobs.

"Oh, love what's the matter?" he put the knife down and went over to her.

"The bastards! the absolute waste of space, blood sucking bastards! I wish we could take six years of their income off them and see how they do!"

Deidre went into the garden finding Roger unloading paints into the garage and threw her arms around his waist hugging him and sending up thanks that at least they were fighting this together. Roger hugged her back; she would tell him when she was capable of speech.

Maureen opened the door to her cottage, its silence booming as she made her way into the cosy kitchen. She went through the motions of making herself a sandwich, but there was only one place she was going, she walked through to her desk and took out the laptop, releasing her negative energy in frantic typing.

As for Annette, she was right, Arthur went berserk. More because she had virtually handed him a fait accompli. It was the first real row they'd had in ages, and it made an uncomfortable atmosphere for the next forty-eight hours. Arthur was right, she hardly knew this woman.

Annette looked at her own life, shared with Arthur, overflowing with love and comfort. Shame coiled in her gut as she saw the stranger's stark reality: a meagre pile of clothes, the wreckage of a life swept away by the government's callous actions and its knock-on consequences. This woman, through no transgression of her own, stood stripped bare – no photographs to whisper memories, no familiar objects to soothe a fractured mind, no horizon of hope painted before her. Just an unending emptiness…a nothing.

She hardly knew this woman, but something in her eyes registered with Annette, who had been doing research on related 1950's women suicides and it worried her. If she could just offer this woman a stop gap until she recovered enough to move forward.

It took time and a lot of discussion, but she made a good argument to give the woman temporary respite until she could find somewhere. They had so much, surely, that they could give an unused space to a woman that, but for the grace of God, could

have been her. Arthur capitulated. His wife, when motivated with nervous energy, was unstoppable, and so the call was made to Adele and all the women were engaged to seek out donations to furnish her with the basics.

Two weeks later, the small bedsit, complete with a shower room above the garage was ready, smelling of fresh paint, courtesy of Deidre and Roger. Sheets and Towels and cushions were all hap hazard, but still a happy jostle of colours and the women stood around admiring their handywork. It was decided to not all be there when Adele moved in, but to arrange an afternoon welcome party when she was settled.

Adele arrived a couple of days later, quietly overwhelmed as Annette opened the side door of the garage and led her up the stairs. The lamps were on and the fire. There was a small tv and a little two bar oven they'd had donated. Someone had given an old fridge freezer that was in a decent state. Everyone had rallied.

Adele had few clothes to put in the small wardrobe, but it was enough. They hadn't wanted to fill the wardrobe just in case it was a step too far. This woman's pride must have been hanging by a thread and they must be careful not to overdo the good Samaritan role.

"I don't know what to say Annette, I don't know how to ever repay you..." said Adele, the tears rolling down her cheeks.

"I'll tell you what you can do" said Annette with an emotional smile, "You can get yourself comfy and you can get yourself better, that's all I ask, you're amongst friends now." She gave Adele an affectionate hug and left her to make herself at home.

After Annette had left, she took her small bag of shopping and opened the door of the fridge, it was already filled and Adele cried again, tears of relief, tears of despair, and tears of anger that she, a decent woman had been brought to this and for what? So, they could waste more money on MP's expenses? Buy Boris a big choo choo set? Whilst all around them women were dying, and they did nothing to put it right. They had no conscience, no morals. Adele knew how it felt to consider the unthinkable and end her life. She had been given this small reprieve and had stepped back from the brink, but the pull was strong still. The gods had finally smiled on her that day when she'd noticed the poster in the café window as she wandered round the town to give her cousin a break from her constant depression.

Where would she go from here? Nothing was certain, just another stopgap in a life that had

become almost unbearable. She noticed the hot water bottle on the bed, Annette had thought of everything. She filled the kettle and turned back the covers from the small single bed. Tonight, she would just sleep, in a warm bed, just sleep.

Annette let herself quietly in the back door as the autumn sun fell below the horizon. She hoped Adele would be ok on her first night alone. Arthur looked up from his book.

"She okay?" He was still unhappy but resigned.

"I hope so...I do thank you Arthur."

"You just don't know this woman; I hope you know what you are doing" he replied an eyebrow raised.

Annette looked around her large comfortable home with its Oast House roof and thought, "I know I do because it was the right thing."

That night Annette slept soundly for the first time in a long while. The Marie Celeste had docked briefly, and all was still.

Chapter Thirty-One

A Holding of Breath

On a crisp October day, the Margate contingent - Beatrice, Maureen, and Manda - embarked on another pilgrimage to the imposing Royal Courts of Justice in London. Their mission: to witness the verdict in their long-fought battle against a government that had demonstrably failed fifty percent of its older women.

Across the nation, women sat glued to their Facebook feeds, knowing that the courts' hallowed halls would be the first to echo with news, followed shortly by the women outside who would relay it. The air crackled with anticipation, buoyed by the knowledge of the damning evidence presented, the government's wilful ignorance laid bare. Yet, nerves thrummed beneath the surface.

Then, a flurry of activity - the press arrived. Perhaps they sensed the tremors of a potential political earthquake. Among them was Simon, a newsman known for his quiet demeanour and genuine empathy. He had previously journeyed to Margate to interview Manda, and his support shone through as he recognised the trio and offered a heartfelt "good luck" before disappearing into the courtroom. Unusual for someone from the beeb.

The day promised not just a verdict, but a potential tipping point, a moment where justice, long denied, might finally rise like the tide, washing away apathy and neglect.

Then came Michael Mansfield and his team, but he headed straight in with a gentle wave and smile to the ladies waiting outside. There was a rumour that they knew the Judgement before it was read, but no one knew for sure. Did he look subdued? Maybe even important barristers got nerves.

The London and Essex Waspi members were there, ever reliable, and they were chatting quietly. No one had the voice to chant, today was a make or break for many women's hopes. Meg, Beatrice's new friend and Sixty member, who she had stayed in touch with, was also there, and they waited, too tense to laugh and chat for once.

The crowd was the most silent Beatrice had ever seen them.

Suddenly there was a commotion, people that had got into the public gallery were flooding out and it was hard to see what was going on. The wave filtered through the crowd, and it was shocking to see, women were crying out in anguish, some just started to cry. Some chanted "Shame on you!" All they knew was that they had lost. How could they, the evidence was overwhelming surely?

Beatrice spotted the reporter Simon coming out of the court and she and Manda went to him.

"What's happened Simon?"

Simon looked slightly phased. Perhaps even he had expected another result. "The court had sympathy for the plight of the women, but they had to make a ruling in law, apparently under primary and secondary legislation in this country, you have no right to fairness and no right to be informed of changes to policy." He shrugged his shoulders at a loss, with a cynical smile that told them his true feelings. "They found there was no direct discrimination on grounds of sex or age. They were saddened by the women's stories, but their role is limited".

"...But that's ridiculous, we've been discriminated against all our lives, how could they introduce something that has devastated our lives and not call it discrimination, what man has had six years added to their state pension age, let alone at such short notice?" Manda was incandescent.

"Because they used the equality act to level up the pension age and according to the terms of that act, they are saying there is no case to answer. The law and Justice are two very different things, I'm so sorry ladies. I'd hoped for better for you." He waved a hand and made his excuses as he had to get back to write it up.

What was there to do, women stood in shock, some were going over to Parliament to protest, others were just crying, it was awful. Maureen felt her heart sink. How many women had been hanging on by a thread waiting for what they hoped would be justice here today. What would be the consequences for the women like Adele who had been beaten down to breaking point? They would have to keep a close eye on her. She would ring Deidre to go round asap today, to make sure she was ok.

Beatrice led them across the famous Zebra crossing in front of the courts to a small coffee shop and they stood silently in the queue. A young woman in her thirties joined them.

"Have you ladies just come from the courts?" she said.

"Yes, unfortunately!" replied Beatrice.

"I'm a solicitor and I just wanted to tell you, it's a travesty. I'm so sorry, you deserve better...I'd like to pay for your coffee's ladies, my mother's a 1950's woman."

Beatrice started to say no, but she wouldn't hear of it. They thanked her and grabbed a seat by the windows. Across the road at the courts, the women

had left, and the courts business carried on as though they had never been.

"We're truly invisible," said Beatrice despondently.

Manda and Maureen nodded and sipped their coffees in silence. This had been a dirty day's work for the government.
Why would they have expected anything different? They hadn't named him the treasury Devil for no reason.
The verdict hung heavy in the air for days, fracturing the women into two distinct paths: some crumbled into despair, while others, like the Margate contingent, ignited with righteous fury. Beatrice and Annette took to the digital battlefield, wielding social media as their weapon. Sheila, however, craved a more tangible response. "We need a protest, we need to up the ante" she declared, her voice ringing with steely resolve, "something that will shake them to their core."

Debate swirled, oscillating between the hope of an appeal and the relief of a clear path to the Ombudsman. Action, however, was the unifying thread, and it was the Welsh women who seized the initiative. November 5th, they declared, a date etched in history, a potent reminder of defiance. "Remember, Remember the fifth of November," the rallying cry echoed, igniting a spark of solidarity across the nation.

Many Group leaders, bound by a shared mission, joined forces. This day would be a poignant tribute to the fallen sisters, a collective remembrance woven with threads of purple, green, and white. Beatrice, Annette, and Manda, their fingers flying across keyboards, spread the word through the vast network of Facebook groups. The numbers swelled, the momentum building, and the air crackled with anticipation. An anonymous benefactor, touched by their cause, sent a gift of cash to buy reels of ribbon, green, purple, and white in loving memory, each colour imbued with meaning. On the white, names of the lost were inscribed, a poignant memorial etched in silk. Beatrice was spending hours writing the names on many ribbons and it moved her to tears. It was a moment of profound unity, a coming together to share testament to the enduring spirit of their fight, and the ones who had been lost along the way.

Chapter Thirty-Two

Keep On keeping On

Maureen looked out of the window as she typed, another rainy October day. Christmas would be fast approaching, and it would open its gaping mouth to swallow her in despair. But first they were readying themselves for the Remember protest. Sheila, Manda, Beatrice, and Sylvia were going and hopefully a few others. Annette was working on Adele but if she couldn't tempt her, she would stay at home as she seemed very fragile. Once that protest was done, they would be on the unavoidable run up to the 'Festive Season,' just not so festive in her case.

The most she'd do was visit a couple of friends in London and the Christmas service at the local church. Whilst couples and families linked arms on the way home through the village, for her it always meant a solitary walk home to an empty house. Her only respite from the loneliness was her Waspi group, and to them she was the strong leader, if they only knew how she felt behind her closed door when the sun went down, and she was alone.

When she was with that assortment of diverse characters, all with the same goal, she felt part of something. Roll on spring when the nights would be getting lighter, and she could at least escape into the garden of her little house once more.

She thought of poor Adele in the small bedsit above Annette's garage and chastised herself for being so maudlin. She should arrange something for everyone, the women, and their partners, so that those who had few people around them, had a sense of community. Yes, that's what she would do.

She rang Sylvia and put her suggestions to her, and Sylvia thought it was a great idea… "As long as she didn't have to bring Alan" she said, "he would just get up everybody's noses, including hers."

Sylvia had done so well not rising to the bait in recent months and she felt so much calmer. The tendency to shoplifting, with her new independence, had also gone and she felt so much better without the unhealthy adrenaline rush it brought. Now if she wanted something within reason, she bought it. Still frugal, but no longer under Alan's direct control.

"A local pub then? and those that can afford it could put into a drinks kitty for those that can't, what do you think?" Maureen suggested.

"Good idea, I don't mind chipping a few quid in, now I'm working."

"How's that going?" she asked Sylvia.

"Work? Oh wonderful! Jamie is such a lovely young man, well not young really, but compared to me, a baby. I get tired standing but he's so kind. If you're asking me how Alan took it, then it went down like

a lead balloon, first he tells me to get a job, then he doesn't like me having my own money...I nearly peed the first time I stood up to him, but he blustered and took it" she laughed, a natural sound that was a far cry from the timid, distracted woman that Maureen had first met.

"I never did thank you for the sunflower idea, it really worked. Every time I think of Alan staring out at those sunflowers complaining, I smile, they were everywhere. He went a bit crazy you know, I found him in the garden pulling them up swearing at them in September. I didn't have the heart to tell him that I would have pulled them up anyway that weekend...but I got lots of seeds off them for next year!" Her laughter rippled down the phone and Maureen smiled. The worm had turned, and it felt good that she had instigated a change for the better in Sylvia's life, however small a thing that it had seemed at the time.

"They were only to cheer you up and give you something to focus on, but I'm glad it worked. Do you fancy another night at the theatre? It might be booked up being near Christmas, but we could try for a panto, something that would make us laugh. We'd have to get the cheap seats though!" Maureen liked Sylvia, she was a gentle soul, but infinitely creative and funny and time in her company was never wasted.

"What a great idea, do you mind if I ask Jamie, he'd love it I think, and he's been so good to me."

"Feel free, I'll check it out and get back to you."

"Lovely, see you soon." Sylvia put down the phone and looked around the stockroom of the florist shop where she was working. Here she got to make the bouquets and she loved it. She fussed over her creations, their silky petals a whisper pink against her calloused hands. Here, amongst the fragrant chaos, she found solace. Alan, bless his begrudging heart, couldn't stand the sight of her happiness, but happy she blooming well was.

Jamie, the shop owner, was a walking anachronism. Imagine Noel Coward reincarnated with a penchant for floral arrangements. He was far too polite, a tad too fond of cravats, but in a way that somehow remained stylish. Unfortunately, this didn't translate well on the Margate gay scene, where ripped bods and neon hair reigned supreme. Jamie yearned for a chap with a bit of "ordinary", someone to share a pot of tea and a lifetime with. "No luck," he'd lament, those lads only had eyes for the latest disco flavour.

So, there they were an odd couple amidst the blooms. She, finding peace in petals, a temporary oblivion to Alan's silent sulks. He, yearning for love while arranging lilies with the precision of a lovesick sonnet. They were like a sitcom waiting to happen, a poignant play waiting for its curtain call. And, just perhaps, beneath the prickly exterior of their lives, a bud of something unexpected might blossom. After all, in Margate, even the most

unlikely pairings could find their own peculiar happily ever after. "Just remember darling," Jamie would say. "Life's a garden, and sometimes the best blooms come from the most unexpected seeds."

Jamie had carried his mother through the ravages of motor neuron disease, nearly sacrificing his financial stability in the process. When she finally passed, a vow solidified within him: never again would he be tethered to the whims of financial hardship. With unwavering determination, he built his business from the ground up, brick by brick, until it stood as a testament to his grit and love for life. That effervescence, Sylvia found, radiated from him like sunshine, a stark contrast to the monotony that once defined her days. Working three days a week, though it creaked at her ageing bones, was a privilege she wouldn't trade for anything, for in his vibrant company, she found a joy she never thought possible.

Maureen placed the receiver and gave up on the call to the docs and stretched in her chair. Her damn back was groaning again, she really should see a physio, but it would grumble for a few days, then settle, so she felt a fraud. The way the doctor's appointment systems operated these days, she'd finally get there and be feeling fine and look like one of those twittering old ladies wasting the docs time for a twinge. She could see the ageist propaganda from govt. "Waspi women burdening

the NHS system with imagined illness" … Yep, she could see that being used against them.

Sylvia's steps faltered as she approached the house that evening, the solitary light in the lounge casting an ominous glow. The bravado she'd carefully cultivated throughout the day and pinned on for Maureen's sake, crumbled, replaced by a cold dread that settled in her stomach. Lately, her confident smile felt like a shield against his increasingly surly demeanour, a fragile barrier that took more and more effort to maintain. His anger, once explosive and loud, had morphed into something more insidious - a quiet, simmering rage that permeated the very air.

Inside, she placed the flowers Jamie had given her on the kitchen table, the vibrant blooms mocking the oppressive atmosphere. Unwrapping the delicate stems, she felt a jolt of fear at the creak of the floorboards behind her. He materialised in the doorway, his face etched with a simmering resentment.

"Where the hell have you been?" His voice was a low growl, laced with suspicion and barely veiled hostility.

Sylvia plastered on a smile, her voice as bright and chirpy as she could muster. "Sorry, it was a busy day at the shop. We had a lot of last-minute

arrangements for the funeral tomorrow, so I had to stay late. Jamie's paying me overtime, you know."

He scoffed; the sound laced with sarcasm. "Six o'clock in the evening, Sylvia? You were supposed to finish at four. I'm bloody starving! Couldn't you have at least called?" His breath reeked of something strong, his eyes glinting dangerously. Obviously, Alan had partaken of a couple of aperitifs whilst waiting to be fed she thought resentfully.

The anger simmered beneath the surface, a potent threat she couldn't ignore. But the recent rebellion against years of conditioning had instilled a defiance in her. "You could have made something yourself you know," she countered, her voice surprisingly firm. "There's food in the fridge."

Before she could react, his hand lashed out with unexpected speed. The world tilted on its axis as a searing pain exploded on her cheek. The vase she held clattered to the floor, water spraying outwards like a silent scream. The impact of the slap sent her reeling, the taste of copper flooding her mouth.

He was shouting now, a torrent of insults and accusations spewing from his lips. Sylvia, her vision blurring with tears and pain, backed away instinctively. The vase, still spinning on the floor, caught his eye. He snatched it up, his face contorted in rage, and hurled it at her.

Raising her arm in a desperate attempt to shield herself, the vase hit, pain lancing through her jaw, a searing reminder of the abuse she endured over the years. But the numbness that followed was worse, a chilling confirmation of the danger she was in.

Standing there, hand pressed against her throbbing cheek, she knew she couldn't stay. Fear propelled her forward as she fled the kitchen. Grabbing her coat and bag as his enraged voice echoed behind her, but she didn't stop, not until the house was a distant silhouette against the darkening sky.

Sylvia ran on quaking legs until her lungs burned, until the cold night air stole her breath. But even then, she couldn't stop. She had to escape, to find somewhere safe, somewhere he couldn't reach her. The abuse, the fear, the pain - they were all too familiar, yet tonight, something had shifted within her. The silence of the night held a different sound now - the whisper of a voice, urging her to break free, to find her strength. For the first time, she was listening.

Eventually, she was too tired to keep walking and found an all-night café and sat down. The man behind the bar looked closely at her, as she became aware that she had a swelling on the side of her lip and a likely bruise coming up on her cheek. Her hand raised to hide it instinctively.

"You ok love, you look like you've been in the wars?" he asked.

Nodding with eyes downcast in embarrassment, she asked for a latte, fearing to talk more. She had begun to shake as she sipped the coffee and fumbling in her bag, she found her phone.

Twenty minutes later a little fiat pulled up and Sylvia went to pay the man.

"On the house love" he said kindly. She thanked him and walked out to the car as the door swung open.

"I didn't know what else to do..." she sobbed.

Maureen beckoned her into the front seat. "You did the right thing; you can come home with me tonight and we'll sort this out tomorrow."

Once home, Maureen settled Sylvia in the armchair, stoked the wood burner, and after checking she was ok and taking a photo of her face, left her with a hot sweet tea. She went upstairs to make up a bed in the box room and took the chance to ring the police out of earshot, to check how this could be handled. This way Sylvia would be without further stress till the morning. For now, she had to ensure she was not concussed, which meant keeping her out of bed for a couple of hours.

Sylvia was still shaking and tearful, but she managed to recount the story and wasn't showing signs of a deeper injury. Slowly in the warmth of the room and the freedom to vent to Maureen, who sat quietly, she started to unfurl the years of

control and abuse that had gone on, and Maureen let her get it all out.

It never ceased to amaze her how people allowed another to slowly build up a regime of abuse, without it seeming anything other than the norm to the victim. She had heard once those women suffered physical abuse on average 39 times before they did anything about it. How much had Sylvia endured? It also never ceased to amaze her how people could profess to love someone and yet subject them to such cruelty.

Sylvia's story resonated deeply, a tremor that echoed beyond the confines of her experience. Her current escape, though hard-won, ignited a concern in Maureen for the countless others who remained trapped. The spectre of lost pensions loomed large, a cruel theft at a time when strength waned and the fight for freedom from an abusive relationship demanded every ounce of remaining resilience and the financial independence to leave.

What worried Maureen most was that this state pension injustice, cloaked in the cheap garb of pseudo equality, had birthed a devastating consequence. It had consigned countless women to the whims of abusers, transforming them into prisoners within their own homes. The narrative of domestic violence transcended even the boundaries of gender, a harsh reality that could no longer be ignored. For within the tapestry of the LGBTQ+ community too, lurked the insidious presence of

those who sought to control and dominate. Sylvia's journey gave Maureen a stark reminder that the fight for dignity encompassed the collective struggle of all who yearned to break free from domestic oppression. Sylvia's pain just happened to be at the hands of a man, and compounded by a government dominated by men, who had deemed a decade of women unworthy of true consideration and impact assessment.

Instead, they had viewed the 1950's women as a means to an end in the scrabble for fiscal glory. We now had parties, more concerned with being seen to be saying the right thing, paying honest hard working people lip service, just until the votes were in and they could shaft them once more.

When she felt it was safe to allow Sylvia to sleep, Maureen gave her some pyjamas and a spare dressing gown and settled her into bed with a couple of pain killers. Sylvia looked worried.

"Shouldn't we tell him where I am?" she asked.

"Let him stew and think about what he's done." said Maureen grimly. Even now the arm of psychological control was reaching out to influence her to check in with him. Maureen sat on the end of the bed. "Right now, you get some sleep. Things will get better, this is the low point, it's on and up from here on in, just remember that."

Sylvia welled up again. The woman needed a good sob but had gotten so used to hiding her true

feelings, it was hard to let go. Maureen gently placed her hand over Sylvia's. "If you can't sleep, help yourself to anything in the kitchen."

"You're a good friend Maureen, thank you."

"Welcome." Maureen closed the door on her friend and sighed, so much pain amongst these women.

Chapter Thirty-Three

Maureen got Sylvia up and fed and out before she could get herself worked up, and they set off to go down to the police station. She hadn't wanted to force action on Sylvia, but neither did she want to let her go home unprotected.

Sylvia's journey, marred by the ugliness of domestic abuse, took a poignant turn on the way to the police station via the florist shop, to let Jamie know why she would not be in. A call ahead had given him notice and so he was ready to receive them forewarned. However, the sight of her swollen face caused Jamie's lips to tighten in an angry line. "Oh darling girl" he murmured, his voice thick with emotion, "You can't put up with this." The dam threatened to burst within Sylvia, and Jamie's embrace offered a much-needed refuge.

"I'm going back Jamie," she choked out, tears welling up anew, "but I'm so scared. I don't want to stay with him." Witnessing her despair, Jamie and Maureen exchanged a look heavy with concern.

"You don't have to Sylvia," Maureen interjected gently. "It's your home as much as his, but he can't force you to stay. We can gather some clothes, and then you can stay with me for a few days while we figure things out." The thought of exposing her to further violence was unbearable.

"There's also the space above the shop," Jamie interjected, offering another option. "It has a

bath+room and a couple of storage rooms. If you're willing to help clean the bigger one up, you could use it as a temporary living space for a few weeks. It won't be luxurious, but it might suffice until you decide your next step. Remember, darling, you have rights".

"If I have, it will be a first" Sylvia said dejectedly. Her self-esteem in tatters.

Overwhelmed by the sudden turn of events, she fell silent. Maureen, sensing her trepidation, did not want to pressure her. However, Sylvia's insistence on reporting the abuse offered a glimmer of hope, a crucial first step in breaking free from the cycle.

"It's worth considering love," Maureen soothed, "but let's not make any hasty decisions today. We'll do whatever you feel comfortable with. First things first, let's get this documented with the police and see what they advise. You can decide your next move after that, alright?" Sylvia, wiping away fresh tears, reached for another tissue, readily provided by Jamie from beneath the counter.

The police informed her of her rights and accompanied her as she gathered her belongings. Fear gnawed at her, and so she took the legal essentials and cherished trinkets that she feared would be destroyed in her absence also.

Maureen, a silent pillar of support, mirrored Sylvia's every pang of anxiety. In the living room, the police, a woman among them, delivered a stern warning to

Alan. His initial feigned worry on their arrival mob handed, quickly dissolved into belligerent silence, the undeniable marks on Sylvia's face a stark testament to his actions.

A week later, Sylvia, emboldened by Maureen and Sheila (ready to intervene if needed), returned armed with a non-molestation order and two men and a van. Facing a bewildered Alan, she reclaimed her remaining belongings and some essential furniture, furnishing her new haven at Jamie's while charting the course of her future. Though the path ahead might be challenging, the unwavering support of her friends offered a beacon of hope, a testament to the strength found in solidarity. She may not have had her pension, but she had the wealth of good friends.

Chapter Thirty-Four

REMEMBER REMEMBER…

London had decided to be kind to the 1950s women on the fifth and the mid-morning sun was shining brightly as the women descended on London from all over the country. The event had been created by a vivacious Welsh lady and taken up by the Welsh group to spread the word.

It always amazed Beatrice how the word filtered out. Without Facebook the government would have seen this campaign off long since. The network of groups on there and message groups in each area were like tributaries flowing into a large river, and here they were yet again, on the green. One sea of purple, green, black, and white, turquoise, pink. It was like a pastel-coloured elderly pride day. Everyone was happy to see each other but with a sense of occasion that really hit home when the memorial ribbons started to be distributed with the names of all the lost ladies, who had died campaigning for their stolen rights.

The women were told to quietly take the ribbons and put them in their pockets, there was a plan, and the plan was whispered ear to ear in case there were spies in the crowd.

The politicians were out in force and were queuing up to take turns to speak. The women had also brought the stark white masks signifying invisibility.

Maureen looked around, laughed out loud a couple of times at the inventiveness of some of these women, two things particularly stood out. The woman with the rucksack looking like she was carrying Ian Duncan Smith like a baby with the words 'Still not going away' pinned to his front. The other had been revealed to them by Sheila on the train, when she had told them her mate Gina was bringing a 'penny for the Guy' on the tube, complete with pushchair in the form of Guy Opperman, and was threatening to set fire to it on the green. Hardly bombing letter boxes, but the suffragette spirit was there. She posted a picture of Guy sat on the tube on his way into Parliament, which caused some hilarity.

Despite the excitement at old friends coming together, they had a purpose. They had lost over 82.500 women so far. They would honour these women the only way they could by lining the railings the full length of parliament in a minute's silence, many in the white masks that stared blankly out at the passers-by as they stood in silent accusation. It was a moment to behold.

When the minute's silence was over a shout went up "Right Ladies, honour your sisters" and all the women turned around and tied the ribbons and even crocheted bunting, to the immaculately

painted railing of that house of disrepute. They fluttered in the breeze as they covered the whole length from below Big Ben right around the front and to the end of the building, several deep.

"They won't forget this," someone said. "That would depend on them having a conscience," replied someone cynically.

Afterwards, they marched silently round Parliament Square and laid wreaths at the foot of the Suffragette Statue of Millicent Fawcett. "Courage Calls to Courage Everywhere" it said, and reading it she wished it called to younger women, who didn't seem to realise this fight against systematic misogyny would one day be theirs.

The time to leave was fast approaching, and suddenly there was a shout "Oh my Lord, they've set fire to it!" Sure enough, insurrection on Bonfire night and Sheila and Gina had done it. Guy was going up in smoke. The ladies all hooted, it was hardly a scorching bonfire, but it brought a few smiles even to the police's faces, who let it burn and then brought the tiniest of fire extinguishers onto the grass, not even trying to smother a grin as they put it out, all which brought further hoots of laughter and applause. The reporters were on it, but guess what? It never made the news, funny that. Neither did the sight of women running the entire length of parliament, with their broken hearts' posters, their memorial ribbons, their

suffragette bunting, their flowers of remembrance, and their spirit.

Beatrice was now recognising the same faces each time they met. Lena who had got married in her Waspi sash, Cheryl a terrific Geordie lass and animal lover like Beatrice and Rina, a pretty lady with a mischievous smile and a mass of white curls, Endora a savvy woman with a soft Scottish accent and a large hat and equal passion. Nan, who did belly dancing, the list was endless. Women that she was starting to admire greatly.

Not to mention the women at home, too ill to make a physical appearance, but they were every day, researching, posting and letter writing to bring awareness into the public domain.

It was so hard to keep up, because the crowds were all so big and the activity frantic, they passed each other, hugged, and moved on to meet the next familiar face. Just a few in a wonderful army of women who refused to be kept down. Glenda from Manchester and Fay from Wales. Another Welsh dragon, Gill, born in the sixties was also fighting their battle with absolute passion, with no expectation of anything for herself, fighting illness, she was one of the most active in the campaign, just to see justice done. Amazing!

Women with strength and passion that she was in awe of. They said their goodbyes and parted company, all heading for different stations and

coaches to make the long journey home, some even to different countries outside the UK.

Sheila texted everyone later to say she and Gina had returned three hours later and all the ribbons had all been cut down. They hadn't even the decency to let the sun set on them. Just as they hadn't let the sun set softly on so many lives, taken early without justice, Shame on them...

Chapter Thirty-Five

Togetherness

Christmas was almost upon them and tonight several of the group were taking the chance to catch up and have a good old Christmas knees up. Deidre and Christina had brought their husbands. Annette had tried to convince Arthur, but he politely resisted and so her date for the night was Adele, who was looking pale but better than they had previously seen her. She sat quietly and smiled but was too shy to contribute. Christina, bless her, gave her a huge hug and kiss when she saw her, whether she needed it or not such was her warmth and personality and thus Adele became a member of the campaign family. Maurice and Roger introduced themselves and despite being strangers till now, Hit it off immediately.

Sylvia, looking so much happier, her bruises gone, and dressed in her new boho dress had brought Jamie along, who was currently holding court and the cause of much laughter.

Manda had brought Bindi who was under the table, shamelessly begging crisps off Roger, and Roger had fallen in love with him on site as he resembled an old dog of theirs. The mood was high, despite

all they had endured, and the kitty was getting a bashing.

Sheila was regaling them all with an idea she had had with her partner in crime from London, not content with bringing their own guy to burn outside parliament, they were now plotting a gorilla sit in at the DWP head office at Caxton House to welcome the new pensions minister, who was not a popular choice. Was there no end to these women's talents? Unsurprisingly, they had named themselves 'The Revolting Women'.

Maureen had brought Grace along who was laughing happily if a little distractedly. Maureen, having been keeping an eye on her could now easily recognise the signs of her oncoming dementia. It was a look in the eye, the same constant questions she had them answer repeatedly. The doctor they had persuaded her to see had confirmed it but said at present it was mild. In these cases, the patient tended to plateau, then fall suddenly, so Maureen and Sheila made sure they kept a good eye over their friend.

Maureen, Jamie, and Sylvia had made the panto, although the seats had given Maureen jip with her bad back. She had given into pressure from Sylvia and made an appointment at the docs although, she doubted it would do much good, she was at an

age were bones creaked and she was so much luckier than some.

This Christmas day, she was looking forward to for the first time since she had lost Ruth. Since leaving her husband Sylvia and Maureen had become close friends. Jamie came along with the package as an added bonus, and both were coming over Christmas day for Lunch. Maureen was quite excited and had made a special effort to make the house festive as she wanted Sylvia to feel happy on the first Christmas away from her home.

They were still awaiting a solicitor's appointment to advise Sylvia on her rights in respect of her marital home, but between the little bedsit and the odd night stay over at Maureen's for a movie and meal, she was managing well. Jamie, bless him, had refused rent saying it was great to have a loyal employee on the premises for security and she was doing him a favour. Maureen felt for the first time that she had a purpose other than fighting for her pension.

Jokes were flying from the men and there was much laughter, when suddenly Manda started tapping on the table for order. Everyone turned their attention to her. Manda didn't say a lot, but when she did it was usually pertinent.

"I have an announcement to make…As of today I am unemployed, this is my first day of freedom"

she said. Mouths gaped, she was a strong woman and it looked like she had made a strong decision.

"How will you manage?" asked Annette.

"Well, the flats paid for, and I have my retirement savings, so I'll just about scrape through to sixty-six, but at this rate, working as a paramedic with a pacemaker I won't make it the last two years if I don't, so I've decided to jack it in, live frugally till I get my pension and go off in my camper. Life's too precious for this shit, I'm living it now, these bastards aren't getting another day out of me. From now on me and Bindi will be seeking life."

"But what about the campaign? You're one of our strongest?" Annette replied.

"Still here, still campaigning but it's been making me ill. I'm angry all the time, and to be honest when I saw that bunfight for the viewing gallery at the courts last June and how sisterhood went out the window. I lost heart a bit. So, I'm still fighting but I won't let it eat me up every day like it's been doing. We've all so few years of health left. I'm seizing the day whilst I can, and besides, I'm too old to be picking drunks off the streets and dealing with mental health patients, when we should be looking after emergencies. All because they've starved the NHS to breaking point. I need some sunshine and I intend to get me some!" Little did Manda know till

later that she had just taken a decision that would likely save her life.

The party started to come to a close and it was turning out time in the pub. Everyone was hugging and wishing each other the very best of Christmas's, and one by one they parted company and made their way home. Life wasn't too bad despite everything, thought Maureen, as Sylvia slipped an arm through her and Jamie's, they laughed and joked all the way back to their respective cars. The Christmas lights on the yachts twinkling merrily on the Ramsgate marina as they passed, added to the party atmosphere, and they stood for a moment to admire the efforts. People were milling along the harbour raising a hand in greeting as they passed. Everyone was mellow. It was Christmas in a couple of days.

Chapter Thirty-Six

A Storm is Brewing

New Year 2020.

Deidre, Roger, and their dog Ramsey had made their annual pilgrimage to Wales to see a friend every year for new year as she was alone. This year was no exception, and whilst the drunks staggered out of pubs in the city, they were sat on the beach at Pen, on a quite moonlit New Years Eve. They had a lovely few days' culminating with the vigil on the beach. The moon was so bright on the waves as they rolled into shore, and the three of them sat there on that cold clear night and waited for midnight to chime and a new year to begin. Maybe this year they would have justice, mused Deidre with a sigh. The campaign had finally started to build and was receiving attention. Even so, sat on this beach, silent but for the breaking waves, was a perfect way to appreciate the world and the promise of a new year. They wandered home to Karens around two am, with Ramsey trotting behind, stopping for the odd scratch. A Westie couldn't go ten yards without stopping for a pee or a sniff or in fact anything that would try their owner's patience.

Turns out Karen had a "guest" dog recently – a flea-ridden fiend! Those little blighters jumped ship faster than a first-mate in a storm, setting Ramsey off like a dog at a butcher's convention. Fifty quid later, they had enough flea spray to fumigate a badger's den, and Karen was apparently fumigating her house before they had reached the end of the street and was mortified! she had told them this in a frantic phone call as they headed along the Welsh coast road.

"Fancy going to Wales and coming back with fleas" laughed Roger scratching his ankles.

Roger and Deidre left on the 3rd of January and headed home to Kent. They texted Karen to say they were home but surprisingly got no answer. Having rung Karen a couple of times on their return and not receiving any reply Deidre was concerned. It wasn't like her to not answer. On the fourth day she managed to get hold of a neighbour on Facebook who told her Karen had been pretty rough with flu and Deidre thought," that's why." She'd give her a couple of days and try again. When she finally got through Karen had said they had sent her to hospital for ex rays and tests, as her chest was really bad.

"They were useless." she complained. "All they said was I had a mass on my lungs and an unidentified

virus, what use is that. I thought I was going to peg it." She had a way with words.

"Great that you're on the mend," said Deidre. "Well, whatever you had, I think you've given me, God I feel rough!"

"You'll be right in a few days" said Karen.

Chapter Thirty-Seven

All Sit Down, Sit down Next to Me

It took Deidre a couple of weeks and Roger, always wary of catching her germs, headed for the spare room. He couldn't miss work and there was "no way he wanted what she had", he had said, giving her a wide berth and affection from the safety of the bedroom door. Roger did not like getting other people's germs.

Beatrice had been rallying the troops through WhatsApp and they now had a hush hush bunch of gorilla granny's ready to hit the DWP, complete with their own photographer. The campaign was fortunate enough to have two excellent ones based in the London area who always covered anything that was going on.

There had been one post on Facebook through the groups asking for feisty ladies for a mission, so as not to draw the attention of any parties that they didn't want interested, and the date was set.

This 'mission' needed the element of surprise. They were to meet at the Millicent Fawcett statue at 12 noon, and then proceed to the location. In this instance the DWP HQ Caxton House. No one mentioned anything but the meet point. The group

was small, just thirty or so of the braver women who didn't mind getting arrested if necessary.

They had to be monitoring Facebook. For when the ladies met at the statue, two minibuses of police were parked alongside clearly awaiting their arrival. Someone had ratted…

"It's like a scene from the miners' strike, but to scale." laughed Sheila. The officer in charge came up and said "We know what you are doing ladies, we're just here to keep you safe" he said.

"I don't know what you mean officer, we're meeting for lunch" Sheila replied." The officer raised an eyebrow clearly thinking "Yeah Right."

Then began a strange dance, weaving about the streets of central London, like a geriatric conga line. The ladies walked; the police followed. The ladies stopped, so did the police. The ladies went to the loo, the police waited across the road. Then they went a little stroll around the back streets.

It became apparent that the police had monitored the Facebook posts, but not the WhatsApp group, so whilst they could hazard a guess on the target, they were clearly not sure. The police vans had to follow and so it meant there were a couple of police on foot and the rest keeping track in the vans and following as best they could through the busy streets. Not the most effective way to keep up

with a meandering group of would-be pensioners who were going up one-way streets the wrong way.

The scene resembled a particularly slow-motion bank heist, except the bank robbers were all in sensible shoes and armed with handbags overflowing with crocheted scarves and carrying banners instead of Uzis. Our heroines, a gaggle of formidable senior citizens, waltzed through Central London, leading a reluctant police escort in their wake.

"This is quite fun" one woman shouted to a friend waving her banner to and fro cheerfully.

When the ladies took a sharp left then right down a back street and rounded the corner walking fast towards the Caxton House entrance, the police hadn't time to jump out of the vans, cross a busy road and get to them before the women pushed their way through the security guards and into the doorway.

Nan had made it through the inner doors and was currently conducting her own private sit in at the front of the reception desk. Her banner raised above her head telling the reception staff why they were here. The rest were happily trapped between the two sets of doors effectively blocking the entrance.

In fairness the security guards were very nice, so nice that two hours on, Beatrice, who was on loud hailer duty outside, with the women who hadn't made it through the electric doors, brought them all coffees with the ones for the women sitting inside. There was quite a camaraderie, despite the threat of arrest if they didn't get up. The ladies turned their heads and ignored the attempts to evict them. It was like a bizarre version of a WI meeting, but without the baking lecture.

Women waiting on Facebook were applauding and laughing with them. Soon, a live stream appeared online, documenting their glorious stand against the DWP's bureaucratic cruelty and the hearts and likes and laughing faces were streaming upwards on Beatrice's camera stream. Women across the country, inspired by their audacity, cheered them on, wishing they were there themselves.

The DWP got a new sign that day. 'THE DEPARTMENT OF WORK AND NO PENSIONS.' It seemed fitting. Three hours on and in time for trains home. they graciously conceded so the police wouldn't have to arrest them. It was a day Beatrice would never forget. They later learned the new minister for pensions had snuck out of the rear entrance…

As Beatrice watched them disperse, a wide smile spread across her face. Nothing could beat the

image of Sheila, cross-legged surrounded by bewildered officers, serenely performing her morning yoga meditation. It was, truly, a classic Granny moment.

Who would have thought that so much was about to hit nearly every living soul across the world within the next month. Just as they had hit a high note, the rug was about to be pulled in the worst possible and most terrifying way.

Chapter Thirty-Nine

Ladies that Lockdown

Deirde's and Rogers daughter had gone into hospital for an elected caesarean, and they were understandably frightened. Their first grandchild had been delivered three months early seven years ago, because of complications, and was severely disabled. Life had been hard for the family and with her daughter at forty-two, this baby had been their last attempt for a sibling. Deidre and Roger were holding their breath and waiting for a call that all was well whilst they babysat Shani.

The TV was on and now there was talk about this new virus that seemed to be affecting the elderly and people from ethnic minorities. They couldn't get their heads round it. Shani was rolling around happily in her padded play area with a carer overseeing her activity as the hours ticked by ominously. The news was on in the background and Deidre couldn't help but watch. The news lately was her downfall, ever looking for something to do with pensions, she was becoming addicted to bad news, and it was starting to affect her mental state. Always angry and sharp, Roger was often telling her pointedly to break away from it.

"Look at what this damned Government is doing!" She would call him over and he would wearily go. "…and as for him (him being her word for Boris) what a charlatan!" Deidre had not forgiven him for lying about helping the Waspi women on the run up to the election, and then conveniently brushing it under the carpet once more when he got into 10 Downing Street. Not that they had expected anything else. The naïve belief that politicians were honest had long since gone, distrust growing ever stronger with the depletion of their bank account and retirement hopes.

She had never been a political animal, but now, she was, with a vengeance. His sunny dispositioned wife had morphed into someone angry, driven, and depressed, where she should have been enjoying retirement. Now this Covid 19. He feared for her mental health as much as he feared his own physical decline.

Today's news wasn't good, they were saying the numbers were rising too quickly and the NHS wouldn't cope, and that vulnerable people must stay home. The internet was showing videos of them spraying the streets in China and bodies on the pavement. What to believe in a world of fake news?

Before she had a chance to be pulled in further, her mobile started ringing and she grabbed it seeing

her son in laws name come up. The fear was so great she could hardly speak, the family couldn't bear another tragedy.

"You have a granddaughter and Sarah's fine" came the voice of her very relieved son in law. He had lost his own mother shortly after he was born, and then came the pain and worry since Shani's birth. As proud as he was, Deidre knew he had been so frightened about this pregnancy. He held so much in, and she worried for him.

"And is the baby ok?" she hardly dared ask.

"She's absolutely beautiful and healthy and they say she can hear."

Deidre's heart swelled with overwhelming relief and Roger standing nearby waited for the words that he could breathe again and when they came with a beaming smile from Deidre, his eyes filled up with tears as he learned the baby was ok. Having lost a child at birth himself, it had been a long, weary nine months. Sarah had been so sick and debilitated; they had feared a similar tragedy. Thank God it was over.

As they walked into the hospital that day, they had no idea that ten days later they would be having to look at their grandbabies through glass.

How did a disabled child understand how her mama and grandpops couldn't love her and hold her and kiss her as they always had done. How would that beautiful tiny new soul know she had more than just a mummy and daddy to love her.

How would her daughter cope, a new mum, also with a disabled child requiring round the clock care, without her own mum to fall back on. They had to keep them safe, because if they went down, then it would be left to her and Roger to step in.

What if the carers got it? What if the carers brought it in? Had she had it already? had that been what Karen had at new year? her mysterious unidentified virus. Did they know even then and do nothing? It felt like her head was exploding.

Every minute was spent worrying. About her grandson in Norwich with his mum, a nurse on the front line.

Deidre was convinced with her weak chest that she would die if she got it, and she started reconciling herself to that possibility. It was absolutely terrifying in the most insidious way, a creeping realisation just how big this was…

Chapter Forty

Beatrice, so strong and funny usually, looked out the window of her house at a street that was bare and silent. The thing she mostly couldn't understand was the silence. No cars, the odd bus that was mostly empty, and few people daring to break the lockdown.

Thank God for video phones, otherwise she might have gone completely insane. Here now on her own, she craved to see her kids, her friends up north, they were safe so far, but the stories on the news were fearful. What would happen to them if they got sick? What would happen to her if she got sick? she only knew the Margate Waspi women and a couple of neighbours, but no one well enough to risk themselves for her. She would be on her own.

There was only so much sorting out you could do, so Beatrice brought out her sewing machine and despite a neck that went into spasm after ten minutes at a machine, she started to produce masks. Of course, the prices had rocketed on the internet for fibre filling and elastic. Someone was already seizing the opportunity to make a buck out of people's fear and misfortune.

Now, even if she could get a job at her age, she couldn't dare. The World Health Organisation had listed anyone over sixty as vulnerable, but the government was ignoring the WHO

recommendations, forcing the 50s women to put themselves out there on the front line, and doing nothing to help them.

Then came the horrors coming to light, of how they had released the elderly with covid back into the nursing homes. Those poor trapped people were dying in their thousands. It felt like the government was conspiring for them to die. She couldn't help but wonder, after a conversation with Deidre about the rumours that the virus had been cultivated, whether it had been designed to do just that, and that the reason they weren't allowing sixty plus to shield was a deliberate move to kill off more of the Waspi women. A paranoid thought that she once would have dismissed, but not knowing what she now knew.

Well, they weren't getting her, or her friends, and so she sewed for anyone that needed masks. It was her salvation, a way to help, a way to fight back against something that was much bigger than the injustice she had suffered.

The bills piled up, but she didn't care. How many Waspi women were being forced to put themselves in harm's way because they were still having to work to survive,

Beatrice had her views as to why they were prepared to risk the female population over 60 by not allowing them to isolate with all the other

classed as vulnerable. How convenient for the government if a few more 50's women died along the way. Less compensation to pay them if they finally achieved justice...

Ten years ago, these thoughts would not have entered her head but in this male dominated, toxic parliament, which viewed people like units of profit or loss, anything was possible. She would survive this, and she would beat it, them, Covid and this incompetent and callous government!

Chapter Forty-One

The day before full lockdown Sylvia got a call from Maureen. They had just been told that the shop would have to be closed, and she wouldn't even have the comfort of Jamie's company. She would be stuck in the room for as long as the Government dictated, with nothing but a small telly and the radio, like a prisoner in a cell of their own choosing. She should have stuck it out with Alan, at least she would have had her garden to escape into.

Maureen's call was like a beacon of light in the darkness. "Get your case packed girl and get over here before they lock us down. We can't have you mouldering away in a storeroom.

"Are you sure?" the reply had a croak and Sylvia's relief was evident.

"Damn right, there's room here and we'll be company for each other. I'll go mad if I stay trapped here alone any longer!" replied Maureen.

"Me too! Oh thankyou Maureen, you don't know what this means to me!" Maureen was putting her health on the line to look after her friend's welfare. An indication of her strength of character.

Sylvia put the phone down and started throwing clothes in a suitcase frantically. Outside it was starting to look like a police state. She would make

her escape before the prison door slammed shut. This should have been her twilight years, not this twilight zone…

Maureen picked her up and they headed home. Sylvia watched her friend on the journey. She was so matter of fact and calm. But Sylvia couldn't help but think how much she must have suffered, losing her life partner just as they were looking forward to their time together in retirement. She was so resilient.

This government had a lot to answer for. If the boot had been on the other foot, she would have gone to pieces. Then she thought, maybe she wouldn't have. She didn't wish ill on Alan; she just wished the hell he was currently putting her through would go away.

All this and Covid combined. How many fifties women were alone and friendless right now. It didn't bear thinking about. She sent up a silent prayer and thanked whoever was the supposed 'great spirit' as she like to call it for sending her this kind friend in a time of need.

Bags unpacked, she and Maureen rang Jamie on video phone, who was delighted for them, and afterwards they settled happily in to sharing a meal preparation once Sylvia got her bearings.

"This is so nice Maureen," she said. Your little cottage is so cosy and welcoming. Maureen smiled and indicated through the window. "Not to mention the huge garden you can help me with, my back's playing up at the moment." She couldn't have said anything better. For Sylvia, the thought of a garden to tend once more would be a joy.

"There's just one thing," said Sylvia.

"What?"

"There has to be sunflowers!"

They both laughed. "Well, we need something to cheer us up at the moment, we'll plant some as soon as." Maureen replied, grinning.

Chapter Forty-Two

The salt-laced breeze that once carried their laughter now sighed through the empty flat, mocking Christina with memories. Maurice, her anchor for decades, was gone, stolen by a cruel virus in the twilight of their lives. He was nearly seventy, an age that whispered vulnerability against the backdrop of a relentless pandemic.

Christina, a seasoned nurse, recognized the signs the moment they surfaced. Dread coiled in her gut, a cold serpent tightening its grip as a familiar cough echoed through the rooms. Isolation became their fortress, her nursing instincts kicking in with practised efficiency. Masks, gloves, and aprons, once tools of profession, now served as grim reminders of a battle she was determined to fight alone.

"Just a precaution love," she had soothed, her voice trembling despite her best efforts. The terror in his eyes mirrored her own. Stories, shared in hushed whispers amongst her ex-NHS colleagues, whom she had consulted for advice, painted a chilling picture of overwhelmed hospitals, a war fought with dwindling resources. No, Maurice deserved better. He deserved her, in their haven by the sea.

Sheila, a stalwart friend, became their lifeline. Deliveries left at the doorstep, a silent language of support, a lifeline in a storm of fear. The once vibrant "everything okay so far" turned into a choked sob, Christina's facade crumbling under the

weight of his escalating fever and the rattling struggle for each breath.

Maurice, a man who had faced life with unwavering strength, now held a silent plea in his eyes, a conversation he was having internally as to whether this unfeeling plague would be the thing to take him in an undignified and premature end to a life well lived. Each interaction etched a path of fear onto her heart, a stark contrast to the life they had built together. By the third evening, his oxygen levels plummeted, leaving her with no choice but to surrender to the cold reality.

The ambulance arrived, a beacon in the growing darkness. As they wheeled him away, she gave him a smile, a fragile shield against the fear etched on his face. "See you soon darling," she whispered, tucking his phone and charger in the bag, a lifeline for a connection she longed for.

"They won't let you in I'm afraid," the paramedic said gently, his words a hammer blow. "I'll follow," she asserted, defiance simmering beneath the surface of her grief.

For three days, they teetered on the precipice of hope and despair. Finally, they allowed her a glimpse – a sterile, masked encounter, a world away from the warmth of their love. "Induced coma," the doctor's words echoed in the sterile room, a death knell disguised as medical jargon.

Two days later, the world dimmed irrevocably. Her haven by the sea became an echoing tomb, the emptiness a physical manifestation of her grief. This "cruel bastard virus," as she called it, had robbed her of a lifetime of love, leaving behind a gaping wound that refused to heal.

The funeral was a pale imitation of their love, a gathering of masked faces and forced smiles that could not even be seen. Even then, the fear lingered, a phantom limb of the pandemic's cruelty as she watched her son crying ten feet from her and was too terrified to risk comforting him, lest she by some cruel chance infected him. It would be her undoing.

In the days following, she answered calls, her voice a practised melody of stoicism, a mask hiding the woman who had slipped away with Maurice. The ocean breeze as she walked the beach road, once a song of shared memories, now carried only the echo of a love lost, a reminder of the life stolen by a single, silent breath.

Chapter Forty-Three

They were fortunate in the first weeks of the lockdown and had been sent an early summer. The relief to venture outside and nurture something in the garden was immense and they took full advantage of it.

As Adele was a member of their household as such, she had started to venture outside and offer help at a polite distance. There had been a moment when she had thought of ending all the pain, but somehow the pandemic and all the trauma it brought, made her ashamed to have even considered suicide when so many were fighting for life.

The quiet but friendly company of Annette was a foil for her low self-esteem, and their kindness in taking her in had given her the breathing space to recover from all she had suffered the previous year. Was she healing a little? it seemed strange in the present times, but the seclusion with this wonderful couple had been a blessing. Even Arthur would now sit and chat to her and they all made the best of being in lockdown.

For some reason, the spring mornings were getting into her blood, and she was out early walking in the beautiful countryside close to Annettes house. It was a balm for her injured spirit. Sometimes Annette would join her, and they would walk the orchards and fields. Nature seemed to be

blossoming in the absence of people. Perhaps mother nature sensing real threat from the human's had sent the pandemic to reset everything.

She had started doing little quilts to keep her occupied in the quiet hours. Annette had said she had quite a talent and so she offered to do memorial quilts for people who had lost loved ones from items of their clothing, once thoroughly disinfected This was keeping her busy when she should have been going stir crazy with the isolation. Her skills were building, and she was getting new ideas all the time.

Arthur, sitting opposite her in the garden one night as she was hand stitching her latest project, watched her for a few minutes and then suggested that "with your talent for this, you should start a business doing it."

" Really, you think so?"

"Yes, I do, they're lovely."

Praise indeed from the man she had sensed resented her. The thought had never occurred, but it planted a seed, nevertheless. Knowing that Deidre had been an ex-business advisor she rang her on video phone and Deidre, (so bored with the enforced spell at home, and so desperate for something to do whilst Roger was unable to work, that they had even built the dog some nosey steps so he could look over the fence at their neighbour,) grabbed at the chance to engage her brain once

more. She started working with Adele on the relevant points of setting up business she would have to consider, covering everything from marketing to accounts and tax. She even suggested some grant opportunities.

Before you could shout PPI fraud, she was pursuing her goal with a quiet determination. Adele had been hiding her light under a bushel of depression. It had taken a pandemic to reignite her fire.

Chapter Forty-Four

Did You Hear the News Today?

The pandemic was never something that frightened Grace, she no longer had the ability to comprehend its tragedy. She had always been a loner, even before the death of her husband and so the days were spent happily cultivating her latest crop, whilst the house waited for the twice weekly visits from Sheila and Maureen, who were defying the lockdown in a stubborn refusal to abandon Grace to the hit and miss care of social services. Too many loan elderly people were having to rely on the goodwill of neighbours. It was such frightening times for them.

The only problem was that she was unaware of the 'new normal' and on the occasions when she did venture out, she caused consternation in the mainly masked up population, who did not understand that Grace was away with the proverbial fairies and had no understanding of 'distancing'. She was leading Sheila and Maureen a right old dance and truth be known the consternation it caused was almost a strange kind of entertainment in a constricted world.

They had managed to get her financial assistance and additional support because of her diagnosis

and things were better. So, when the first lockdown opened up, and people were allowed to meet outside at a distance. They took the opportunity to invite the women round to Grace's ample garden for a meet up.

This was the fourth meeting since the easing of 'measures,' hosted before the weather started turning cold. Everyone was looking forward to it for respite from the loneliness that had been forced upon them. Even Roger came, such was his need for company. They had made him an honorary woman anyway, so it was fine. All the women respected the fact that he had the balls to stand up for them and as far as they were concerned, he was a Waspi.

The afternoon sun painted long shadows across the garden, casting a melancholic air upon the women gathered there. The news was just out. Back to 60 had lost their appeal, and what should have been a happy gathering was overcast with despair in the judicial system once more.

Manda, ever the realist, arrived with her loyal companion Bindi, the "cleverest dog in the world" trotting at her heels and she shrugged with a "Didn't expect any less from this sham they call British justice." The usual chatter about lockdown experiences was subdued, a mere formality exchanged despite the requisite two meters between chairs.

More horror at the mismanagement of PPI and government corruption had come out today. Dominic Cummings and the Barnard Castle debacle was still high on the news agenda, as was Boris's failings in attending the emergency planning meetings. It was a shit show and people were cottoning on.

"What chance have we got of getting any justice with this shower in tow." said Christina. "The other lot's as bad, there'll never be another Corbyn!" She was referring to just before the 2019 election. Jeremy Corbyn and John McDonnell had declared that they would pay the Waspi Women well deserved compensation, and even went as far as to name figures. Now that was true integrity.

"Or at least a ploy to win votes," Manda said cynically.

"Whatever, but he did it, and put his neck on the block for us, which is more than any of these charlatans are prepared to do. The damn Tories seized it as an opportunity to discredit him for doing the right thing, that and giving everybody free internet cloud. They called him unrealistic, and yet here the Tories are scrambling to come up with something that would allow poor children without the internet to be educated in lockdown". Christina wasn't backing down. Perhaps they should have listened to Jeremy.

Maureen surveyed the circle, her heart a tapestry of conflicting emotions. Grace, once weary and half starved, although only through their efforts and with no thanks to government, seemed healthier. Adele radiated newfound energy, a stark contrast to the woman they had first met. While Christina offered a smile, it lacked its usual vibrancy, a faint echo of the woman they once knew. Even the ever-present spark in Annette's eyes had dimmed, and Deirdre's smile had been replaced by a quiet resolve. Only Beatrice remained unchanged, her spirit a beacon of activism, her voice strong through the digital world. She had become the queen of the campaign blog.

The injustice they had endured had etched its mark on them all. They were all strong women, each fighting the good fight in their own way, yet the carefree futures they had envisioned for their golden years now felt like a distant dream. The pandemic, it seemed, had the power to break and to rebuild, its effects a capricious tide.

Deirdre, ever the firebrand, voiced her scathing opinion on the Ombudsman's report. "Absolute baloney!" she spat; her voice thick with disgust. "Letters finally sent ten years after the fact. I certainly didn't receive one, and Steve Webb even admitted there were errors to parliament. I didn't know till 2017… Why are they ignoring this...and what about the recommendations in that report that the government paid for that says every one-year rise should have ten years notice? They're

trying to pull the wool over everyone's eyes!" It was an emotive subject.

Christina, her gaze filled with steely determination, interjected, "The Cridland Report."

"That's right! The Cridland Report!"

"Limiting compensation and downplaying the impact. It's as plain as day." Replied Christina "… and they were lambasted by Philip Halston European Special Rapporteur." Christina knew her stuff.

Maureen looked around the room, the faces of her dearest friends swimming before her eyes. A wave of unbearable sorrow threatened to engulf her. "Ladies," she began, her voice barely a whisper, "I have an announcement to make, and I may need your understanding and support… perhaps even someone to handle my admin duties for a while."

All eyes turned to her, except Grace, who was captivated by a butterfly flitting among the fragrant buddleia flowers. Even Roger, playing with the usually boisterous dog, fell silent.

Taking a deep breath, Maureen unveiled the truth, "I received some test results yesterday. I… I have pancreatic cancer."

The room fell into a suffocating silence. Sylvia, unable to hold back the tide of emotions, drew a sharp, choked sob. "Why didn't you tell me

yesterday?" she rasped, her voice laced with anguish.

"I just wanted to do this once," Maureen replied, her voice trembling slightly. "I'll be alright, but I might need your help. Today seemed like the right moment, to get it over and done with."

The pain in the room was a tangible entity, a potent mix of despair and fury. Pancreatic cancer – the very name sent shivers down their spines. This remarkable woman, who had already endured unimaginable loss and hardship, now faced this latest battle. The injustice of it all felt unbearable, particularly when cancer treatment was being sidelined due to the ever-present pandemic. She would be lost before she could claim any of the pension she had fought so hard for.

Sylvia, summoning a wellspring of unwavering strength, rose from her chair and walked towards Maureen. "You have us," she declared, her voice steady despite the risk of breaking social distancing rules. In that moment, defying the fear that gripped the world, they all stood as one, a circle of love and unwavering support surrounding Maureen, honouring the need for distance but reaching their arms towards her in a testament to the enduring power of friendship in the face of overwhelming adversity.

Chapter Forty-Five

The weeks following Maureen's announcement seemed to crawl by. Lockdown was easing, but not the delays in treatment. Every couple of days either Sylvia or Maureen were chasing an appointment and every time, they received the same bland reply. "It is listed as urgent, and we'll be in touch asap."

Maureen seemed resigned to the delay but for Sylvia it was like a red rag to a bull. A friend who had private insurance said even she couldn't get treatment for her son, because the private hospital beds were being reserved for Covid patients and standing empty.

The summer had turned in the direction of Autumn and Sylvia dreaded the confinement of winter. There were rumbles that the numbers were on the rise again and it didn't bode well. Maureen was mostly confined to the house to shield her, and so it was left to Sylvia to oversee shopping and Maureen's normal good Samaritan roles, of which she realised there were several, some that the group wasn't even aware of. The woman had kept herself busy.

Maureen spent most of her days on computer typing intensely, and when Sylvia questioned her, she would just say 'project, I'll tell you when I'm done." That was her cue to keep her beak out, so she would bring Maureen a coffee and leave her to it.

One day Sylvia arrived home to an empty house and went into an immediate panic, dialling Maureen's number,

"Sorry," she said, oblivious to Sylvia's concern. "It took me longer than I thought, I had an errand to run and I'm on my way home."

Sylvia wondered what was so important to have Maureen risk her health by venturing out, but it wasn't her business. The one thing she knew about Maureen is that she would let her know when she was ready, but not a minute before.

Chapter Forty-Six

Christmas had come and gone in another lockdown, and everyone was heartily sick of the lack of freedom. The impact was beginning to tell on all of society, but for the Waspi women Covid was one of the cruellest of times, effectively closing down so much of the campaigning and they were confined mainly to social media. It was a bitter blow. Beatrice had been blogging relentlessly to try to keep morale afloat.

The costs of losing their pensions, followed by the fear of being forced to work on through Covid with no help from the government to isolate, even though they were vulnerable, was the most frightening of times. To then have their few precious years of remaining health spent locked down was having a terrible effect on the mental health of even the strongest willed.

Annette had succumbed to a visit to the doctors to try to tackle her insomnia. Even Arthur was in favour. Her anxiety had increased over the campaign and compounded by the fact that despite their rights having been taken as women, they were now virtual prisoners in their own home, some by policy, others by their own fear of Covid.

The Christmas lockdown had incensed many but at least now they had started the vaccines roll out and they were moving forward into 2021. She prayed

that life would get better from here on in, and this 'new normal' rhetoric would disappear with it.

The one thing that still burned bright within her was the need for justice, especially for women like Adele and Maureen, who was now on her second round of chemo.

Even Christina, having waited all those years surviving on just her husband's income and a small work pension, their retirement dreams delayed by the pension's injustice until the brink of Covid. It gave them only a few short months to experience that financial ease together before he was taken. It was unspeakable cruelty.

Now Christina was back to square one, surviving alone on one of the worst pensions in Europe, below the basic income level and with prices rising daily, the torture of never having said goodbye to her beloved Maurice dulling her eyes.

Annette had researched. They cited greedy pensioners, what a crock! How could they expect pensioners to survive on less than the basic living wage? Many of the Waspi women were going through hell, she was lucky, but God help those divorced, widowed, single women, with no savings or partner to fall back on.

She had even learnt today of a Waspi woman having to downsize just to survive, because her husband had a breakdown with the stress of trying to fill the gap her missing pension had left. They

nearly lost their home and she herself was now suffering a breakdown.

Meanwhile the politicians had given themselves another huge rise, whilst the doctors and nurses and carers were going through hell and the PPI procurement scandal was beginning to break. This was Not So Great Britain today. She had remembered giving her vote to Maggie Thatcher in the seventies, thinking that a woman would have more common sense, but that didn't exist in politics, money and ambition was all that mattered and it shamed her to think she had fallen for it.

The only light in all this was Adele, watching Adele grow her ideas and start to have money coming in for herself instead of that paltry amount considered enough to survive on from Jobseekers. An amount about seven times less that they were paid to sleep for a day in the house of Lords...

She was a wonder that Adele. She was coming up with inventive craft ideas every day, and with Deidre's help had got a small grant for a start-up business and had invested in an overlocker and industrial machine. Annette quite liked to hear the hum of her industry from the garage apartment as she worked on her latest orders. It comforted her that someone in this current hell was moving forward.

She had even offered them rent, but whilst Arthur was all for it, Annette wouldn't hear of it. It was

great to see her rise up from all life had thrown at her and maybe in a few weeks when she was established, they could take a small amount for electric.

Annette wished she could rise in the same way, but instead, she capitulated and made the doctor's appointment. The female Doctor sat bemused as she poured out her pain and angst, insisting that she put it on her medical record that her mental state was caused by the theft of her pension and not covid related. Another woman of a certain age that knew nothing of the pensions grab, for pity's sake!

The doctor gave her mild sleeping pills and apart from the several visits a night to the loo that now plagued her, she had her first night's reasonable sleep in a long time. The trouble now was getting going in the morning till the drugs came out of her system, there was always cause and effect it seemed, but at least she slept.

Adele was becoming a whizz on internet marketing and had joined several crafts sites. The pale drawn woman that they had taken in, smiled, and smiled naturally giving them all a glimpse of the woman she might have been until life and the government delivered the sucker punch.

The Chapter Forty-Seven

A pale sun was just coming up as Manda and Bindi walked the beach at Westgate, it was six am and their usual lockdown routine, and the only thing that kept her sane. This was the best time to be out and about. An almost deserted beach where she had the freedom she craved, without anyone telling her where she could be and with whom.

When she had divorced, she had been forced to downsize and bought a first floor flat. Spacious rooms in a traditional house thankfully, but whilst it had amazing views across the gardens of Margate from the rear lounge, she had no access to the garden below. It was suffocating her slowly in lockdown. Normally she was never home, walking the beaches and fields with Bindi, with her camera ready to take stunning shots of skies, trees, rivers. She pushed the boundaries now and walked twice a day. It was her salvation in the monotony.

As an ex-paramedic she knew the infection risks and had no intention of putting herself in harm's way. The walking was a crusade, the only way to beat this pandemic and the bars it had placed around her gypsy soul. She passed the van, sat on the road outside, and cursed whoever had sent this pandemic their way. She should have been free as a bird right now but had not even got on her first adventure when the lockdown hit, and her van was left to fall into disrepair with the lack of use. The dreams she had had when she took that step to

leave work, all gone with no sight of an end to this nightmare.

Without Bindi for company, she could not imagine what would have been her fate. There was only so much pension research she could do, without losing the will to live. Confined alone, like so many others, but for her beautiful boy, she would have lost her sanity. He had a sixth sense as to when she was on the edge and would come and place his head on her knee and look into her eyes as though he read the despair in her soul.

Trotting alongside her on the beach the dog would sense her mood and adjust his behaviour. On days when she was inhaling the air and striding out in defiance of the pandemic, he would run in excited circles, on the bad days, he would run and then return to her side and repeat, almost as though he was checking she wasn't going anywhere.

Manda mused on the timing of her decision to leave and sent up a prayer of thanks that she had taken that decision when she did, it had saved her life. She would have likely been told to isolate on full pay because of her heart condition, but if not, she would have no doubt by now fallen prey to Covid, with what result? They were losing medical staff from this as well as the elderly and vulnerable and she was all three.

No, she had been very lucky to take that financial hit and retire early when she did. Someone had

been looking after her on that day. How many other countless nurses over the age of sixty, not allowed to isolate and forced to work on through sheer necessity, were waking up this morning in dread, that this might be the day they were infected…

The women were ringing each other to keep buoyant, but social media, where she would have sought solace and companionship in the seclusion, was full of scare stories and she now avoided it, choosing fresh air and the sound of the surf as her balm. They all thought she was the strong one, the matter of fact one, but today without the company of this canine soul, she would have felt very alone. He was saviour and her best friend.

Chapter Forty-Eight

Oh my god that woman's leading me a dance" wailed Sheila down the phone to Sylvia and Maureen. "I've come down here to go through her bills and she's left me a note saying she's gone to Walmer Castle! What the hell is she going to do there?"

Maureen smothered a laugh and grinned at Sylvia. "She'll be fine, it's not cold, someone will bring her back if she gets lost. Have you tried her phone?"

"On the bloody kitchen table of course" came the response and they burst out laughing. Sheila was disgruntled. "It's alright for you two laughing, but what if some nutter latches on to her?"

"More likely the other way round." said Maureen quietly to Sylvia who spluttered.

"I'll have to go look for her!"

"Do you want me to come?" asked Sylvia. But Sheila shrugged it off as her humour reasserted itself.

"Nah. I'll go to the shops on route and kill two birds with one stone. I'll ring if I need you."

"Okay, take care."

Fortunately for Grace, the lockdown was finally over. Not that she knew it with her declining mental health. The cafés and shops were pretty much open, so someone would help her hopefully.

Meanwhile Grace had ensconced herself in a comfortable little café on the green at Deal having got the bus in and was regaling an elderly gentleman with her exploits as a 'Waspi Warrior.' Poor soul hadn't a clue what she was talking about. (well did anyone under 60 years and over 75?) but was too polite to say so. By the time she'd had cake and two cups of coffee and given the thirty something assistant a pound coin in payment with a beatific smile, Sheila was walking up and down the castle ramparts, muttering angrily to herself for getting dragged into this.

Grace had managed to avoid arrest by the skin of her teeth yet again when the elderly gentleman had offered to pay for her, and she thanked him like Scarlett O Hara flirting with Rhett Butler. She was currently on the bus home whilst Sheila was running round the grocery store, frantically throwing things into a trolley. Strange how dementia affected some things but not others. If there was a right way to have dementia, Grace had it. Oblivious to all but the good in life, it was a blessing, though at this moment Sheila perhaps, would not have agreed.

When Sheila arrived back at the house, she was home sitting at the table. Seeing Sheila enter through the back door she looked up and smiled sweetly.

"Oh, lovely to see you Maureen, have you come to pay my bills?"

Sheila had no words.

Chapter Forty-Nine

Beatrice had news from her now extensive Facebook contacts and was steaming ahead. She had come up with an idea and had been working towards it from the second lockdown.

"What about an online event to get all the groups together to cooperate in a simple way. Like, I'm hosting an event or a rally, its open to all groups to come together in Unity…and I know it's been done before, but hopefully the difference is that I haven't an ego. I don't want to lead; I just want to facilitate to bring us all together. I've broached it with a few people who are up for it. What do you think?

Maureen looked up from her recliner, she looked weary and had just recovered from a round of chemo. But was eager for company.

"I think we need something right now as everyone is so despondent with the result of the Back to 60 appeal, I feel for Karen and Julie having to go through all that again. Its horrendous! No, I think it's a good idea. We must all pull together or its useless."

"Great, I'll start planning. Glenda says she can ask Andy Burnham to introduce it as he's happy to support us."

Sylvia, bringing a tray of sandwiches and coffee in, placed it down between them. Beatrice sitting back against the wall at the appropriate distance, had to

stretch in and dart back without breathing near Maureen.

"Cheers for this Sylvia" Bea said tucking in. Today was a good day. Maureen was coming round from her treatment, and she was on the brink of an exciting endeavour. Had she known what work she was taking on, she might have never started.

Chapter Fifty

Deirdre's body protested. At sixty-three, wielding a jackhammer to gouge holes in concrete foundation to release the old fence post was a task better suited for a younger frame. The eight-foot fence panels they were installing felt like an insurmountable challenge. Manoeuvring them into place, let alone securing them, proved impossible on their own. In the end, a makeshift lever became their reluctant accomplice, the process fraught with exhaustion and the chilling absence of margin for error.

As the panel finally yielded, aligning to the post, Deirdre turned to Roger, her resignation etched deep. "We can't handle any more of these eight-footers Roger. My arm is screaming, and I have night duty tonight. You can't manage them alone. You'll have to tell them it's a two-person job from now on, and I'm afraid I'm not the other half."

They packed up the trailer, their weariness a tangible weight. They had done a good job, but it was just one more example adding to the growing list of reasons why hiring an older worker might not be the best idea. She saw the flicker of despair in Roger's eyes. He didn't like feeling weak, but it was just too much with his arthritis. They had worked for the agency since 2017 but loyalty meant nothing these days and it was a worry. They

were reliant on someone a generation younger, who had no understanding of their plight, for their livelihood.

Their current workload was an anomaly, a frenetic surge amidst the pandemic's lull. The lockdown had brought an unexpected twist - a surge in DIY enthusiasts. This, in turn, had crippled the supply chain, leaving the trades scrambling for basic materials like wood, concrete, and plaster. The shelves were bare, and the prices were skyrocketing, a stark reminder of those who profited from misfortune.

The jobs were plentiful now, but for how long? Could they afford to keep turning the physically hellish ones down?

That night, during her shift as an agency night carer, Deirdre's mind swirled with questions. Her granddaughter, Ishani, was outgrowing her ability to lift her safely. Despite reassurances to her daughter and son-in-law, the daily pain was undeniable, amplified by the constant wriggling of a seven-year-old yearning to break free. With a heavy heart, she sat her daughter down.

The physical demands were simply too much. Working in stifling masks, gloves, and aprons, the ever-present ache in her back and shoulder was a constant thrum. Physiotherapy and eight long months of healing awaited her. Not to mention the nights without sleep, catching up only when she

could. Roger needed her help, and the caring role would have to be sacrificed. The administration and helping Roger were enough.

Chapter Fifty-One

An Assembly of Discontent OCTOBER 2021

"Hiya love, how's things?" Glenda's warm voice came over WhatsApp from Manchester, "S'cuse me I look a sight, just finished a long week!" she said.

"That's a pain, I finished a long week's job searching, but there's nothing to match my skills. They're turning the screws now saying I must be open to more achievable goals." Beatrice was gutted really. She had never had problems getting a job under the age of fifty. Perhaps I should turn to prostitution, some of us are, you know, poor beggars!"

"I know they are and it's an absolute disgrace!" said Glenda. "Do you know I had a friend at the jobcentre who says they had a memo round saying don't pressure men over fifty or anyone who gets violent, yet they don't mind bullying older women. Misogyny as usual…anyway to business, It's the conservative conference in October and I've said we would support Waspi Campaign there, do you fancy it?"

"I'll have to ask my friend if I can stay." Beatrice was pretty sure a long-delayed visit to friends up north was in order.

"Don't worry about that, there's a bed here and we'd love to have you and by the way, The People's Assembly is asking if we have a speaker and Gill from Wales has recommended you, as you're confident and know your stuff."

Beatrice gaped, she was used to mics and stages, but not addressing a large rally of men and women.

"How long for?" she asked weakly,

"Six minutes." came the reply.

Now normally you had trouble stopping Beatrice. Talking on the phone, on her blog, in posts! but this one was a biggy, she could fall on her face. "Oh, to hell with it say yes." she said. Now she was in trouble...

October third came, and she found herself with the 1950s women and Glenda's husband, who had the funniest dry wit she had ever encountered. They waited on a crowded street in Manchester where she would be addressing the crowd before the march.

A guy with dreads came up, asked if we were speaking and then started ranting about the proletariat and how all hierarchy should be abolished. Not even lower management. Glenda and Bea listened politely at first, until the nonsense of his argument and bombastic manner started to annoy.

"How do you get anything done then" said Ron, who was an ex-shop steward and used to ranters.

"The task would be done by everyone pulling together." the slightly fanatical man in the parker continued.

"…and how would you get them to pull together?" Ron was deadpan, but he knew bullshit fanaticism when he saw it.

There ensued an exchange where the guy got progressively angrier, and Ron got calmer. Eventually the man could stand it no longer and with a shout of "Get fucked!" he stomped off. Ron turned and winked.

Glenda and Beatrice stood by the steps to the stage and a woman with the running order approached them. "Are you the Waspi women?" she asked.

Glenda looked down with a smile at her bright green and purple suffragette outfit and smiled "How did you guess" she said.

"Are you Beatrice?" she asked, As Bea nodded, she confirmed she was second on. She waited by the steps to the stage as the first speaker walked forward…and started to rap! How the hell was she going to follow that? "Big girl pants Bea." she told herself as she ascended the stairs.

The wind was strong, and she was beginning to regret not tying her hair up but "here goes" she thought.

"God, how do I follow that? and I ain't gonna sing!" she said into the mic.

"Hi everyone, My names Beatrice and I'm sixty-three years old. And I'm very proud to be standing here with all of you today. Sixty-three years old…Why do old people always start by telling you their age? Well maybe it's because we find that life gets more precious, and maybe we think we've reached a great age, but for me and 3.8 million 1950s 'Waspi women' as you would know them. We haven't reached a great age.

I planned to reach my great age around the age of sixty and I should have now been enjoying my hard-earned retirement. Instead, for the last four years, every spare minute when I am not working, I am campaigning, angry and driven, for the pension and the right to rest after a hard, long working life that for me started at the age of sixteen years old.

So, consider this, seriously please, for just a minute and please take this thought home with you. Imagine, all of you today, have just been told that in twelve months' time, you are going to have all your entire expected income taken from you for the next six years. How would you survive? How would you keep your home? How would you keep your sanity? And then imagine that you are getting tired

and ill, and possibly alone? Well, that is what is happening to the Waspi women.

The Tory propaganda will tell you that we are selfish, wealthy old women. They will completely omit that we are mainly working class and far from wealthy. They definitely won't tell you that taking our pensions wasn't about equality. It was about money, pure and simple. It was a cynical cash grab that took fifty thousand pounds from each of those women with little or no notice, in my case 12 months, no chance!

This is a future fight that all of you are going to have to get involved in when you are forced to work harder and longer as your rights are eroded. All this whilst they will tell you that there isn't money for pensions. for proper social care, or our NHS that we treasure.

They targeted the Waspi women because they thought we wouldn't fight back. Well, I'm standing here to tell you that we have become...those powerless old ladies...a right royal pain in the Tory backside.

Ian Duncan Smith, in his arrogance, said of the Waspi women, "Ignore them they will go away. What he actually meant was that we would start to die, and we are...in our thousands! Every day currently, sixty 1950s women between the age of sixty and sixty-six are dying early. Many of those women are

dying in poverty. All of them have not received a penny of their hard-earned pension.

So why is my fight, your fight? And my problem, your problem? Well because, we Waspi Women, are the start of your future. Because under Tory future plans, the less affluent of you, will be forced to work until they die, and I do mean die!

Why am I here today, well mostly I am here for my family, but particularly for my grandchildren, one of which is severely disabled. Because they will have to endure the reality that the Tory future will create for them.

My family all works hard, but according to Tory propaganda, we are pretty much a burden on the state. They are working flat out to sell us this lie, so that whilst we are turning on each other, we are then distracted from the fact that the rot actually comes from the top down! And unless all of us come together to fight ALL injustice, then this is how it will continue, and you yourselves, like me, may find yourself, through no fault of your own, a burden on the state! ...and finally, consider this...If your grandmothers are out on the street protesting, then there must be something wrong. Thank you!"

A cheer went up from the crowd and Bea looked stunned, she'd survived! In fact, she'd done ok. Descending the steps to where Glenda was waiting, she encountered a young reporter.

"That was fantastic, well done!" she said. "I've videoed it, so can I put it on my blog? and can you spell your name for me.

Bea looked at Glenda who was grinning. "Power to the People, Citizen Smith!" She laughed and hugged her friend, and they made their way back to the front of the march to join the 1950's women who had come a day early for the planned Waspi protest, just to support her.

"Right ladies, we're off!"

The next day there was a decent turn out of the Waspi women outside the Tory conference, despite the fear of being too close together and Covid still around. The joint chairs of the APPG came out to support them. One labour, Andrew, and one conservative, Peter.

It was let slip that Peter was a little in fear of a mauling from the ladies, but they appreciated he had come to support them and were on their best behaviour. That was until Jacob Rees Smug (as they called him) made an appearance followed by Loran from Wales, who was giving him a right telling off. True to form he ignored her, but she was not for going away!

Christina had come up on the train and had brought a walking stick stool to sit down on, due to the deterioration in her back. It was the first time

she had ventured out on Waspi work since losing Maurice, and truth be known she had almost not come but she gave herself a telling off, visualising Maurice raising an eyebrow from his empty armchair with a "Come on my girl, get out there and give 'em hell".

Beatrice pointed the camera at her, always knowing that whatever came out of Christina's mouth would be intelligent with a sharp wit, and she could get it on Facebook for everyone watching at home.

"Do I need to ask you why you are here today?" said Beatrice.

"Well, we continue to fight on. We go to the next stage of the Ombudsman's processes. So, let's hope we reach a resolution, at least before I die!" Christina had some of her spark back in her eyes. This outing had done her good after the tragedy of Covid.

Bea was in the middle of interviewing her, when Mogg was spotted heading back. She jumped to her feet and bellowed across the crowd "You're as popular as leprosy!"

The crowd around her collapsed in laughter and Christina calmly sat back down and said, "Shall we continue."

"Right" says Bea "So how do you feel right now about the fact that we've had maladministration proven and yet we are still getting rhetoric from the

man that's just passed, and all he can pull out of his little bag of tricks is that we lost in the courts. What have you got to say about that?"

Christina pulled herself up to her full height of five foot four, like a seasoned Politician. "Well, I would say, he's not bright enough to read all of the papers. He clearly isn't a man of detail. He pinches sound bites and that's what he runs with...He's pulled a lot of things out of his little bag over the years, but it's got nothing to do with women's justice!"

"Thank you, Christina, I think you've just about summed it up!" This woman cracked her up.

They had a wonderful reunion with old friends and the added excitement of a brief visit from Andy Burnham setting a few aged hearts a flutter. But the thing that she noticed most that in all the upheaval and disgust at the Tories currently, it was the little old ladies that had the biggest presence outside the conference. Suddenly the news crew was there for regional TV and Glenda and Bea found themselves thrust in front of the cameras and too their great surprise they made the evening news on this occasion. Maybe the campaign was starting to take hold again? It had only been 6 years after all!

The journey home for Bea, from Manchester to Kent, was a long one, with Boris, the hated Volvo, throwing out smoke in the final hour, unused as he was to any hard work...

Chapter Fifty-Two

Warrior Women February 2022

Maureen struggled upright, reaching for the tea Sylvia offered. The steaming mug felt heavy, taunting her churning stomach. This latest chemo round had been a beast. Everyone had said it got easier, a cruel joke in her case. Tears welled, the first in years, but even the simple act of crying felt like lifting mountains.

The girls had been such a comfort, every one of them rallying to a man, and in fact, the men as well. Roger had been mowing the lawns and keeping on top of the garden, to give Sylvia a break. Even Arthur had been suggesting things that might help her and explaining through Annette anything she had not grasped in the fog and dread of the first few month's treatment.

They had all taken turns to sit with her, even Manda, who had returned from her travels to take a turn when she was too ill to lift her head from the pillow and needed experienced care and someone who knew how to lift.

Good days found Maureen pecking away on her laptop. Bad days meant headphones and favourite playlists, the music a lifeline of peace and memories of better times. Other days, she simply sat by the French doors, absorbing the garden's sights and

sounds as if for the last time. Sylvia, ever observant, burned with curiosity about Maureen's mysterious project, but respected her need for privacy.

Sheila's arrival brought a clatter of groceries and a gentle rearrangement of Jamie's ever-growing floral tributes. They would not have been complete without the addition of sunflowers, at Sylvia's request.

Sylvia, changing Maureen's bedding – fresh sheets were a small comfort – felt a surge of frustration. "Covid's sucked the momentum out of everything" she muttered, slamming the washing machine shut.

"The bloody Ombudsman's the real culprit," Sheila snarled. "Six years! That's averaging one complainant's evidence a year? Even a sloth could move faster."

"We'll be dead before they do anything," Sylvia sighed.

"Agreed," Sheila continued, her voice tight. "They don't care. Starmer's no better. They both want to avoid this hot potato. It's a vote loser you see. The other side will exploit it, just like they did with Corbyn. £181 billion stolen from us, and they'd rather see us perish than offer a single penny back. Even a small percentage of that is massive money. No-one wants that to land in their lap! "

Politics had become a steep learning curve for Sylvia, but she wasn't naïve. "You think Starmer's holding us back too?"

"Of course. He's no Corbyn. Corbyn and MacDonald fought for the people, even if it cost him the leadership and the election. Starmer just wants the status quo and Number 10. He'll do anything, and taking a stand for us right now would make him vulnerable." Sheila, a lifelong socialist, wore her opinions like armour.

"Do you think he'd offer compensation if he won?"

"Wishful thinking love. The Tories are crumbling, and Starmer's rising. I'd like to believe he has some integrity, that he'd do the right thing even if he stays silent until after election day. But realistically? They're all passing the buck, hoping the next government gets stuck with this mess. It's a financial and moral nightmare for them all. Here's hoping for a quick election, but holding my breath for Starmer's integrity? Not happening. I'd show my backside on the town hall steps if he did!"

Sylvia chuckled, remembering a similar conversation. "Beatrice said Glenda in Manchester wanted to do something similar at the Conservative conference, but some of the women thought it would be undignified."

"Show their... backsides?" Sheila raised an eyebrow.

"No, their big bloomers!"

"Well, they'd better be big ones if they are going to cover this backside!" She turned and stuck her bum out, and their laughter filled the room, a brief respite of humour in the storm.

Maureen came slowly into the kitchen, a tired smile gracing her lips, a silk head scarf printed with suffragette motif around her head that Adele had made her.

"What's this mischief?" Maureen eased herself slowly into a chair at the table.

"Feeling stronger love?" Sylvia asked, handing her the tea.

Maureen took a sip, her voice raspy. "No hair left, that's for sure, but otherwise... I think I might be getting better."

Sheila joined them, raising a biscuit-laden hand in a toast. "To warrior women then!" she declared, taking a large bite before it could topple.

The three raised their cups and clinked. "To warrior women"

Chapter Fifty-Three

March 2022 Christina Alone

Christina pushed open the door, the groan of the hinges echoing the dull ache in her back. Each day felt like an uphill climb, the burden heavier with every sunrise. Her recent denial for Personal Independence Payment stung – she could walk two hundred yards, they said, and continent! Apparently, that was all it took to be deemed "independent" these days, no concern for the pain that physically and mentally debilitated her every day. Independence, at least the kind that afforded a modicum of comfort, seemed a distant dream for anyone past sixty-five.

Despite her indomitable spirit, the relentless pain chipped away at Christina's resolve. Bills, like malevolent weeds, had sprung up overnight. A glance at her bank account, the latest heating cost a stark reminder, ignited a slow-burning despair. How long could she sustain this precarious tightrope walk? A suffocating helplessness wrapped around her; a shroud that refused to be lifted. She had been like this all through and since Covid. Yet, a flicker of defiance remained. There had to be a way to reclaim herself, to reignite the spark that had always fuelled her fight for justice.

Maurice's absence had left a gaping hole, his loss a seismic shift that had altered the very landscape of

her future. The path ahead seemed shrouded in fog; her purpose blurred. But then, a wave of gratitude washed over her. The Waspi women, her fierce band of sisters, and the ever-present support network on Facebook were lifelines, a testament to the enduring power of human connection. In their unwavering companionship, she found solace, a reminder that she wasn't alone in this storm.

That's what she would do! She would start a private help group, where women could buddy up and share their problems, and if enough came on board, they could potentially supply answers. She would run it by the group when they met next week.

She wasn't alone, there were so many out there, widows, sick, divorced, single women and even those with husbands who were struggling also either for money or as their carers. She had read the reports on the effects of the pandemic on people sixty and up and they were widespread and huge. The Waspi women were even cited in those reports, yet she could hazard a guess that would never be included in the Ombudsman's report. There were so many struggling.

So many previously strong campaigners had just disappeared from any presence on Facebook since Covid 19. How many were lone women who had succumbed to the pandemic, or the poverty and isolation forced upon them with no loved ones to post an obituary on their behalf. The numbers were approaching a quarter of a million now lost.

The government could issue compensation on what they had saved on their pensions alone to right this wrong. Christina had been a strong labour supporter all her life, but the recent revelations had left her feeling politically orphaned, with no trust in any party.

As the day progressed, the idea started to take hold and she sat down at her computer to find the path she needed to take to pull herself and others like her, from this mire of despair.

Chapter Fifty-Four

"Arthur, for goodness' sake!" Annette cried; her voice laced with sharp impatience. "Norway? How can I even consider a holiday when Maureen's so ill? It's simply impossible!"

Arthur, his voice betraying a touch of exasperation, countered, "Annette, this is madness! Three weeks my love. It's our retirement. We're supposed to be enjoying our golden years, not perpetually burdened by guilt. You can't let their struggle be your prison."

"But I AM burdened, Arthur!" Her voice trembled with a mixture of anger and frustration. "Can't you see? Living off you... how do you think that sits with me? All my life, I've cherished my independence, and now I'm reduced to this!"

Arthur, his patience wearing thin after revolving this discussion for several years, met her gaze with unwavering concern. "It's not about whose money it is, Annette. We're a team. In sickness and in health, remember?"

Her voice rose, laced with a bitter edge. "Easy for you to say! You haven't lived with this constant humiliation, this lack of respect for my contribution to society. All my life, I've paid into that pension. Can you show me a single man who's had six years of his retirement stolen? It's an outrage! Where's the respect, the trust? They're culling us Arthur, and you want me to gallivant around Norway? Look at

Adele – what state would she be in without our help?"

"Adele is recovering," Arthur interjected firmly, his voice gentling. "Right now, my greatest concern is your well-being. This anxiety is consuming you. You haven't been sleeping, you're constantly on edge, and the research... it's relentless. Don't you trust me, Annette? I see everything you're going through, and I truly understand why, but frankly, I'm worried."

Annette's outburst faltered, replaced by a heavy silence. Arthur's quiet words, devoid of anger, landed with unexpected weight. The dam broke, and she collapsed into her chair, tears streaming down her face.

"Arthur, I'm so overwhelmed by it all, I worry every day, about us, about dying before I get justice, about the women we're losing, I can't keep a cohesive thought in my head!"

Arthur got slowly to his knees beside her and covered her trembling hands, his voice a soothing balm. "We'll get through this love. But how can we fight if you're depleted? This manic behaviour, the sleepless nights... it's taking its toll. You need a break, Annette. A chance to breathe, to heal. Trust me, this isn't about abandoning anyone, it's about coming back stronger. For yourself, for them, for us."

Annette dried her eyes and looked at her husband. It had taken this meltdown to realise how badly her

self-esteem had been damaged by all this. She would make the call to the Doctor again. No doubt she would become one of the Citalopram crowd. Waspi women dependent on antidepressants to get through the day, but right now that might be preferable to the alternative...

Chapter Fifty-Five

Even now the lingering shadow of Covid hung heavy. "Right," said Sylvia," her voice calm despite the frustration in her eyes, "we can't stay in this holding pattern any longer. Women are losing hope."

Maureen, ever the pragmatist, sighed. "We're stuck until the Ombudsman gets a move on," she conceded. "But a meeting? That's a start. Let's brainstorm some ideas." A flicker of life returned to Maureen's face, her fine down of hair a testament to the summer sun's healing power. For the first time in years, a semblance of pre-Covid normalcy graced their world.

Shedding the fear that had gripped them for so long had been a slow, arduous process. Covid's scars ran deep, and for some, life would never fully resemble what it once was. Maureen, like many others, awaited the ever-delayed results of her tests, yet a newfound optimism coloured her spirit. The pallor that had haunted her during chemo had faded thanks to the restorative power of her beloved garden. More importantly, the freedom from the treatment's brutal side effects brought an immense sense of relief.

Everyone had rallied around her, and it wasn't lost on her that in this new world of me first, there had been a generation of people, that despite their own adversity, had done everything they could to see

her through a terrible time. It had opened her eyes to human kindness and one day she hoped to repay them.

The urge to act spurred her forward. With newfound purpose, Maureen settled at her laptop, fingers poised over the keys.

Meanwhile, Sylvia thrived at Jamie's florist. Her skills and confidence blossomed daily, despite Alan's venomous attempts to hinder any division of assets. Divorce, a financially crippling affair for anyone, proved especially brutal for Waspi women – their meagre incomes offering little leverage to escape the shackles of abusive marriages. The system, it seemed, was rigged for the affluent.

The cost-of-living crisis added another layer of hardship. "Heat before eat" became the grim reality, food banks a ubiquitous presence. Frivolous pursuits like holidays or theatre visits were now luxuries far beyond reach for most Waspi women. Society, it seemed, was being deliberately cleaved in two – the haves and the have-nots. And the Waspi women, by and large, belonged firmly to the latter. Their fight for justice had never felt more like a fight for survival.

Chapter Fifty-Six

Howdy Partner

Beatrice had forged deep bonds with several founding members of groups around Britain, particularly Glenda in Manchester and the formidable Welsh contingent fronted by her striking Welsh lioness friend. The Scottish women mirrored this fierce passion and dedication. Witnessing so many women generously donate their time to fuel the fightback was truly inspiring. While confidence levels varied, a remarkable diligence and, it seemed, an inherent creativity in their methods united them. The administrators behind WPIYPO, one of the most extensive groups, had been tirelessly toiling for years. Beatrice held them in immense respect for their unwavering commitment, devoid of any desire to control. This, she believed, was the essence of effective collaboration.

However, a nagging concern gnawed at Beatrice. The rigid compartmentalization within the movement, she felt, was the root cause of many of their setbacks. Divergent demands and endless debates concerning the nature and attainability of their goals constantly impeded their progress.

It mirrored the historical conflict between the more militant suffragettes and the letter-writing faction, both ultimately crucial for the campaign's victory. Likewise, Andy Burnham's online address to them,

highlighted the detrimental effect of internal clashes within the Hillsborough campaign. Only through unified action did they start to achieve success.

Currently, the ongoing friction between some of the main factions was a growing source of frustration for Beatrice. Women were desperate for a united front, yet human nature, at its most obstinate, seemed intent on sabotaging their progress. Why, she pondered, did they create self-inflicted obstacles?

Through a series of calls with key leaders, a consensus emerged. They craved a simple solution – a morale booster that facilitated collaboration whenever possible. It had to be an initiative individuals could embrace without seeking group approval. No additional structure was desired; merely a way to proclaim, "We're doing this, and anyone is welcome to join, regardless of affiliation." After the usual brainstorming hurdles, the name "Pension Partners for Justice" was born, a testament to the tireless efforts behind it, yet a straightforward concept.

This was not another faction. There were no leaders. It was simply a unifying spirit, allowing cross party events to be organised, the PP4J logo, a clear message of inclusivity for every group or woman regardless of affiliation. Forging unity was paramount. Egos, agendas, and internal squabbles had to be sidelined for the greater good. Ironically,

the very identities established to foster female solidarity had become a barrier to campaign success. It was time to work as one.

Chapter Fifty-Seven

Petals Falling

The tranquil garden buzzed with anticipation as friends gathered for their monthly meeting. Yet, a disquieting scene unfolded. Grace, oblivious to their arrival, toiled away in the soil. Sheila peered around her, concern etching her brow as she appeared agitated. "What are you up to Grace?" she inquired gently.

Grace, momentarily startled, resumed her task with unwavering focus. "Planting carrots for winter, can't you see?" She gestured towards a peculiar sight – not seedlings, but rows of supermarket carrots fully grown and harvested, their orange tops poking out like misplaced soldiers. The garden was Grace's foundation, it should be the last of her faculties to be affected, ingrained as it was for most of her life. Dementia was a fickle mistress. It took the least expected aspect of your life from you.

A wave of unease washed over the group as Maureen and Sylvia arrived. Sheila, her voice laced with trepidation, explained the situation whilst nodding pointedly at the ground. Sylvia, covering her surprise, offered a hesitant approval as Grace looked up, and Maureen grimaced in concern at Sheila, who was still desperately pointing out the absurdity.

The arrival of Manda, flustered from the breakdown of her van again, followed by a subdued Bindi, only heightened the tension. She plonked herself into a garden chair and called Bindi to "Settle" beside her, which he did, such a good dog. As Manda witnessed the carrot fiasco, a chilling realisation dawned on her. She had picked up many a dementia case in her role as a paramedic, and she knew the dangers for someone suffering from this wicked disease if they were left unsupported and alone.

"This isn't good," she declared, her voice heavy with worry. "Is that what I think they are?"

"Yes" said Maureen looking concerned to where Shiela was helping Grace to her feet. Manda looked back at her.

"You know her dementia has dropped a level don't you, she can't really be left to fend for herself without proper care now."

"I know, but what can we do?" asked Maureen.

The discussion shifted towards Grace's declining mental state. Whilst Grace pottered around her garden seemingly happy. Manda advocated for immediate intervention, proposing social services, and exploring alternative care options. Christina, known now for her new direction in supporting fifties women, was considered the best resource for navigating this new challenge.

The gate swung open, and Adele came in carrying a bag of her latest creations to show everyone. Annette was following up at the rear after locking the car. She was looking less drawn since she had had that holiday to Norway.

Manda and Maureen looked at each other.

"Are you thinking what I'm thinking?" asked Manda.

Coffee passed round, along with the cakes that Sylvia had brought, and Christina rushed in, as fast as was possible on crutches. The back was a problem again.

"Sorry everyone, bloody bus services again, where are we at?" She hadn't been able to afford to keep her and Maurice's car, and it stung. She had at least now her bus pass, but it was only as good as the service provided and rural routes had been badly hit, particularly isolating the elderly.

"We're going to need some help with Grace, we know you're good at this type of thing." said Manda.

"I can do that." Christina wasn't fazed at the prospect, which was a relief for all.

"Adele, what about you moving in with Grace for a while, she has a big house, and you can't stay forever above a garage… what do you think" Sheila asked.

"I don't know…could I think about it?" Adele quite liked her little bedsit, but it was small. Truth be known, she was a little nervous of Grace, and had heard horror stories about the effects of caring for someone suffering from dementia on the family. She didn't think she had the strength to deal with something like that when she could barely keep a lid on her own mental health.

"Of course," said Maureen "We'll need to take turns for now everyone. Is that ok?" Everybody nodded agreement.

Warm coffee and Sylvia's delicious cakes momentarily offered solace as the conversation then turned towards a solution for Grace, who was biting happily into a chocolate cupcake, oblivious that she was the subject of the conversation.

Sheila, with a hopeful glint in her eye, proposed a temporary rota for now. A rota was established, with everyone willing to contribute. However, a heavy silence enveloped the group when it came to Maureen's turn and the words spoken quietly.

"I won't be able to help, I'm afraid ladies."

They all looked to Maureen, especially Sylvia who had noticed how low she seemed the last few days. Seeing Maureen's face, a knot of dread settled in her stomach.

"Why Maureen?"

Maureen looked up and her eyes were full of tears. "I had my results, there's nothing they can do for me, except palliative care..." They were all struck dumb, except for Adele, who started to cry silently.

Tears welling up, Maureen revealed a devastating truth. Treatment had failed, leaving her with precious little time. The group, stunned into silence, witnessed an extraordinary display of courage. Maureen, ever the fighter, had refused further medical intervention.

Her final wish resonated deeply. She craved quality time with her friends and a dignified passing. As she finished, a promise hung in the air – a promise to fight for themselves and for her, even in the face of this cruel blow. Everyone to a woman promised. Their friend had always been the best of women, and they would not let her down.

What could anyone say about this? A woman so badly treated, faced the tragedy in her life with absolute dignity. Who had fought for others as much as herself, to be put through the hell of chemo, only for it to fail. She would have months, not years she said, and frankly she did not want to put herself through the nightmare of chemo again. She preferred you live out what was time left in peace.

As they left that evening, there were tears, but much more. There was so much anger burning within each of them, for this cruel injustice and

even crueller fate. Yet, amidst the grief, a renewed determination flickered, fuelled by love, admiration, and a vow to keep their promise to Maureen. They were one.

Chapter Fifty-Eight

Fightback January 2023

Christmas had come and gone and what little festive spirit they had manufactured for Maureen's sake was gone, leaving a heavy silence in its wake. Maureen's terminal diagnosis and the relentless decline of Grace weighed heavily on them, a constant blow to the gut. Yet, they persevered, each member shouldering a piece of the burden. They had come together to decorate her house and give her the best time they could, but no one was fooled, least of all Maureen, but she played her part out of love.

Beatrice, now a tireless campaigner, teamed up with the Welsh women for the "Fightback Rally." Muffled whispers surrounded the WASPI campaign, a flicker of hope that the Ombudsman might be challenged before their final report was released. There was so much wrong with the Ombudsman's process. It needed massive reform.

A pervasive frustration hung in the air; the women needed a spark to reignite their spirit, a resurgence after the long, isolating grip of Covid. Back to Sixty was still pursuing the CEDAW convention and discrimination route, and it was discrimination without a doubt, but would it have any teeth in law? Everyone hoped that one of the groups, or

both, would shine the light to long awaited justice. Their efforts certainly deserved it to be so.

Maureen's strength waned with the winter, the harsh weather confining her mainly to the warmth of her home. Sylvia wasn't certain if her secret project had reached a natural conclusion, or she had succumbed to fatigue. More often than not, Maureen sat by the window, a haven for silent contemplation.

Occasionally, on good days, Sylvia (now listed on Maureen's car insurance) would whisk her away to the Deal beach, or, when the weather conspired against them, to the comforting heated embrace of The Botany Bay Hotel. There, amidst the gentle chatter and the crashing winter waves in the distance, through the large glass windows, their minds found solace overlooking the bay.

Maureen's walks were limited, and the proximity of a restroom a constant concern. It was an indignity she bore with quiet grace. A wheelchair loomed on the horizon, a suggestion Sylvia dreaded voicing, yet a reality they both acknowledged internally.

The women's visits, though sometimes laced with a tinge of forced cheer, brought a flicker of joy to Maureen. Sylvia's gentle inquiries about fatigue were met with a weary smile. "Time for tiredness when I'm gone darling," she'd say, her eyes crinkling at the corners. "Your chatter warms my soul." With that, she'd close her eyes, a peaceful smile playing

on her lips, the pain medication a gentle lullaby. Her energy was too depleted to join in.

Beatrice kept them abreast of the rally preparations. Their aim: a maximum turnout on International Women's Day. "Parliament Square it is," Beatrice announced, a glint of determination in her eyes, "so they can't ignore us."

Gill, one of the organisers in Wales, after all her hard work, was too ill to come and was warned off by her doctor, which frustrated her immensely. She would now be back at base in Wales, organising coaches and sharing her heart out to all the others waiting for news. She was a powerhouse, despite ill health.

Though not solely their cause, the rally, organised by the Women of Wales, fell under the PP4J banner, a beacon of inclusivity. Everyone was welcome, and everyone was pitching in. The normal rumours of trolls trying to cause trouble abounded, but they accepted that in campaigns as large and diverse as this, there would always be the dissenters. Human nature was human nature, but it angered Beatrice that the types causing friction rarely contributed to anything positive. Coming on posts to comment negatively for five minutes of their day and doing little else to help the cause.

Maureen longed to attend, but the reality of her condition settled upon her like a winter frost. The weather seemed to be constantly awful, and she

could not possibly endure the journey and the negative conditions.

The team had even approached Mick Lynch, securing his assurance of no train strikes on that crucial day. An anonymous donation fuelled the creation of three enormous banners, and the "knickers stunt", much to the disapproval of some, was also back on the agenda.

They had a list of MPs and supporters coming as long as an arm and the amount of activity being prepared for the day was exciting. Big numbers were responding and at a time when the majority of older campaigners, there from the beginning, were now approaching seventy, the commitment was heartwarming.

They were now living with the real threat of arrest as the police were being given more rights and the humble protester was having theirs taken from them by new legislation. Organisers could now be given up to ten years imprisonment if any one attendee breached the law on their event in some cases. It was a worry, and a scare tactic, so much that Beatrice had studied 'what to do if arrested' and intended to go with the support line number on her arm, just in case! The sheer amount of planning and communication was staggering. Three months of relentless work, day in and day out.

The relentless online harassment, the "trolls," remained an enigma. Fay, the main organiser, bore

the brunt of their vitriol, her resolve a testament to an unwavering spirit. "We must be doing something right if they are trying so hard to destroy our credibility" she would say. Thank goodness she was made of strong stuff; lesser women would have crumbled under the onslaught. It was a highly stressful time for the organisers, as so much relied upon them.

A chance thanks on Facebook, to a lady who was too ill to go but wanted to pay someone else's fare that couldn't afford to go, set off a deluge of donations, so that women who were fit enough to attend but could not finance the journey, could attend. It was exhausting for Bea juggling the ins and outs, to and from the fund, but they managed it, and she was proud to do it. Yet even prouder of the women who had made it possible by their generosity.

One woman, in the final moments of cancer, arranged for her twin sister to donate in her stead, ensuring another two women's presence at the rally. Her courage, her dignity, shone brighter than any star. She lost her fight just before the rally date.

Another, disabled and living in Scotland, journeyed on her motor scooter by train, an embodiment of unwavering commitment. These women, with hearts of steel, possessed more integrity in their little fingers than half of Parliament combined.

The day finally arrived, and Bea was up at the crack of dawn. She was catching the early train and a neighbour had offered her and the three huge banners a lift to the local station. She had checked the night before and when she awoke and despite the awful weather that had been deluging for days, her train was on time.

Five thirty am she received a text from Fay in Wales. The coach was still going, but some women couldn't get to the pickup point because of the Blizzard, so they might be delayed…What! There hadn't been proper snow in years! The transport gods, seemingly in cahoots with the weather, decided they weren't destined for a smooth journey.

Arriving in Sandwich, Shirley parked in the drop off zone.

"I'll carry your banner whilst you pick up your tickets" her friend had said, and they both walked to the window. The woman behind the glass checked her ticket.

"Your trains been cancelled" she said without the slightest inkling of the trauma she had just delivered,

"The next one?" Beatrice asked panic struck.

"An hour, but no guarantees, the trains are being cancelled right across the country due to the unprecedented weather.

Bea stood there frozen in a moment of panic, they had to be there for Noon, it was eight am. The adrenalin started to flow, she had the banners and was making a speech. How bad would it be if she wasn't there.

"Canterbury?" asked Shirley, it was a main station.

"Too far! Ramsgate!"

"Come on get back in the car" said Shirley and her saviour bundled her back in whilst she made frantic train searches. The Ramsgate train was still running but wasn't picking up after Ramsgate in order to make up time.

After a journey that seemed like a chase from Starsky and Hutch, Shirley swung to the curb at the front entrance, she had three minutes to go. Beatrice grabbed her bag and the large roll of vinyl banners and ran like a demented carpet fitter, why was it always the furthest bloody platform? and she on blood pressure tablets!

The train pulled out of Ramsgate and picked up speed, when it occurred to her there might be other women getting on at Margate and would have the train shoot past them. In fact, it didn't. In the final insult, it pulled up at the station as Manda was coming up the last few steps onto the platform. The train stood and didn't open its doors despite being in front of time, and Bea looked like a frantic escapee from an asylum, hammering to attract her attention on the windows. How many women's

trains were being cancelled today. It felt like the world was conspiring against them.

Checking her time, she would be ok, thank goodness, but she would need a taxi. On the train she met two ladies who'd never protested before, and they agreed to share. Bea bundled them through the station. Relenting briefly to let them go to the loo and then virtually threw them into a taxi.

Normally the journey took fourteen minutes, but today, there was accidents in the city and the roads were at a standstill, Bea felt if anything else went wrong she would start screaming like a banshee and never stop. It was then she noticed how hard it was raining. It never rained in London on protest days!

The journey excruciating took over forty minutes and she was fifteen minutes past the start time, she handed the banner to the ladies travelling with her and said, "Here's my fare, I have to run, will you bring the banners to the Millicent Fawcett Statue over there, anyone will point it out" and with that she leapt out of the taxi and ran through the crowds.

Fay had made it thankfully, complete with their local Town Crier, a lovely man, and the widower of a Waspi Woman, who always supported them.

She was doing her speech through a veil of rain, coming down like stair rods and the green was now under two inches of water, it was horrendous.

Sheila had stayed with Gina the night before and was holding out the loud hailer to her. Her hair plastered wet to her bare head, as she grabbed it with relief.

Handing over the five hundred memorial cards she had had printed as a thank you for all the attendees to anyone close by with the instruction to share them out, she climbed up onto the raised steps below the statue to speak.

Everyone was wet through. There were a couple of news crews there, but nothing like what they had been told to expect. It was soul destroying after months of relentless work.

The sing song was impossible as nothing could be heard above the blanket of rain, everyone was soaked. It was not good, especially for elderly women, vulnerable to chills.

As soon as she had finished her speech. She made her way down to the front of parliament where bless them, the ladies had handed out the large banners and they were being walked down the centre of the road eight women to each, bringing traffic to a standstill and Bea, sent up a thankyou that at least one of the things they had planned was going right.

Apparently, she had missed Corbyn and Lord Sikka who had come early to support them and was devastated, she so wanted to shake their hands. Other supporters were there but she was not able

to distinguish them in the large crowd, who were now doing a slow walk across the zebra, effectively stopping all directions of traffic.

Finally finding Fay, she shouted 'Knickers?' to her.

"Lost the stunt crew in the crowd, no one's checking WhatsApp" she shouted back.

"Bugger! Right! anyone brave up for a stunt" Beatrice bellowed to anyone close enough to hear.

"I'll do it!" called one woman.

"Great, follow us," said Fay.

No one ever thought of the eventuality of having to put large bloomers on over layers of wet clothes, wearing boots and in pouring cold rain, soaked through to the skin and too old to balance well on one leg, could be so challenging. But hopping, staggering, and laughing, they managed to get the volunteers costumed. It was like herding geese… Miraculously they did it, without putting any backs out and as they walked into the road, their fabulous campaign photographer stepped up at exactly the right moment to take an iconic shot.

They even managed to pull off a rather impressive (if slightly geriatric) can-can with a message for the Ombudsman as they up'd their skirts and bent over. It was a far cry from the glorious day Bea had envisioned, but there was a certain comedic absurdity to the whole thing, a valiant (and very wet) fight against all odds.

BUM DEAL! The knickers spelt out…

It was only on looking at the pictures days later that they noticed the sign on the crossing they had blocked. LOOK LEFT it said. Perhaps labour might step up after all…

The women valiantly stuck it out for over four hours, Sheila came up to her with blue lips and she was wet through.

"Sheila, go get yourself indoors somewhere with a coffee, you look hypothermic."

"I will," she said, shivering. "Everybody's going now anyway, they're all so cold" she replied. Fay had had to take the Welsh contingent back to the coach meeting point and hadn't even had time to say goodbye.

How quickly everyone had dissipated. They had made their mark, but it was not the glorious day that Bea had thought it would be. Twenty years of events management and she had never encountered combined conditions like this.

Left to clean up with a woman who had travelled from Ireland and in no rush, she found the banners, about to be thrown away, crumpled on the pavement and she picked them up wearily, a feeling of defeat coming over her in a wave. They rolled the banners up, which felt twice as bulky as when she arrived, and the ratchet straps to secure them that Roger and Deidre had lent her were missing, so

that would be fun on the journey home. Sheila had forgotten her loud hailer, so she added that to her already cumbersome luggage and hailed a taxi.

There was usually a train to Sandwich on the platforms at St Pancras and she stepped onto the escalator and ascended, eager to be home. As she approached the gate, she asked the ticket officer if this one is the train to Sandwich.

"No, Dover" he said, "but I suggest you get on it if you can, as they are likely cancelling all trains after 5pm, It's leaving any second". It was ten to five.

Beatrice ran, knowing she couldn't bear the alternative. Climbing onto the train, like a drowned rat, she manoeuvred slowly towards the nearest empty seat, aware she was clumping hapless fellow travellers on the back of the head with the banners. Her faux fur hat probably smelt like a wet dog, and she was soaked to the bone and not the most pleasant travelling companion for anyone.

A young Asian guy beckoned her to sit opposite him and started to ask her about her banner and the protest. He must have seen the desperation in her eyes. She sat down in relief, but with no idea where the train was actually heading and started to search this trains route on her app. Thank goodness for the internet. She rang her neighbour.

"I think I'm on a train to Dover" she sniffed.

"Its fine, text me what time and I'll pick you up" she said.

Bea walked out of the station a sorry sight and close to tears as Shirley opened the car door. Greeted by a concerned banana, a bag of crisps and a flask of coffee from her ever-supportive neighbour, Bea couldn't help but laugh. Her normal sense of humour was reasserting itself. Although the laughter might have been bordering hysteria.

"Well done" Shirley, an ex-lecturer said, in a voice reserved for high performing students, as she turned the car heater on full to defrost her and stashed the banners in the back seat.

It hadn't been the protest she'd planned, but as Maureen, the wise woman of the group, pointed out the next day from her daybed on the sofa as Beatrice poured out her trauma, they'd made their mark, and that, in the grand scheme of things, was what truly mattered. Beatrice couldn't have loved Maureen any more than at that moment.

Chapter Fifty-Nine

No Words

Christina got a desperate call from Sylvia at 7am a couple of days later. Maureen had been really struggling overnight and she was at a loss of what to do to help her.

"I'm on my way" Christina said, a ball of despair knotting in her stomach, as an ex-nurse, she had been watching Maureen's recent decline and she knew she didn't have long. The call went out on the WhatsApp group to warn everyone they might be needed.

Sylvia called the helpline and was assured the Macmillan nurses would be out asap that morning, and she went back upstairs to give Maureen her tablets. Hopefully they would give some respite from the pain, but it wasn't enough, she needed stronger now.

Maureen, spaced with the meds, was waving towards the sideboard, and after a few confused moments Sylvia realised that she wanted something.

Opening the drawer, she found two large and heavy brown envelopes with 'In the event of my death' written on them. Maureen knew also her time was limited.

"I want you to handle everything, it's all in there. All the information you'll need. Promise me you'll do everything I've asked; I'm relying on you." Maureen clutched Sylvia's hand as she put the envelopes down on the bed.

Sylvia started to cry, slow, silent, big tears that she couldn't stem, and so she sat holding her dear friends' hand, unable to speak, and just let her talk.

"I'm so angry Sylv… I'm so close to my pension, and I wanted to live long enough to not let them get away with stealing my life, I just wanted a few good years of respite, was that too much to ask?"

"It wasn't my friend, and you deserved so much better than this." Sylvias' throat hurt so much with the effort not to sob that she could barely reply.

"I have no family. Will you scatter my ashes in the garden where Ruth is, promise me!" Her head fell wearily back against the pillow. Then as an afterthought she raised her head again,

"Don't let them take me into a hospice Sylvia, I want to be here, with all my friends around me…" She was too weak to talk further, and she lay back on the pillow. But her eyes burned into Beatrice's still fighting to be heard. Ever the warrior. Never silent, even when the ability to speak was leaving her.

"I will do everything you ask, you have my promise" Sylvia vowed, and satisfied, Maureen slipped back into sleep once more.

One by one, they arrived at the house, solemn, with pain too great to express. All standing quietly around the kitchen, whilst Sylvia made them cups of tea. What else was there to do? There was no chatter, no laughter, just a dawning realisation that they were going to lose a wonderful friend, far too soon.

Every fifty's woman lost was like losing a part of themselves. 300.000 plus of 3.8 million, now gone, and one more precious life to follow soon. The clinical numbers masked the true devastation that losing just one of these brave women was to everyone that had known and loved them. Maureen was loved, alone inevitably, but loved.

Mothers, Grandmothers, Daughters, Friends, Wives, Partners, Sisters, hardworking and often amazing women, betrayed by the country they had been taught allegiance to. Beatrice stood looking out the window as the others talked stiltedly. "I am no longer a citizen of this country!" she fumed inwardly.

One by one, they took their turns to sit with her, to talk as if she could hear, even when her eyes were closed. They would talk of protests, of the fun they had all had. Of the laughter. They wanted the last words she would hear to be of strength of

sisterhood. Each one sitting holding her hand until it was time to leave her to the care of the next, and then they would go home to sob out their grief.

Even Roger took his turn as a mark of respect, and he burned with anger that this woman, who had fought so hard, and had been so kind to everyone she encountered, had been left to die without justice, but he spoke none of his feelings. Instead, he regaled her with funny stories about Deidre, about the other women, never once letting his mask slip.

Maureen passed away peacefully six days later, just weeks short of her new state pension age of sixty-six. Taken quietly by the morphine, with Sylvia, Sheila and Annette watching over her, inwardly heartbroken but ready to smile the moment she opened her eyes. She would smile back, almost up to the moment her breathing grew shallow and then almost imperceptibly stopped.

The three of them looked across to each other in shock, the quietness of her passing, taking them by surprise. They had expected her to fight, but Maureen never did the expected.

Calling the nurse, who had been having a break in the kitchen. They hovered behind her as she checked her pulse.

"She's gone ladies, at peace now, I'm so sorry". the nurse said. Sylvia put her hand to her mouth to

stifle the sobs that were exploding upwards from her throat.

She sent them downstairs whilst she saw to Maureen. It was a loss that none of them could vocalise. It was too great.

As they sat there in silence. Sylvia prayed that she was indeed at peace, that there would be something for her to go to, and that her beloved Ruth would be waiting for her there. This couldn't be the end surely, after all these wasted years fighting. It would be too bloody cruel.

"What do we do now?" asked Sylvia.

"We do what she would have wanted and carry on." said Annette quietly.

Chapter Sixty

A Guard of Honour

The day of Maureen's funeral dawned, and the women gathered one by one near the crematorium. It was a lovely place out in the fields of Kent, and looking about them, the trees were bursting into full blossom, something that Maureen had loved. It was her favourite time of year; she had told Sylvia one day, as they went out to tackle the winter growth and bring the garden back to life once more. Spring was for regeneration, but to these women it was just one more year on, one more year of fighting. One more year in the growth of their disgust for government. One more year with so many more to add to the honour roll.

There were a few friends from Sylvia's neighbourhood and the community groups she had supported, but the most impressive presence was that of the fifties women that she had befriended over the years of her fight, who had made the journey to honour her memory, and all the years of support and effort that she had put into the campaign.

They stood in two lines in their suffragette purple, white and green, whilst the coffin moved between them. Members of different groups with sashes that spoke of more than allegiance, but of the fight for their rights. Today it didn't matter that they had not

always agreed in policy, but as women, they were bound together in grief and respect. Messages from those who were too frail or too poor to make the journey abounded.

The Margate group went over to The Botany Bay afterwards, as it was Maureen's favourite go to, so it seemed the right place to say their last goodbyes. The day was sunny and warm, and after the meal, the women sat outside on the veranda, no one had any words, it was just too much.

Sylvia had been overcome with her grief and strangely quiet in the days leading up to the service. Christina thought she was bound to be the most upset, as they had been so close the last couple of years.

Not aside from the fact she would now be having to search for a home of her own. Luckily for her, she had recently had her settlement from her ex-husband and had now the means at least to fund a small flat. Maureen had given her the greatest gift of a haven in which to rebuild her life. Sylvia owed her so much; she was bound to be devastated.

"Ladies, Maureen has asked me to convene a group meeting and I wondered if we could do it Friday?" she asked quietly.

Sheila laughed and broke the tension "Well bugger me! She's still leading this group, even from the grave. Atta girl Maureen!" Everyone laughed. It was just like Maureen to organise them all.

"She's making sure we keep going," said Christina. "Well, I for one will be there. I'm starting a full charity that supports people over the age of sixty. It's a combination of food bank and buddy service for those people who are isolated or ill. I had to do something, or I would have gone mad! I'll be looking for support and I'm starting a fundraiser, which I'll need some help with. Volunteers please?"

"I reckon I can help you there," said Sylvia wit. a quiet smile.

"Me too" said Manda "At least till my vans' fixed and I can afford to foot the bill! although that's not looking so good at the mo." The van was one tappit from crumbling. She really needed to scrap it and start again.

"Great. we'll talk Friday," said Christina.

A waitress came out with a tray, glasses and two bottles of champagne. Sylvia smiled." Maureen said she wanted you all to have a drink on her, something we couldn't normally afford, so she ordered a couple of bottles of the best" for us.

The waitress popped the cork and they all looked at each other and laughed. Roger took his glass and grimaced. "I think I might have preferred a cider." he grinned.

"Trust Maureen, last laugh!" said Beatrice.

Friday morning came and they all filed into Maureen's kitchen. It was a moment that was poignant as they looked around the familiar things, left behind from years of making their home, but not precious to anyone but her and Ruth. They would have to be boxed and disposed of, with nothing left but a few keepsakes for the woman who remained to dismantle the trappings of a life that had deserved more recognition for all she had achieved.

Sylvia had made a cake and it sat in the middle of the table wrapped in its purple, green and white ribbon. It was an occasion after all, she thought, and Maureen would have liked the touch.

As they all sat down with a mug of tea and started to share out the slices quietly, the loss of Maureen was still raw. Sylvia moved over to the dresser and pulled out a pile of paper, placing it squarely in the middle of the table.

"What's this?" asked Annette.

"Maureen's book…" Sylvia said. "She wanted the truth out there, but she thought non-fiction wouldn't have the chance to engage with the general public like a novel would, so she wrote about all of us." Sylvia smiled. "Problem is she wants us to publish it and market it."

"Ever the organiser!" said Beatrice.

"Crafty little bleeder" grinned Sheila mouth open.

"She wrote us all a letter and you may be surprised at the contents." Sylvia picked up the letter and unfolded it, clearly emotional.

My dearest friends,

By now, I hope you're reconciled that I won't be here to nag you anymore. But indulge me one last time, for this is my farewell.

These past few years have been a tapestry woven with shared burdens, laughter, and an unwavering fight against injustice. Each of you has become a thread in the fabric of my life, a source of solace and strength I cherish deeply. You are more than colleagues; you are my chosen family.

We stand together, bound by a spirit once celebrated in British women: fierce determination and unwavering compassion. In a world often consumed by self-interest, our bond shines ever brighter.

You have all been the dearest friends and I thank you all for making my time over these last few years less painful. It has been an absolute joy to be in your company and fighting beside you. I am honoured to call you all my friends.

This book, Sylvia's burden now, is a testament to our struggles. It is my final act of defiance, a weapon to wield against the darkness we face. I

apologise for the weight I place on your shoulders Sylvia, but the fight lives' on through you all.

Sylvia holds the details, and she will share my wishes with you all. But seriously girls. I have no surviving family to ask this of, but if I could choose my family, it would be all of you. In fact, I do choose you as my family and with that in mind Sylvia will be happy to explain the bequests to follow.

As for the book, my warriors, my portrayal of your bravery speaks volumes. Though names may differ, the characters embody the spirit of every woman who has suffered under this inhumane policy. Remember, giving up is not an option. I may not be here in person, but I'll be watching – and trust me, haunting you is preferable to seeing your fight falter!

A small sum remains to bring my book to light, but the bulk of my estate rests with Sylvia. She has the option to buy my house at a fraction of its worth, a token of my immense gratitude for her unwavering support. Should she choose this path, I have instructed that the purchase sum is to be divided equally amongst you all, a small gift of respite for you from the hardships we've endured. It's not what you deserved, but pretty close to the amount of one of your lost year's state pension back. It is my gift for your unrelenting friendship.

Words cannot express the depth of my admiration for each of you. Never stop making your voices heard. Let history remember your fight and let them know – WE WILL NEVER BE SILENCED! Remember the next time you're out on that green that I am NOT GOING AWAY. I will be standing beside you in spirit, and I hope my book will be there for generations that follow, forever pointing a finger of shame at the perpetrators of this cruel policy.

With unwavering love and gratitude,

Your friend and fellow warrior (always) Maureen

For the first time in many years there was stunned silence around the table.

Chapter Sixty-One

Still Not Going Away

2023 had been a sad and frustrating year for them since the loss of Maureen. all months of nothing, in a hiatus brought about by the Ombudsman and government combined. MPs with a conscience were asking questions of the Ombudsman's system and lack of teeth and speed. This was in no little part because of the campaigning of women they thought they could ignore.

For a certain group of women in Kent they had spent this time honouring Maureen's wishes. Each of them using her bequest to them in their own special way. Manda bought herself a new van, and she, Beatrice and Annette were taking it out with the three large banners to hit various iconic places in southern England to raise awareness.

Christina also bought herself a small automatic van and spent the rest on a year's rent of a unit to start her food bank and buddy service. Her laughter and intelligence as always, drawing people to her in the fight to make lives easier. Sylvia was her deputy when she wasn't working with Jamie at the shop.

Sheila had moved in with Grace and Grace was still leading her a merry dance, but she kind of enjoyed the chaos. Her big heart not able to leave her to the

fate of being dumped in a care home and consigned to goodness knows what.

Adele's business was starting to thrive, and she was making a modest living, she was still at Annette and Arthur's but was saving hard for the deposit on a flat rental of her own.

Deidre and Roger finally made the promised return to where they had been married in Italy and, on their return, they used Maureen's bequest to reduce his working week to four days, until Deidre's pension was finally due, to give them some respite. Every little helped. Time together was far more precious than money after all.

It was March 2024 and the Ombudsman had been challenged after a fundraiser through WASPI and made to re-review their findings. Back to 60 was fundraising for more court action and it was almost like Groundhog Day.

The final report was due soon, for what it was worth. It still would have to be taken up and acted on by the government, whoever would soon be in power and ultimately must be addressed by the DWP.

The signs were already there that they were getting ready to shaft the women once more. The Ombudsman looked likely to offer less than some women had spent on train fares to protests over the years and it would be an insult.

The fear was that the ombudsman's scale of compensation was so restrictive that it would be utilized by an unscrupulous government to restrict compensation to, at very best, a tenth of what the average woman had lost in pensions and savings. Let alone compensate them for a lives destroyed.

MPs with integrity where shouting loud in debates once more, almost ten years on from the start of the campaign, that compensation would likely be trivial, and a disgrace. The women should be properly compensated.

If the Ombudsman did the right thing and offered a recommendation of substantial redress, there was a government currently, who had no intention of paying a debt of honour, even though that had been legally achieved. There would still be a huge fight to come.

They had been here before, and likely would be here again very soon and to coin a phrase from Christina "The fight continues."

People were waking up and with the recent Mr Bates Drama, they were starting to realise just how much corruption was in play in today's society. Another scandal, as with the bad blood, Covid and care homes, Hillsborough, and countless others, stonewalled until the campaigners died or became disheartened. This was how the government would continue to operate until the dysfunctional systems

changed, and integrity and common sense prevailed.

As Beatrice pinned on her suffragette hat badge, given to her by a lady she was close to, but who could not travel, and who wanted her to wear it to take a small part of her with them. she and Sheila walked onto the green with the loud haler, followed by the others carrying boxes. The crowds of purple, green, white, complete with WASPI, Back to 60, We Paid in you Pay Out and the other groups sashes were in abundance as always.

Yet today was different. Today was yet another debate, but today was also launch day. Today the books were being given to MPs on their way to speak in support of them, and the book itself was going live on the internet. If all the women bought on the same day, it would fire the book to the top of the charts and then the message would be out there.

The 'Still Here' Book Group as they called themselves, had interviews and appearances lined up. Media was finally wanting to talk to them, instead of them frantically pursuing the media.

As Sylvia, Manda, Christina, Annette, Sheila, Adele, Beatrice, Deidre, and Roger and today, Arthur, (who had finally caved) piled the free books high to give out as promotion for the Launch there was a real

excitement building as the women collected them to distribute.

There was no fancy artwork. Maureen hadn't wanted to distract from her message. A simple cover, featuring a 50's women and her dog, bearing an uncanny resemblance to Manda, bore the proud words.

NOT GOING AWAY!

THE END...OR NOT

AUTHORS MESSAGE TO THE 1950'S WOMEN AND THEIR

SUPPORTERS

I have written this book to bring the truth of the effects of the pension injustice and the over half a decade of pension deprivation that has been endured by the 1950s women...and the ten-year fight so far, to the fore.

The characters you see portrayed are a mixture of the personalities of the many women I have been privileged to encounter. Several of the characters have elements of more than one woman's personality and circumstances combined.

Please note any political views contained within are my own and those of others I have come into discussion with, and not a reflection of any one campaign group's views. I have great respect for many of the genuine MPs fighting on our behalf. I do not respect the sycophants and the ambition addled!

There are so many women in this campaign that I would like to name but will not be doing, so as not to single any one person out, (with the exception of the three in my dedication). I cannot tell you how hard it has been. Please forgive me if I have

inadvertently not included your story, there was just too much, and the story needed to be simple to flow.

As far as I'm concerned, each one of you that has stood up against this injustice in any way, whether you share my personal views or not, is deserving of great admiration for your strength, your spirit, and your contribution to the overall campaign for 1950s women's justice. Only true unity will win the day. Those who lead the groups need to pursue this or we are lost and when they are able to work together, they have a responsibility to all the 1950's women to make all best endeavours to do so.

For those of you that would argue we should not be referred to as Waspi Women. I understand but make no apology. I have no allegiance to any one group, but respect for the work of all their members. It just happens that my area group was Waspi East Kent and for the purpose of the story, it was natural to base the story around them. WASPI has been suggested for inclusion in the dictionary, and the people outside our generation are more likely to recognise us under this description than anything else...

If you have enjoyed this book, it is so important to get the awareness out there. Please share it on Facebook and Twitter to help get the 1950s women the true justice they deserve, and the

enormity of what has happened to them into the public consciousness.

Thank you all, Dee Wild Kearney

My thanks also, to all the women who have sent me their pictures to include, especially our wonderful campaign photographers Ann Syers and Cheryl Prax, whose skills have produced some wonderful insights into the women and men of this campaign and their spirit. I have also included my own photo memories.

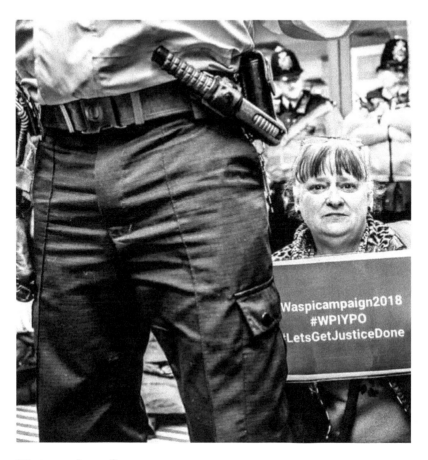

Picture Ann Syers

My Thanks to Ann Syers and Cheryl Prax - Campaign Photographers and Timandra French.

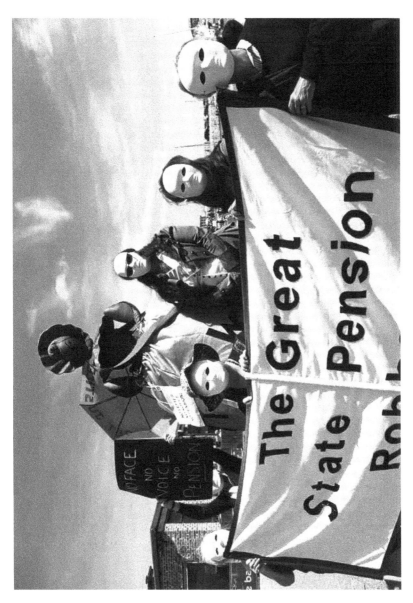

Photo Timandra French

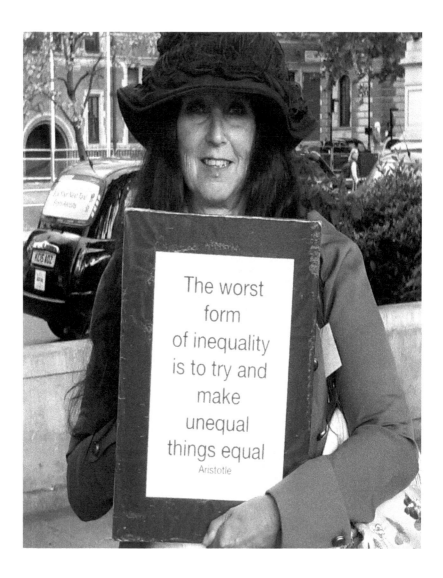

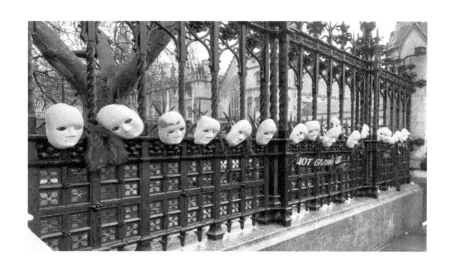

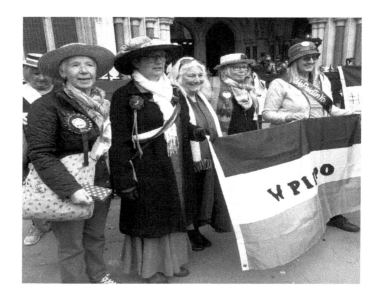

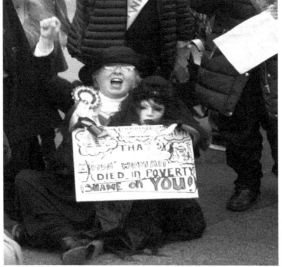

Picture Ann Syers (above)

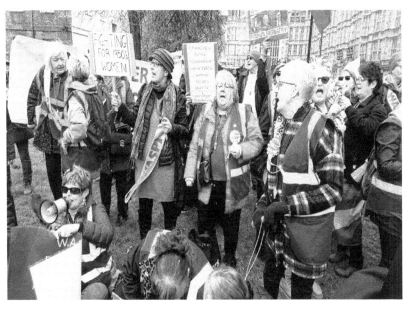

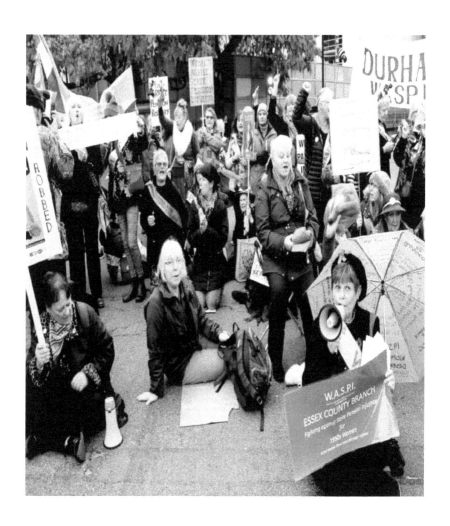

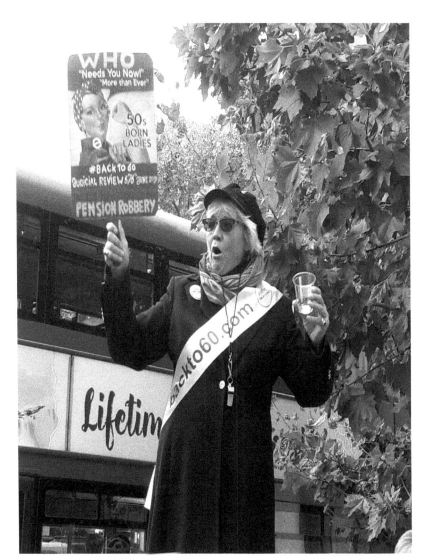

Photo Timandra French (below)

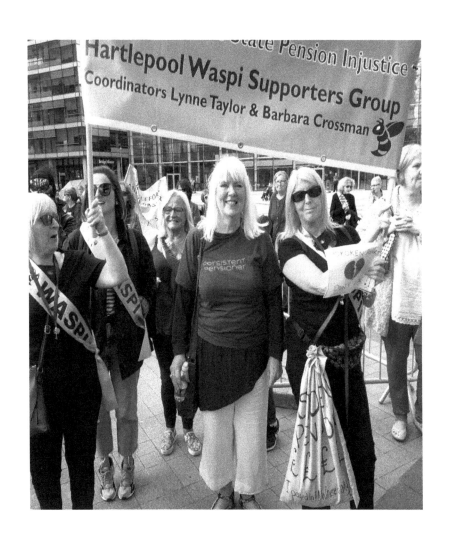

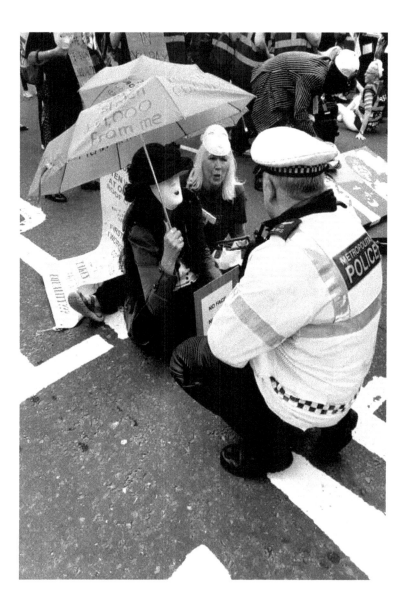

T

This woman, (below) a nurse, had just found out in 2019 that she could not retire for another six years. "Her body," she said, "was broken." She came up to me on the Royal courts of justice Steps to ask why it had happened to her.

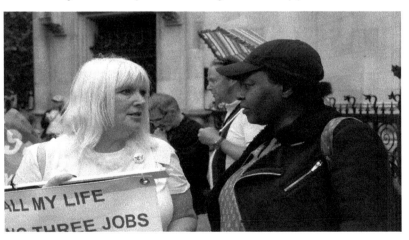

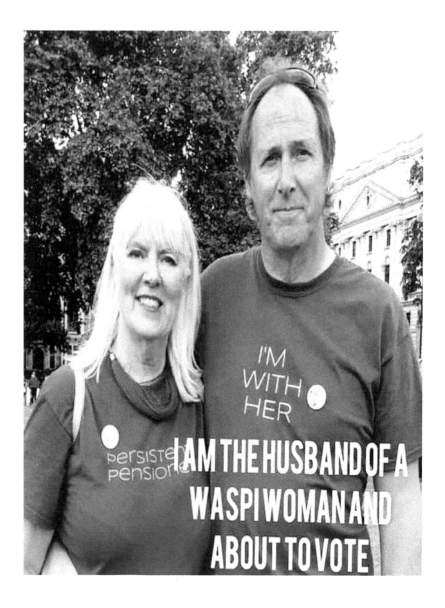

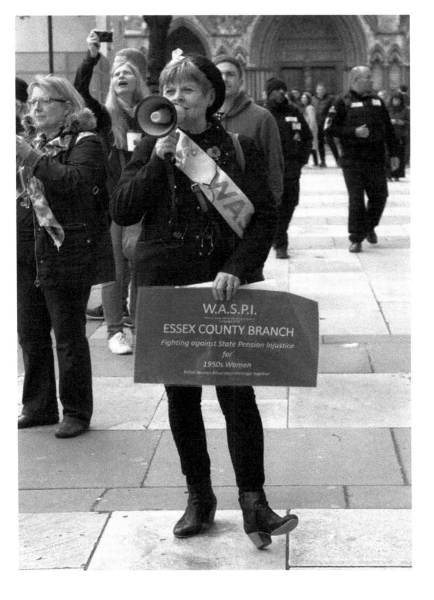

Photo Ann Syers (above)

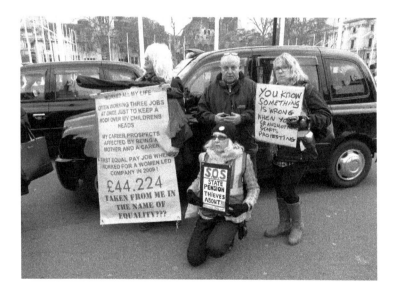

Photo Ann Syers

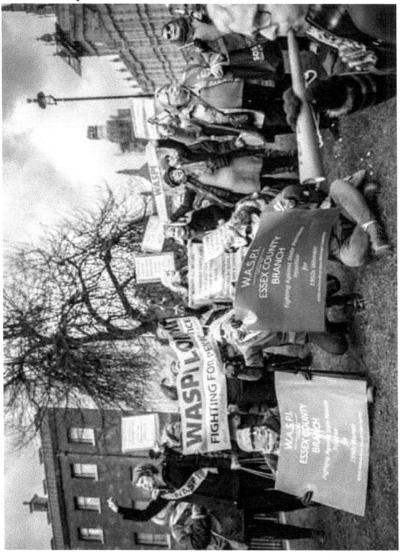

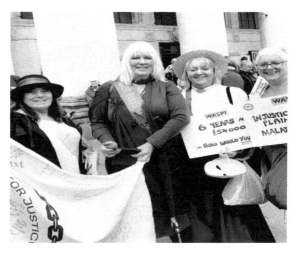

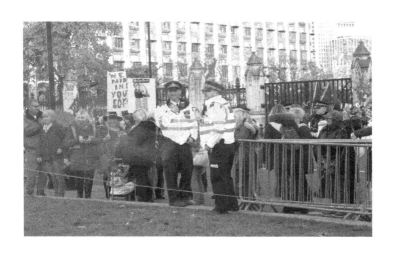

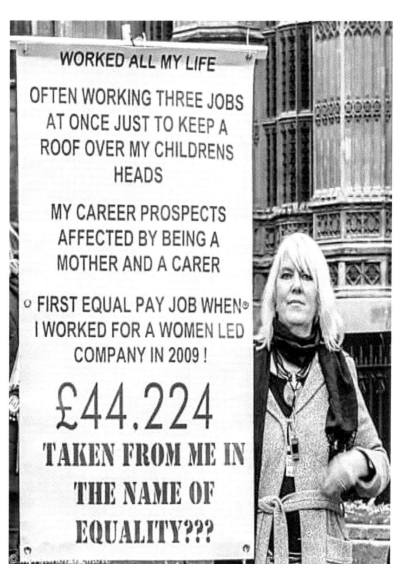

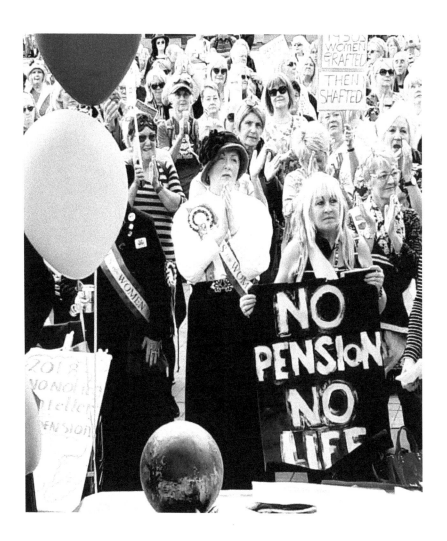

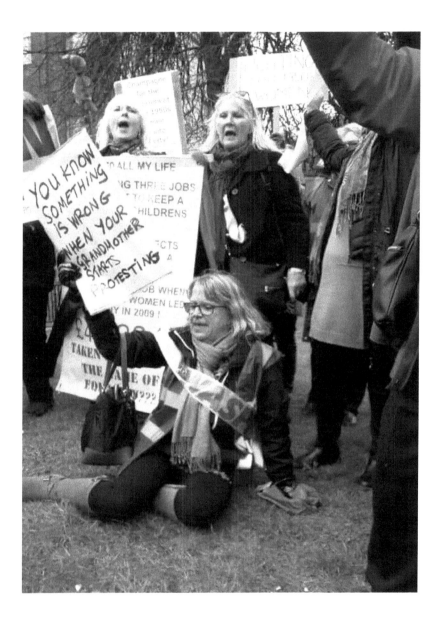

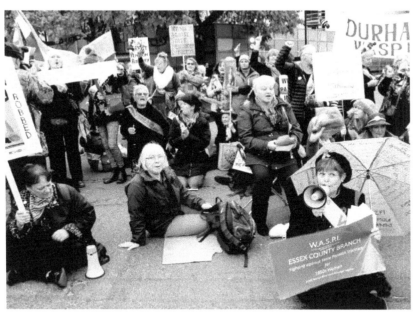

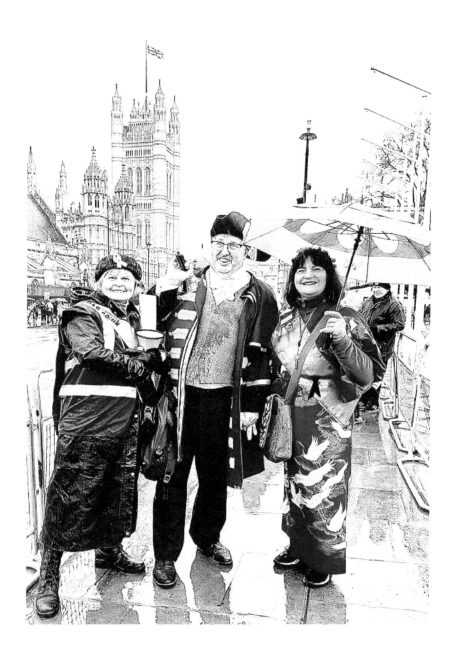

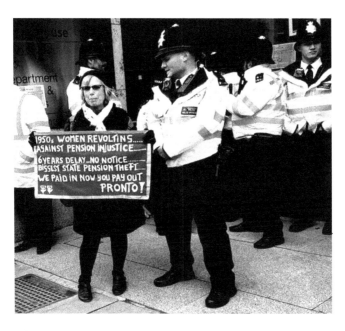

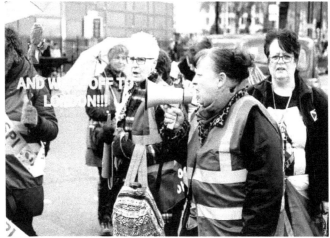

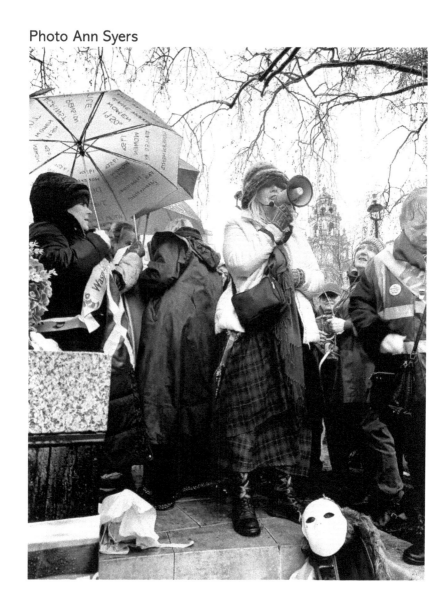
Photo Ann Syers

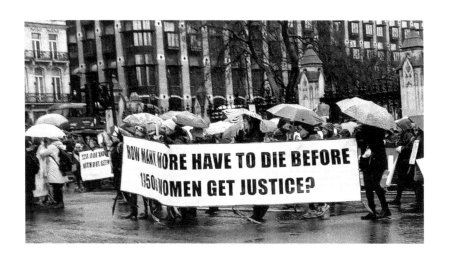

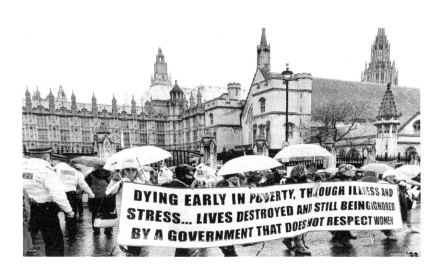

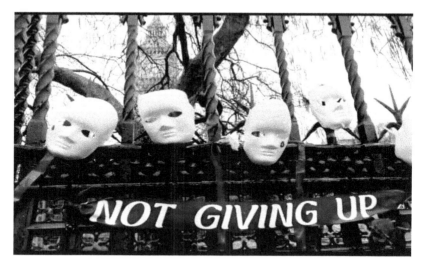

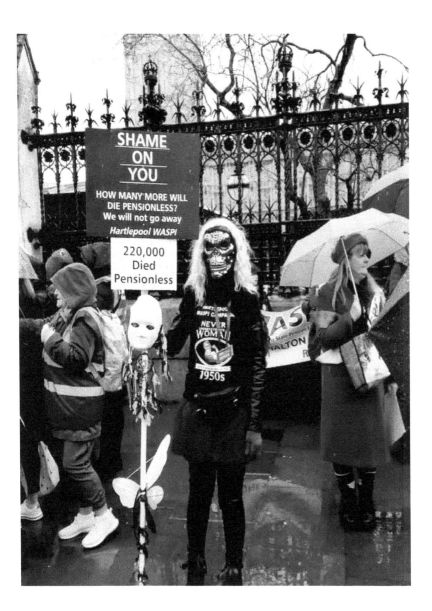

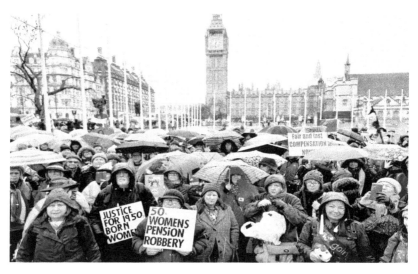

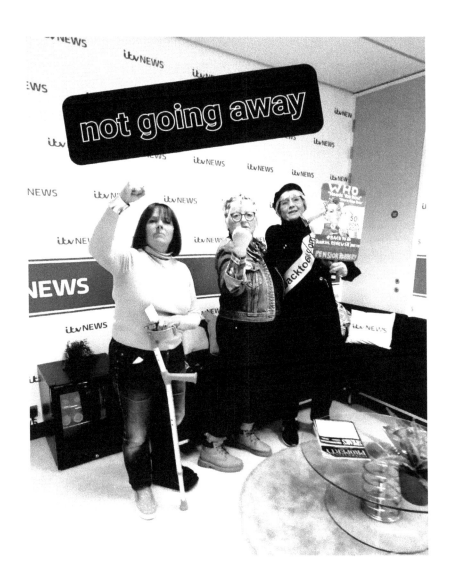

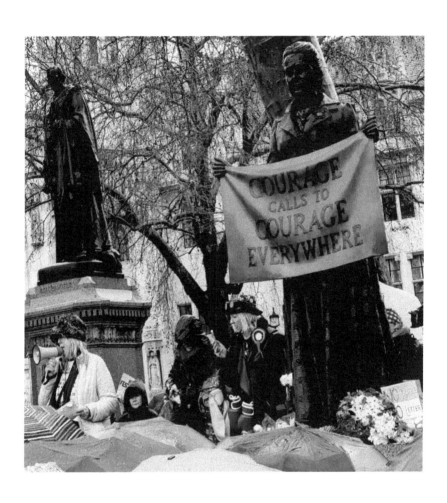

Photo Ann Syers (below)

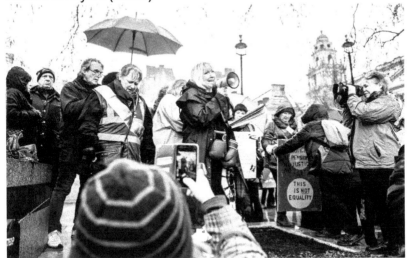

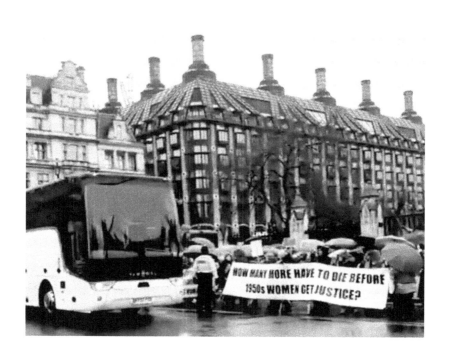

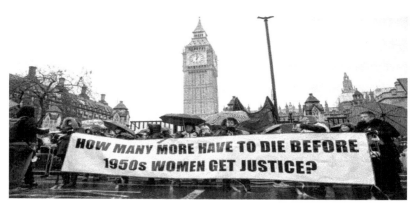

Together for SP justice

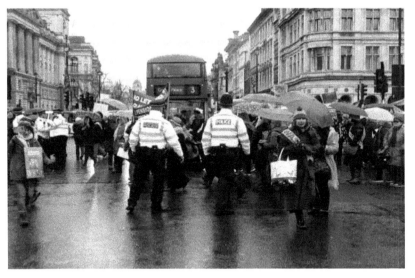

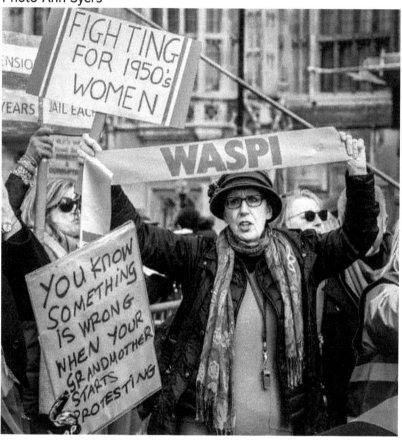

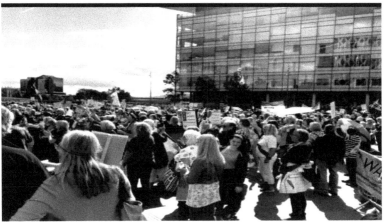

Photo Ann Syers

Photo Cheryl Prax

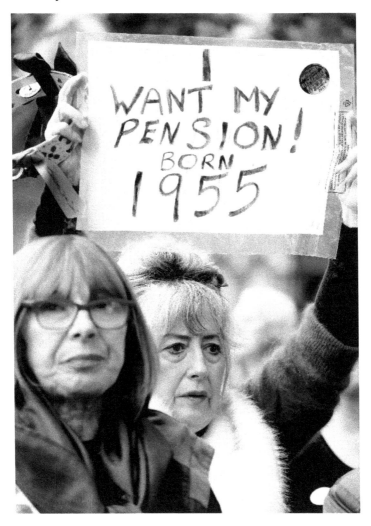

Photo Ann Syers

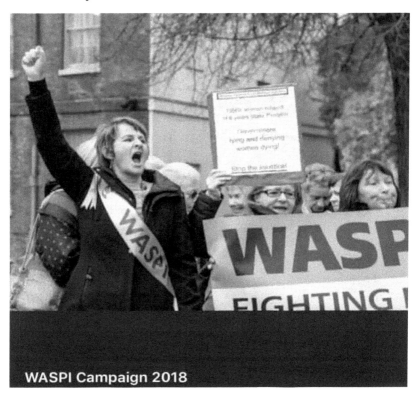

WASPI Campaign 2018

Photo Cheryl Prax

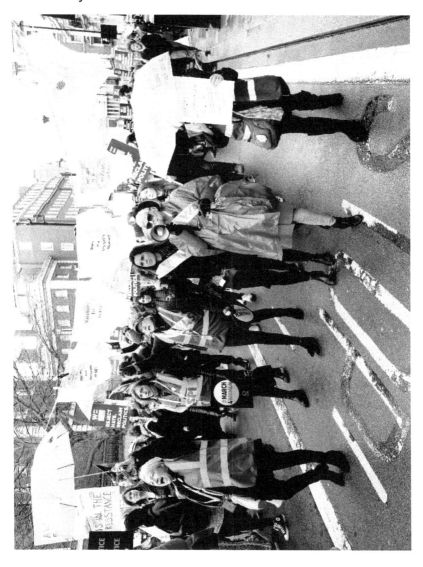

Photo Cheryl Prax

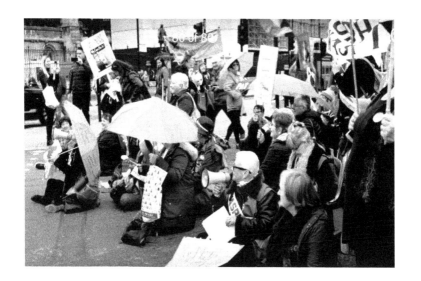

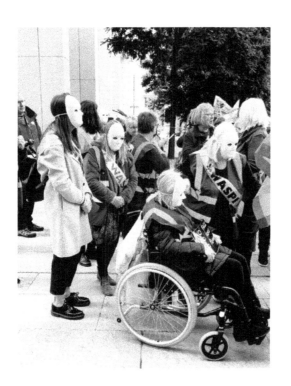

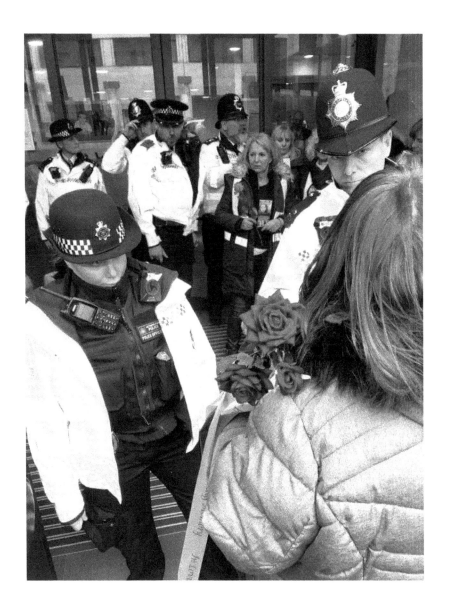

Photo Ann Syers

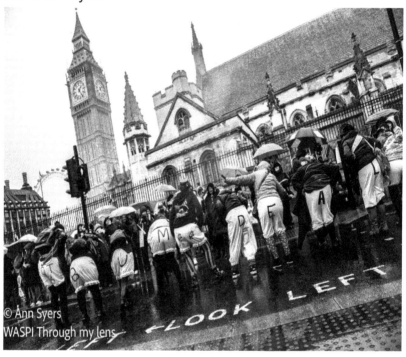

Photo Cheryl Prax

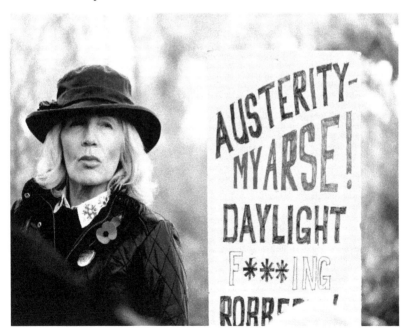

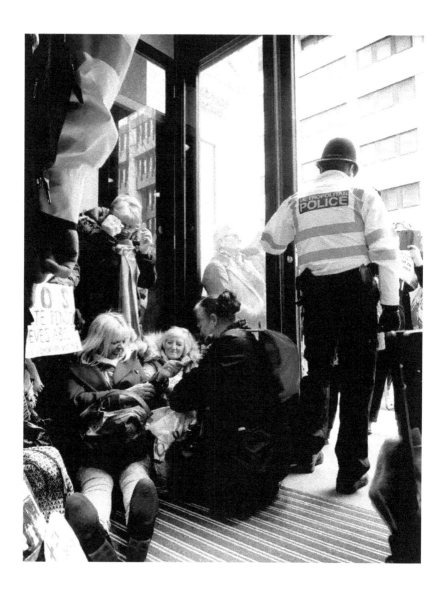

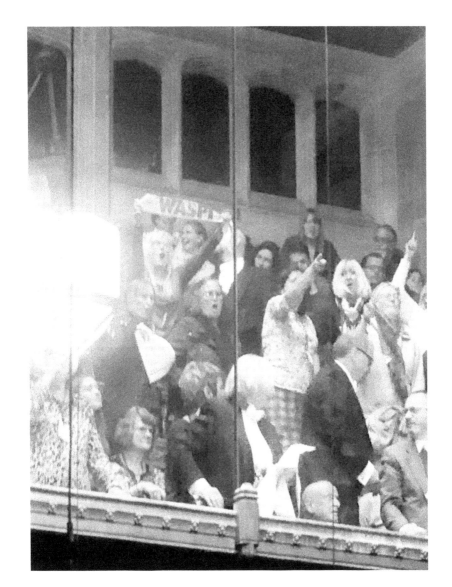

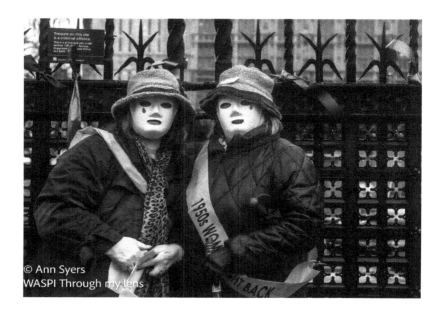

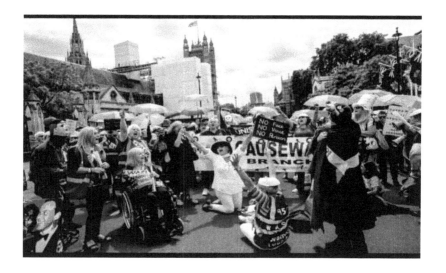

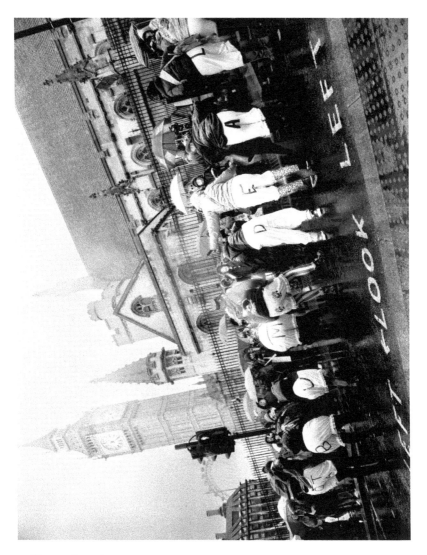

Photo Ann Syers

Photo Cheryl Prax

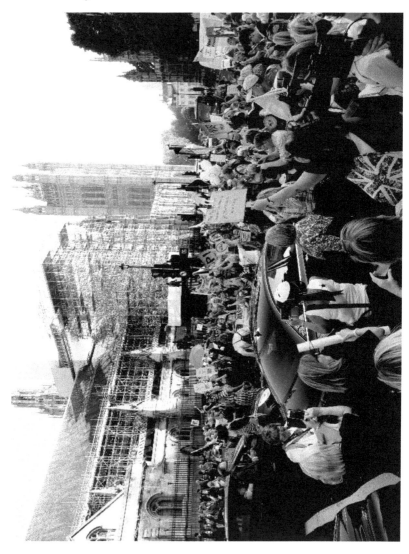

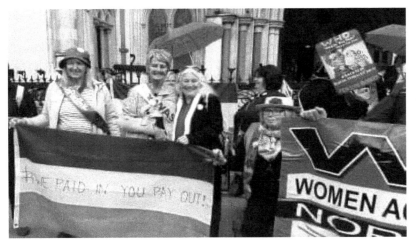

Phot Cheryl Prax (below)

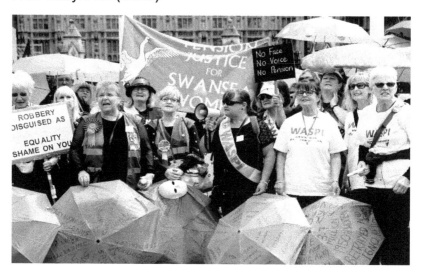

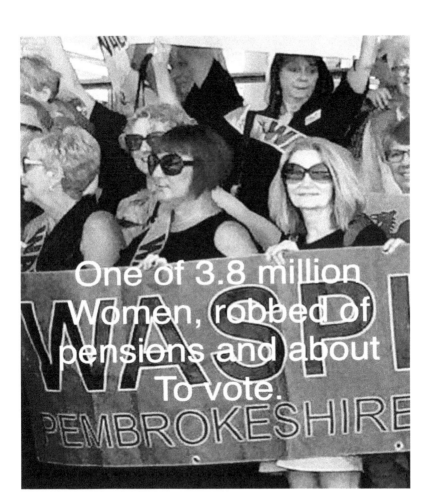

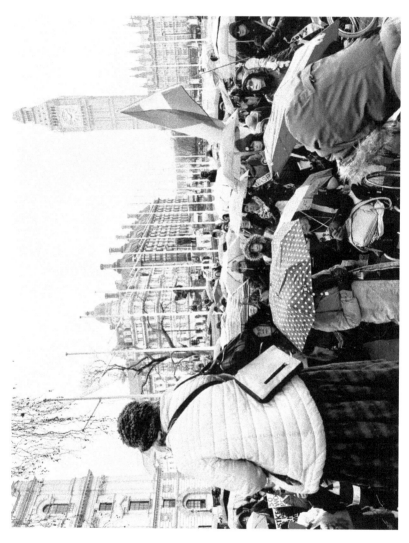

Photo Cheryl Prax

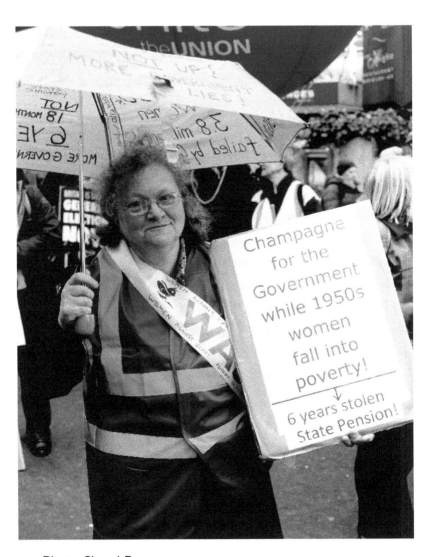

Photo Cheryl Prax

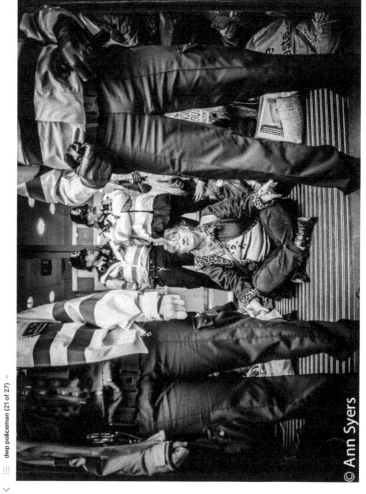

© Ann Syers

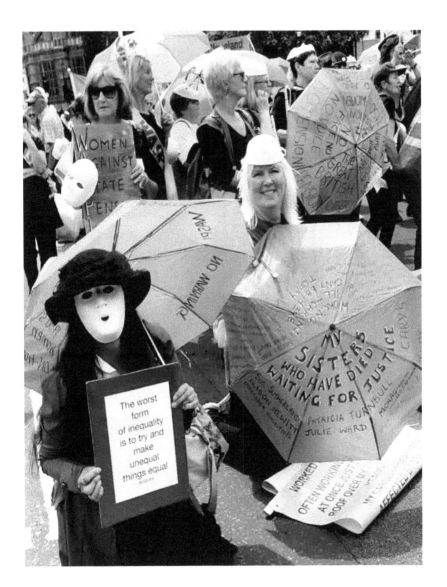

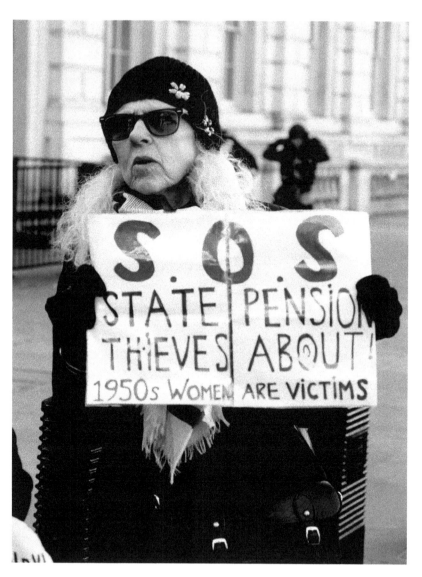

Photo Cheryl Prax

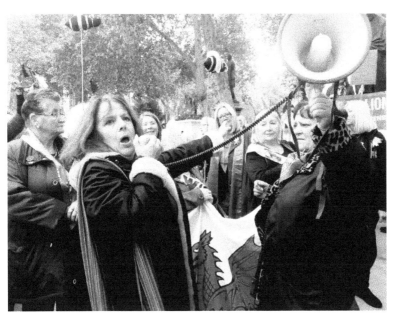

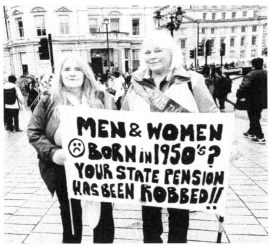

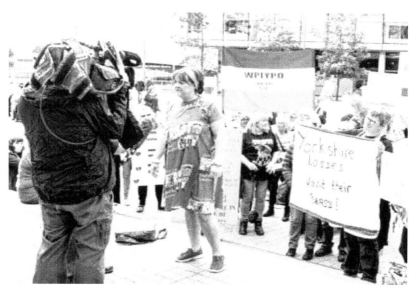

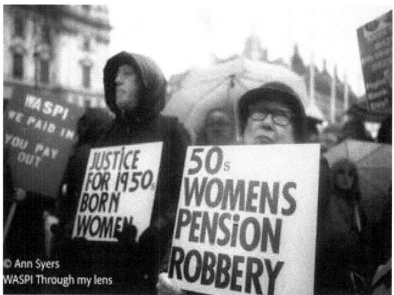

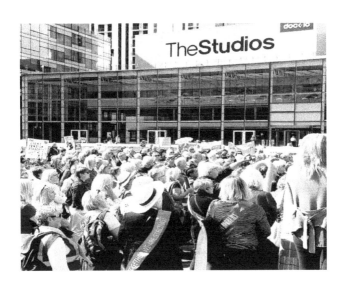

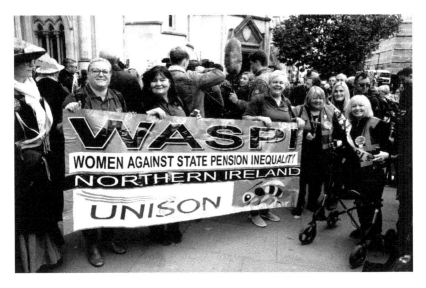

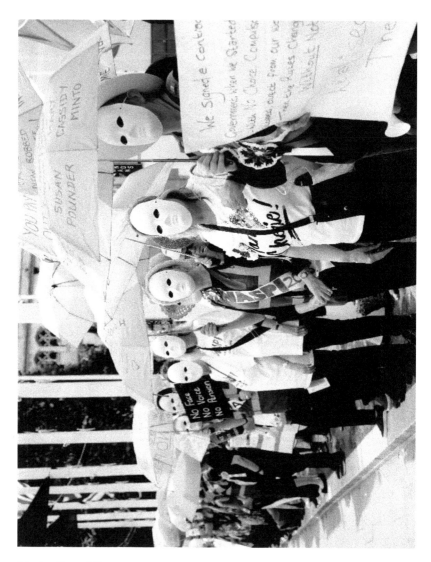

Photo Cheryl Prax

Photo Ann Syers

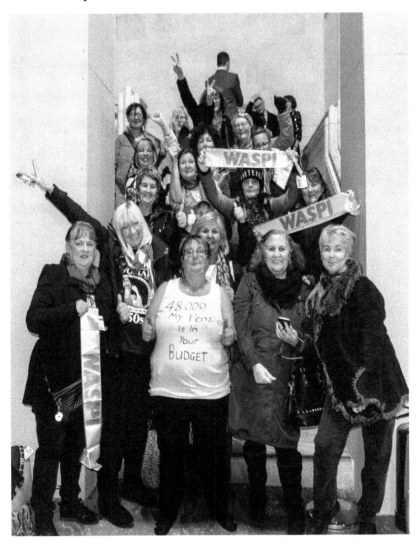

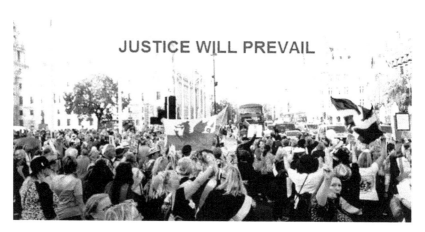

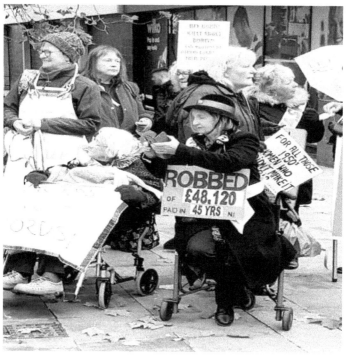

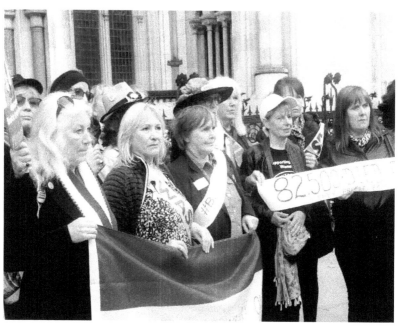

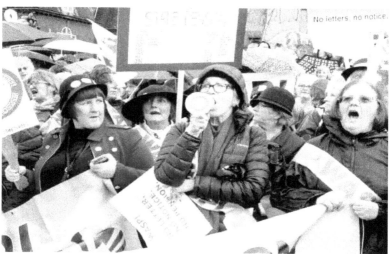

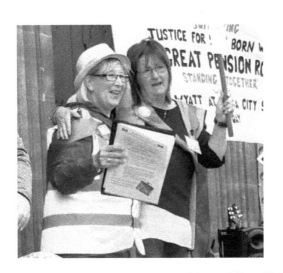

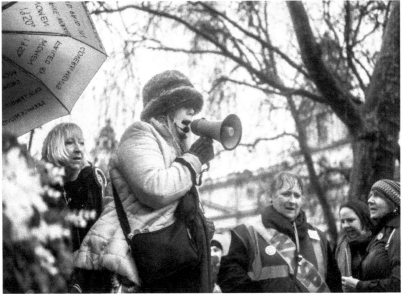

Photo Ann Syers

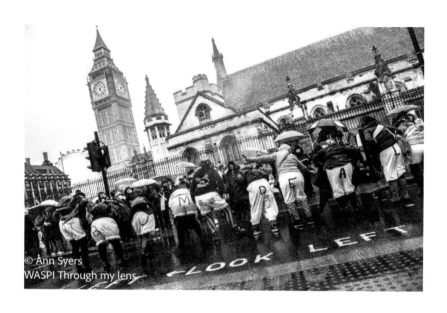

© Ann Syers
WASPI Through my lens

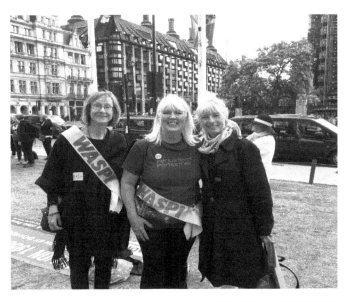

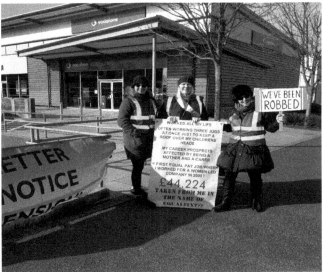

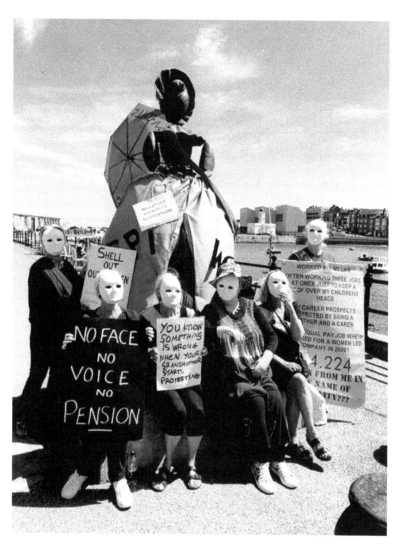

Photo Timandra French

Photo Jackie Gilderdale

Photo Cheryl Prax

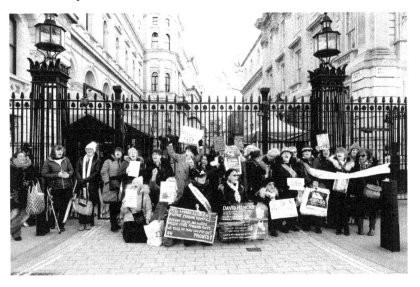

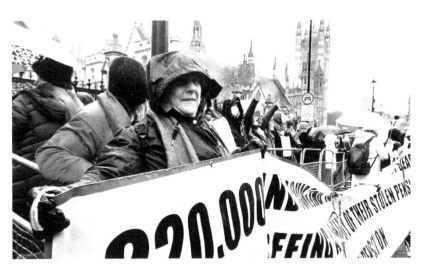

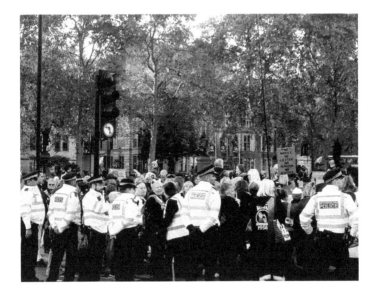

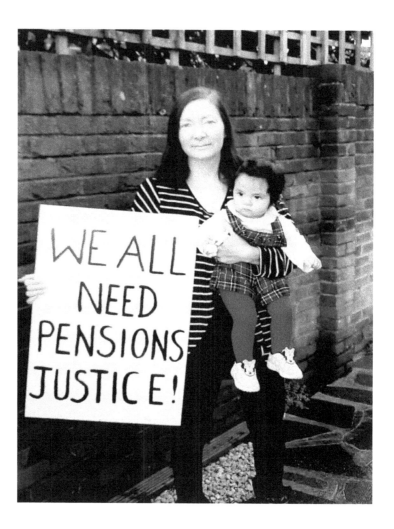

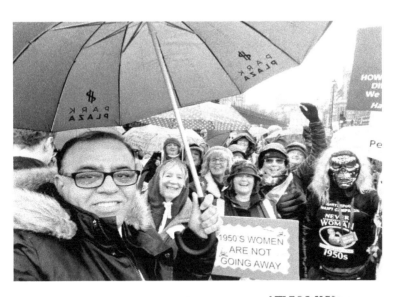

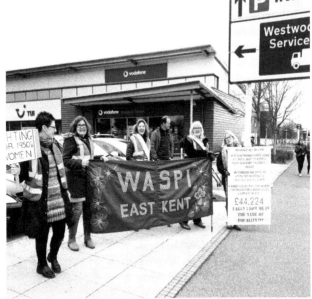

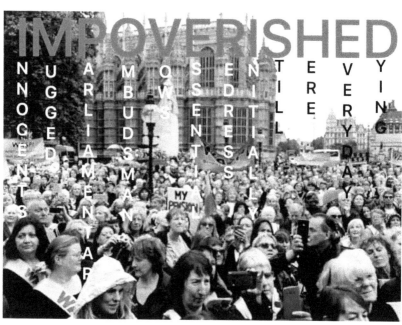

IMPOVERISHED

INNOCENTS
RUGGED
PARLIAMENTARY
OMBUDSMAN
MOSBY'S
SENTENCED
DISTRESS
INITIALLY
TILL
TIREDLY
EVERYDAY
YINGING

MY PENSION

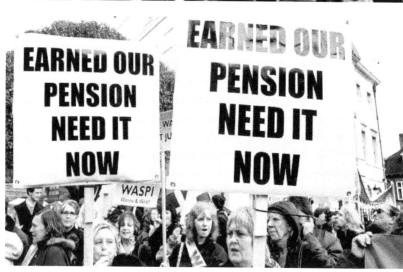

EARNED OUR PENSION NEED IT NOW

WASPI Wales & West

EARNED OUR PENSION NEED IT NOW

Photo Cheryl Prax

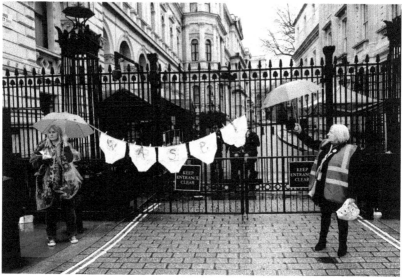

Gagged but not silenced
– Dee Wild Kearney

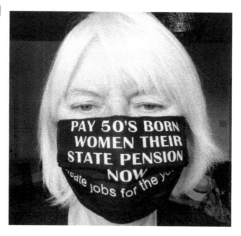

Remember Remember Thankyou Cards – Artist Dee Wild

Just some of theny memorial ribbons

Photo Cheryl Prax

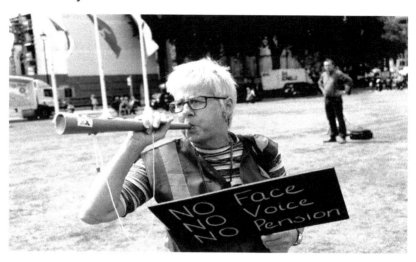

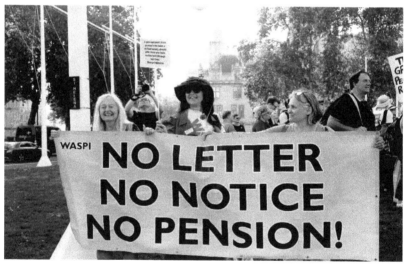

PENSION PARTNERS FOR JUSTICE

PP4J

NON ABIENS!

Milton Keynes UK
Ingram Content Group UK Ltd.
UKHW020729080424
440801UK00013B/626